JULIO GONZALEZ

Sculpture in Iron

Josephine Withers

New York · New York University Press

Picasso, *Portrait of Julio Gonzalez*, c. 1902.

Photographic Credits

Photographs of works by Gonzalez not otherwise credited are courtesy of the Galerie de France, Paris. References are to text figures.

Gemeente Musea van Amsterdam, 115.
The Baltimore Museum of Art, 12.
Pierre Bouchez, Paris, 3.
Brassaï, Paris, 10.
Galerie Chalette International, New York, 13.
Delagénière, Paris, 120.
Walter Dräyer, Zurich, 17, 132.
Claude Gaspari, Fondation Maeght, St. Paul, 4.
Henri Guilbaud, Paris, 24, 28, 32, 33, 34, 35, 37, 40, 41, 44, 46, 48, 55, 68, 70, 71, 74, 81, 94, 97, 100, 101, 104, 112, 119.
John Hedgecoe, London, 7, 8, 9.
Hervochon, Paris, 96.
Hirshhorn Museum and Sculpture Garden, Smithsonian Institution, Washington, D.C., 131, 134.
Kennedy Galleries, New York, 14.
Bernd Kirtz, Duisberg, 36.
Walter Klein, Dusseldorf, 5.
E. Janet Le Caisne, Paris, 62, 80, 109.

Luwa, Zurich, 42.
Galerie Maeght, Paris, 4, 140.
Archivo Mas, Barcelona, 1, 26, 82.
Jacques Mer, Antibes, 139, 141.
Allen Mewbourn, courtesy of The Museum of Fine Arts, Houston, 114
Moderna Museet, Stockholm, 56.
Museum of Modern Art, New York, Frontispiece, 73, 92, 106, 107, 113, 122, 128, 133, 135, 136, 142.
Philadelphia Museum of Art, 47. A. J. Wyatt, staff photographer, 45.
Service de documentation photographique, Versailles, 11, 31, 43, 61, 91, 123.
Soichi Sunami, New York, 137.
The Solomon R. Guggenheim Museum, New York, 15.
Tate Gallery, London, 66.
Marc Vaux, Paris, 16, 129, 130.
John Webb, courtesy of the Arts Council of Great Britain, London, 6.
Josephine Withers, Washington, D.C., 38, 39, 52, 57, 59, 60, 63, 65, 69, 72, 75, 76, 77, 78, 79, 90, 93, 95, 116, 117, 118, 126.

Library of Congress Cataloging in Publication Data

Withers, Josephine.
 Julio Gonzalez: sculpture in iron.

 Bibliography: p.
 Includes index.
 1. Gonzalez, Julio, 1876–1942. 2. Sculptors — Spain
— Biography.
NB813.G6W57 730′.92′4 [B] 76–26798
ISBN 0–8147–9171–9

Manufactured in the United States of America

Foreword

The work of Julio Gonzalez has long been acknowledged as of crucial importance for sculptors of the third quarter of the twentieth century in both Europe and America. A pioneer in the creative use of welded iron, Gonzalez was an inspiration to David Smith, and the debt owed him by Eduardo Chillida, Anthony Caro and others is hardly less significant. Yet this book is the first full scholarly account of Gonzalez's sculptural career.

There are various reasons why historians of modern art have been reluctant to undertake so rewarding a task. One of them, surely, is that the work of Gonzalez defies classification in terms of the established categories of twentieth-century art between the two World Wars: it is not Cubist, Constructivist, or Surrealist, although it incorporates elements of all of these styles. Another reason may have been the unorthodox pattern of the artist's development. While modern art offers a number of well-known instances of artists who did their most important and original work at the beginning of their career and then fell into a long period of decline (Giorgio de Chirico and George Grosz are perhaps the most striking cases), Gonzalez did not come into his own until he was in his early fifties, in 1929. A decade later, his career was cut short by the Second World War, so that his sculptural oeuvre covers a span of barely ten years. Among artists of the first rank, so late and brief a flowering is unique. Still another reason, and probably the principal one, stems from the fact that Gonzalez's artistic awakening was precipitated by his collaboration with Picasso in 1928. What was the nature of this collaboration? Hilton Kramer has compared it to that famous earlier one between Picasso and Braque, possibly from a desire — understandable if misguided — to make the two partners more nearly equal than in fact they were. There is no denying that Gonzalez entered the collaboration in a subordinate capacity, as a technician, while Braque did so as an important artist in his own right. Dr. Withers, through meticulous

v

78-00579

research, has established the exact circumstances that led Picasso to call upon the help of Gonzalez. She demonstrates no less convincingly what each gained from the relationship, why the two went their separate ways afterwards, and how Gonzalez arrived at his uniquely individual style. In the process, she uncovers a series of fascinating relationships between the art of Gonzalez and that of other sculptors working in Paris during the 1930s. Her reading of Gonzalez's personal character is equally perceptive: his strong sense of Catalan identity comes to the fore again and again as the most persistent element of his emotional makeup. Nowhere do we feel it more powerfully than in that difficult and strangely moving text, *Picasso sculpteur et les cathédrales*, here fully transcribed and translated for the first time. Dr. Withers has produced an exemplary piece of scholarship that fills a serious gap in our knowledge and, in doing so, pays homage to one of the seminal masters of modern art.

<div align="right">H. W. Janson</div>

Preface and Acknowledgments

When Julio Gonzalez died in a small suburb of Paris during the last world war, he left behind a sculptural oeuvre which had only come into being in the last fifteen years of his life. In that short period of time, Gonzalez transformed himself from an artistic jack-of-all-trades into an accomplished sculptor who pioneered a new and difficult medium — forged and welded metal sculpture.

Gonzalez did not die young, he began late. He was already fifty-one years old when he found his true calling, and was sixty-six at the time of his death. Before this, he had made unsuccessful attempts to realize himself as a painter, supporting himself by making jewelry and decorative art objects with the smithing skills which he had learned as a youngster in his father's workshop. His new beginning at such an unusual age was the result of a remarkable sculpture collaboration with Pablo Picasso. In a short time Gonzalez gained the initiative and artistic direction which until then had eluded him.

Gonzalez has always enjoyed a special reputation. Although his abstract constructions in welded iron never became widely known in his lifetime, he was, and continues to be, particularly appreciated by the most demanding of critics, his artistic peers. It was, above all, the welders coming after the Second World War to whom Gonzalez became the example as the "first master of the torch," as David Smith phrased it. What Gonzalez's work lacks in breadth and diversity is more than made up by the concentration of his effort and his masterful control of a medium which has become an integral part of a technological art.

Since the large retrospective exhibition of Gonzalez's work held in Paris in 1952, his sculpture has never been far from the public eye. There have been numerous one-artist exhibitions in museums and galleries, and he has been regularly included in books and exhibitions of a more general nature. There has, however, been no critical study of his work, and the large bibliography devoted to his sculpture has added very little to the sum total of our knowledge.

After briefly reviewing Gonzalez's life and activities up to the moment when he began his welded metal sculpture in the late twenties, this study focuses on a critical examination of the sculpture, in the light of his own theoretical objectives and those of his contemporaries. Although presented in a separate Appendix, the Catalogue of the Sculpture forms an integral part of this examination; before any serious study could begin of the sculpture as an ensemble, it was necessary to reevaluate the dates of all Gonzalez's work, and to put it into a sequence which, as it turned out, differed in important respects from the generally accepted order.

I am indebted to the General Research Board of the University of Maryland for awarding me a research grant, and to Dr. George Levitine, Chairman of the Art Department, University of Maryland, for helping me to obtain the time needed to complete this project. I am grateful to many friends for their help in bringing this study to its present form. Barbara Frank, Marion Adams, and Leslie May all gave expert assistance in preparing this manuscript for publication. Julia Markus and Ursula Ehrhardt were invaluable in helping to focus my flagging critical perspective. The late Rudolph Wittkower, Charles and Margret Withers, Ruth Butler, and H. W. Janson have generously encouraged and supported me in ways beyond counting, and have sustained my conviction that this book was well worth doing.

In studying Gonzalez's work over the past several years, it has at times seemed as if I could reach out and touch the man. For my knowledge of both, I have a great debt of gratitude to Gonzalez's daughter, Mme. Roberta Gonzalez, news of whose death reached me while this was in press. Mme. Gonzalez combined the rare gifts of filial devotion, an artist's sensibility, and a keen appreciation of her father's work; in addition, she was quite close to her father and, one suspects, similar to him in many ways. The numerous references to Mme. Gonzalez are only a small indication of the extent of her help; indeed, this study would not have been possible without her generosity in letting me use letters and other documents in her collection, her unfailing cooperation throughout many months of interviews, and her patience in answering my letters.

Josephine Withers
Washington, D.C.
July 1976

Contents

List of Illustrations

List of Illustrations

JULIO GONZALEZ

Sculpture in Iron

I

The Life

BARCELONA

This barbaric land, as beautiful as it is wretched . . . this country which since its beginning, was always subjugated to new conquerors . . . this martyred people, oppressed, without their own liberty, without the hope of ever obtaining it.

This was how Julio Gonzalez described his native Catalonia in his essay, "Picasso sculpteur et les cathédrales," written many years after he had left Barcelona for Paris.[1] Whenever Gonzalez had occasion to mention his homeland, he referred with pride and affection not to Spain, but to Catalonia.

His name tells us he is of Castilian origin, and in fact Gonzalez's paternal grandfather was new to Barcelona, probably having moved there in the first part of the nineteenth century. It was through his paternal grandmother, of the Puig family, and his mother, Pilar Pellicer, that Gonzalez claimed Catalan ancestry.

Julio Gonzalez (in Catalan, Juli Gonzalez-Pellicer) was born in 1876, and was the youngest of a close-knit family that included four children. By the time that Julio was a young boy, father Concordio was already established as a master in decorative metalwork, a craft which in Spain had a rich tradition of many centuries. Not only was his father an accomplished craftsman, who introduced all his children into the craft of metalworking, but he was also an occasional sculptor, and took an active part in the artistic life of Barcelona. Julio's mother also came from an artistic family; her brother was the prominent Barcelona painter and draftsman José Luis Pellicer (1842–1901), who was well known for his spare and factual pictorial reportage at the time of the Carlist and Franco-Prussian wars in the 1870s.[2] Gonzalez's youth, then, was spent in a

3

family milieu sympathetic to his artistic ambitions, which at that time and for many years after his move to Paris were directed toward painting, rather than sculpture.

Julio's debut, however, was as a metal craftsman, not a painter. When he was still quite young, he was initiated into the family craft and by the time he was seventeen, he had already exhibited his metalwork in Barcelona[3] and at the Chicago World's Fair.[4]

Although it is possible to reconstruct the broad outlines of Gonzalez's youth, it is unfortunate that very little documentation of a precise nature remains to us. The most reliable information concerning the artistic activities of Julio and the family is found in the catalogues of the biennial exhibitions of fine and industrial arts held in Barcelona throughout the 1890s. Following the great success of the Exposición Universal de Barcelona of 1888, the Exposición de Bellas Artes and its sister exhibition, the Exposición de Industrias Artísticas, were established as a continuing series of biennial expositions. Like the great universal exhibitions of London, Paris, and Vienna, on which they were modeled, they were intended to encourage the arts and to provide the city with a means of buying works for its public collections.[5]

The catalogues of these exhibitions show that Concordio, his sons Juan (1868–1908) and Julio, and his daughters, Dolores (1874–1962) and Pilar (1870–1951), all worked in the family business of decorative metalwork. They exhibited together as "Gonzalez y hijos" and individually under their own names in the industrial arts exhibitions of 1892, 1896, and 1898. In addition, the catalogues mention Concordio as a member of the juries awarding medals and prizes.

Possibly because Concordio had increasingly substantial help from his children, his business prospered, and in 1892 he was able to move from small apartments in the Calle de la Diputación[6] to a large house with adjoining studio on the Rambla de Cataluña.[7]

It is difficult to discover the type and scale of metalwork which the Gonzalez family did. Was it primarily of a large scale, or did they specialize in small pieces such as the lamps and objets d'art listed in the industrial arts catalogues? Did their work include jewelry and objects in precious metals, or was it limited to iron and bronze? There are no certain answers to any of these questions.

While all the pieces listed in the industrial arts catalogues, whether exhibited individually or under the family name, are small and generally portable items such as lamps, candelabra, statuettes, jardinieres, and flower pieces, this is no certain indication that these small pieces were their only work, since they would have been more suitable for such exhibitions than large pieces requiring special installation.

A few accounts of larger pieces are recalled by Gonzalez's family and friends. According to one of the few surviving Barcelona relatives of the family, Sra. Marota Pellicer, the family was commissioned to execute the fountain in front

of the Romanesque church of San Pere de las Puelles in the old quarter of Barcelona. This was designed by the municipal architect Falqués and was installed in 1896, replacing the old stone fountain (**1**).[8]

The only other mention of a large piece in iron comes to us at second hand through Gonzalez's family and friends. In one account handed down in the family of the artist Claudio Castelucho, a friend of Julio's in Barcelona and later in Paris, the Gonzalez family assembled a very large iron piece in their workshop on the Rambla de Cataluña, and belatedly discovered that it was too large to be taken out through the doors; consequently it had to be lifted out through the skylight.[9] There may have been other similarly large pieces done on commission; according to Mme. Gonzalez, the family was commissioned to do architectural ironwork for one of the local convents.

The metalwork which Julio exhibited under his own name was small decorative pieces in wrought iron such as the "little branch of flowers" (1892), "branch of flowers" (1896), and "branch of poppies" (1898) listed in the catalogues of the industrial arts exhibitions. They were probably similar to the "four flowers" of iron and copper now in the Musée d'Art Moderne in Paris.[10]

The metalwork exhibited under the family name was generally of a slightly larger scale, and included iron, bronze, and gilded bronze, fashioned by forging and repoussé. The fountain near San Pere de las Puelles is fashioned of both forged and cast iron. The crisp and rigid forms of the larger structural parts suggest that they were cast using the sandcasting technique, while the corkscrew finials and smaller decorative units appear to be of forged iron.[11]

The techniques of forging iron such as Julio Gonzalez would have learned in his father's workshop would have included the basic processes of shaping and joining the metal. Customarily, the components are shaped individually before being assembled. The part to be shaped is first heated; in this condition the iron is no longer a hard and intractable metal but is plastic and ductile. The most common operations used to shape the metal are bending, twisting, and hammering. A variety of tongs are used to hold the work and to bend or twist

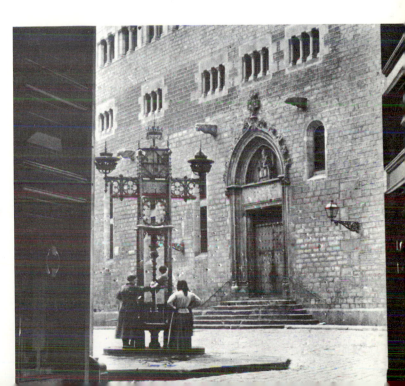

1. Gonzalez Workshop, *Fountain*, Barcelona, Square of San Pere de las Puelles.

2. Gonzalez, *Page from an album presented to Dr. Josep Torras y Bages*, 1898.

longer pieces such as rods and wires. Any part that is made from flat sheets of metal is usually shaped by hammering. According to the shape of the hammer and the technique employed, hammering can be used to stretch, draw or thin out, bend, or thicken the metal. After being shaped, the components can be assembled by hammering or rolling them together under heat, or by soldering. A hammered, or forged, join fuses the pieces together using heat and pressure. To be successful, there must be a fairly large area of contact, and because the metal is actually fused, a stronger join is obtained than by soldering. Solder is a generic term referring to various metal alloys having a lower melting temperature than the principal metal. Soldering a join cements, rather than fuses, the parts together.

The term "repoussé" literally means "pushed from the back;" unlike forging, the metal is hammered and worked cold, and for this reason, must be thinner in order to be tractable. It is, therefore, particularly suited to the finer metals, such as copper and silver. Repoussé pieces are usually small, since they are necessarily more fragile.

These techniques of shaping and joining metal are the basic and traditional repertoire of the craft which Gonzalez would have learned in his father's workshop. Although these processes have been described in terms of iron, they would also be used for direct work in bronze. Similar techniques would also be used in working gold, silver, and copper, although these metals are softer and more ductile and can therefore more readily be worked cold.[12]

During the 1890s, while Gonzalez was working in the family business and exhibiting his metalwork, he also spent a fair amount of time drawing and painting. Some authors have suggested that he was enrolled in the art academy of Barcelona, known as La Lonja, but no record of this has been found.[13] He did, however, join the Circul Artistic de San Lluc, a Catholic and rather conservative art group familiar to us through one of its most illustrious members, the architect Antonio Gaudí. Juan and Julio may have been encouraged to join the group by their uncle, J. Luis Pellicer, who was president of the Circul. It is through this group that today we have the only documented work, modest as it is, done by Julio during his years in Barcelona. This is a group of sketches and watercolors executed in a delicate and conventional style, and presented in 1898 as part of an album to the chaplain of the Circul, Dr. Josep Torras y Bages (**2**).[14] One of the drawings, of finely detailed spiky leaves, is almost indistinguishable from a drawing of his brother Juan's, exhibited in the gallery of the Ateneo in 1893.[15] It is also similar to the style of the painter Apelles Mestres, an established Barcelona artist of eclectic and Gothic persuasion.

It was not, however, the staid and conservative atmosphere of the Circul which attracted Gonzalez, but rather a younger group of artists and writers whom he met there, and who went on to form their own group. This Cénacle frequently gathered in the Gonzalez home, either for discussions or for drawing sessions with a model. Besides the Gonzalez brothers, the regulars of the group included the Argentinian painter Torrès-Garcia, recently arrived in Barcelona, the painters Pijoan and Pichot, the poet Marquina,[16] and the musician Ribera. While Julio no doubt profited from his association with these artists, he himself remained a spectator to their public activities, which included regular entries in the Exposición de Bellas Artes and frequent contributions to the avant-garde periodicals.[17]

Through the few accounts which remain to us, the picture emerges of a shy and sensitive man, eager to become an artist, but uncertain of how to go about it. Already as a young man in his early twenties, Gonzalez appears to have been plagued with a certain hesitancy and skepticism which was to remain with him for many years. While his older brother Juan asserted himself more vigorously, exhibiting his sculpture and drawings in the biennial exhibitions, Julio was more retiring and kept to himself, only revealing himself to his friends through occasional pronouncements and emotional explosions. A precious glimpse of him comes to us from his friend Torrès-Garcia, who recalled this in his memoirs:

Juan and Julio had very similar ideologies that could almost be called familial. They readily made generalizations and from there went on to construct universals, which, however, always referred to Nature. In this way they built a world that was ideal and real at the same time. They always held to this special way of seeing things . . . [and] their manner of expressing themselves, artistically, was the same. Apart from

7

this, they were completely different, especially in their character. . . . Julio was more expressive than his brother, and for that reason, if Juan was content to smile, not Julio; he had to make his ironic point, or get rid of his bad humor whenever an innate skepticism made him see the wretched side of things.[18]

From this we obtain a brief but valuable impression of Julio's characteristic ideas and manner of expression which otherwise do not appear to us with any clear definition until many years later.

The prosperous and rather tranquil life of the Gonzalez family came to an abrupt end in 1898. In this year, Concordio Gonzalez died, at the age of sixty-five, and prospects for workshop commissions dwindled as a result of the disastrous termination of the Spanish-American War and the ensuing financial uncertainty.

It was probably the economic predicament which figured most importantly in the decision of Juan Gonzalez, now head of the family and the workshop, to move to Paris. There the family would be able to re-establish its business, and at the same time the brothers would have more opportunities to further their careers in painting.

PARIS

About 1900, then, the whole Gonzalez family, Juan and Julio, their mother, and sisters Dolores and Pilar moved their household to Paris. Except for several visits to Barcelona, Julio, then aged twenty-four, was to remain in Paris for the rest of his life.[19]

In writing of this, Hilton Kramer is probably accurate in observing that

Characteristically, it was a family move. Whereas Gris, for example, had left Madrid by himself after selling everything he owned . . . and arrived alone in Paris with a few francs in his pocket, and Picasso simply removed himself from the bohemian world of Barcelona to its larger and more active prototype in the French capital, Gonzalez's move to Paris came as part of his family's decision to leave Spain and set up housekeeping in France. [This move] was anything but the usual personal rebellion against family life and conventional values.[20]

It was perhaps natural that Gonzalez was thrown together with other Spanish and Catalan artists who were also recent arrivals to Paris. Many of them he probably knew from Barcelona, except one, Pablo Picasso.

Gonzalez had certainly heard about Picasso, who had already made a name for himself in the avant-garde circles of Barcelona, either through mutual friends, or through his brother Juan. He probably first met Picasso through Juan, sometime after coming to Paris. The earliest mention of their friendship is made

by Picasso's friend Sabartés, who arrived in Paris during the fall of 1901; Sabartés recalls that he soon came to know all of Picasso's friends, including the Gonzalez brothers.[21] Picasso treated Juan with a certain respect, since Juan was thirteen years his senior; Julio, however, was more a confidant. During the time he was in Barcelona, Picasso would write to Julio of his loneliness and of his desire to return to Paris.[22] Picasso always delighted in making portraits of his friends, and in the spring or summer of 1902, he presented Gonzalez with a charming and informal watercolor, souvenir of a pleasant afternoon spent together at the Tibidabo, a large hill overlooking Barcelona (see Frontispiece).[23]

Gonzalez and Picasso continued as close friends, although in 1904, when Picasso finally settled in Paris, he came to rely less on the companionship of his Spanish friends and increasingly sought out French writers and artists. Thereafter, their paths diverged, until that moment, more than twenty-five years later, when Picasso recalled the special skills of his friend, and initiated a collaboration which was to completely change the course of Gonzalez's life.

Two factors may have contributed to their estrangement. Mme. Gonzalez has written that "circumstances took him from an avant-garde milieu into one that was more 'well-behaved.' "[24] While Picasso went on to conquer the artistic world as the creator of Cubism, Gonzalez continued on his quiet and lonely way, perhaps evincing a certain distrust for the antics and enthusiasms of Picasso's entourage.[25] In addition to their differing lifestyles, their friendship may also have been ruptured by a small misunderstanding arising shortly after the death of Juan Gonzalez in 1908. According to Mme. Gonzalez, there were certain drawings of Juan's which were given to Picasso's family in Barcelona for temporary safekeeping. The drawings, so the story goes, disappeared rather mysteriously, and since Picasso was known to have liked Juan's work, Julio suspected that they had found their way into Picasso's collection, and became quite upset over this.[26]

When Juan Gonzalez died in Barcelona in March of 1908 after an illness of several years, Julio lost a friend to whom he had always turned for direction and companionship. Julio was close to his brother, and Juan's death seems to have affected him deeply. But there seems to be little evidence to support Mme. Gonzalez's suggestion that as a result of Juan's death, he slipped into a depression which made him unable to work for many years.[27] Although Gonzalez did not show his work between 1907, when he first exhibited in the Indépendants, and 1913, when he began exhibiting in the Salon d'Automne, he did continue to paint and draw. In a letter to his sisters in Barcelona shortly after Juan's death, he writes that he is in good form, had found some work doing metal repoussé, and was finding time to paint.[28]

While Gonzalez's artistic ambitions were directed toward painting, he also found time for sculpture. His modeled pieces, although possessing a certain charm, are ultimately of less interest than the unusual repoussé masks in bronze and silver which he began making around 1910. Beyond their technical

Julio Gonzalez: Sculpture in Iron

brilliance, they show a great sensitivity to the material. Many, such as the *Portrait de Jean de Neyris* (**4**), were executed as portrait commissions, and these are usually crisp and clearly defined. Others have vaguer and more generalized features, and are rather impressionistic (**3**). Although these masks were consistently well received, Gonzalez seems to have been diffident as to their value as works of art. On the many occasions when they were exhibited in galleries and salons from 1913 through the mid-twenties, he persisted in referring to them merely as decorative objects.

In 1909 Gonzalez married a young woman named Jeanne Berton, who was able to give him the home life which he had missed since early in 1908 when his mother and sisters had rejoined Juan in Barcelona. In 1911 a daughter, Roberta, was born, but the marriage did not last, and in 1912 the couple separated, the child remaining with Gonzalez. At about the time Jeanne left the family,

3. Gonzalez, *Tête penchée ancienne*, c. 1910–1914. **4.** Gonzalez, *Portrait de Jean de Neyris*, 1918–1920.

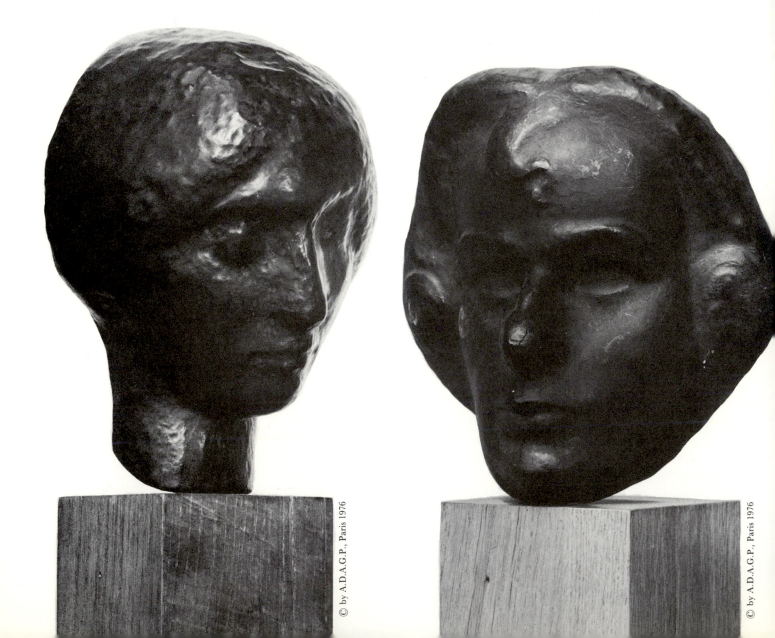

Gonzalez's mother, two sisters, and new brother-in-law, Josep Basso, returned from Barcelona, where they had been living for most of the time since Juan's death.

During this period before the war, Gonzalez busied himself with a variety of decorative arts projects, some in concert with his old friend Torrès-Garcia, who was in Spain at the time, and with the Montmartre ceramist "Paco" (Francisco) Durrio.[29] In partnership with Basso, he opened a boutique on the Boulevard Montparnasse in 1912 which sold his own and his sisters' decorative metalwork.

About 1912 his talents caught the eye of Alexandre Mercereau. Mercereau, a remarkable impresario of the art world, was helpful in establishing many artistic reputations. Marinetti once characterized him as the "central electric" of modern arts and letters, and by the time that he met Gonzalez, he had to his credit the organization of several important exhibitions of Cubist painting in Russia and Eastern Europe, participation in the activities of the Abbaye Crétail, and the establishment of a literary section in the Salon d'Automne. When Mercereau became associated with the Salon d'Automne in 1909, it was rapidly replacing the Indépendants as the most advanced salon in Paris. The format of the Salon d'Automne was unusual in presenting ensembles of an artist's work, rather than exhibiting painting, sculpture, and the decorative arts separately. This was ideally suited to Gonzalez's talents, and Mercereau encouraged him to exhibit there.[30] Out of this developed a close friendship which was to endure long after the war, when Mercereau was less active in the art world. In 1921 he sponsored Gonzalez in an exhibition at the café-galerie Caméléon, which presented a cross section of Gonzalez's painting, sculpture, jewelry, and decorative objects. Although he continued to exhibit his sculpture in the Salon d'Automne through 1929, and in other exhibitions such as that at the Galerie Povolovsky in 1922, Gonzalez preferred to identify himself as a jeweler,[31] or as a painter and decorative artist.[32]

Toward the end of the First World War, Gonzalez mastered a skill which was to be of some importance in the creation of his sculpture in metal. This was the technique of oxyacetylene welding. Modern acetylene welding was first used during the First World War in the production of armaments, at the very time that Gonzalez picked it up. At first relegated to the fabrication of less important parts, it gradually came to replace forging as the principal method of joining separate pieces of metal. As previously described, traditional forging is a mechanical method of joining, using heat and pressure, in which the surfaces to be joined are either hammered or rolled together. Since much higher heats are available with the burning of oxygen and acetylene, the pieces to be joined can be fused using heat alone, making a joint which is often stronger than the material of the parts it joins. Of equal importance, the welded joint can have a much smaller area of contact than the forged joint.[33]

Although Gonzalez made no significant use of this technique before 1929, he

seems to have realized at the time that it might have great importance for him. This was how he described it in a letter of June 14, 1918, to his sister in Barcelona. After relating that one of his clients, a Swiss by the name of Kaelin, worked in a shop manufacturing ammunition, he goes on to say:

And so I went to see him to ask if he could teach me this new technique, AUTOGENOUS WELDING. You know you have to wear dark glasses! He said he couldn't do anything for me because it would take too long and require a lot of expensive equipment which he didn't have. And here I thought that knowing the traditional soldering techniques, I could learn it in two lessons. But this isn't so.

He goes on to relate that Kaelin was able to put him in touch with one of his customers, who was eager to help artists, and that after being handed on through several people, he was eventually employed in a branch of the Renault factories at Boulogne-Billancourt, and was trained on the job as a "solderer."[34]

In the years during and immediately after the war, Gonzalez gradually began to renew contact with the avant-garde milieu which he had previously abandoned. Yet he did not immediately become a part of it. As in the early years in Barcelona, he freely associated with artists more adventurous than himself, and yet he remained a spectator, his shyness blocking any decisive utilization of his talents. His old Barcelona friend, Torrès-Garcia, who came to Paris via New York in 1924, remarked, "knowing everybody in Paris, he yet seemed to hide himself, . . . abandoning any intention of pursuing a specific goal."[35] Gonzalez occasionally joined the company gathered around Mercereau at the Caméléon and the Coupole, and enjoyed the companionship of Severini, Jacques Villon, Zadkine, Despiau, Salmon, Fort, and Billy. But he reserved a special affection for Constantin Brancusi, who became a familiar figure in the Gonzalez household. In Brancusi, Gonzalez found a friend who, like himself, had quiet ways and avoided the gregarious café life of the artists' quarters.

In the early twenties, Gonzalez rekindled his friendship with Picasso, although, characteristically, it was Picasso who took the initiative. One day as he was walking along the Boulevard Raspail, Picasso caught sight of him and, throwing his arms open, exclaimed, "Come now, we can't stay angry all our lives! Let's make up!"[36]

In 1928, when Gonzalez began working with Picasso, he was fifty-two years old. While he had regularly been exhibiting his painting and sculpture, there seemed to be no one direction in his artistic activities, nor was the style of his painting and sculpture stamped with any particular or personal vision.

This situation, however, was to be radically changed as a result of his collaboration with Picasso. Although the details and chronology of this important collaboration will be considered in a separate chapter, we should note here that it began in 1928 when Picasso hired Gonzalez to help him execute some small open-form constructions in iron wire. Shortly after they started working together, Gonzalez began to make his own sculpture in iron.

Nineteen twenty-nine was the crucial year in which he came to terms with himself and concentrated on sculpture. This year saw his rejection of the last vestiges of the prettiness which had often marred his work (for example, the *Petit masque baroque*, **13**, cat. 5), and a rapid evolution toward an austere abstract style (for example, the *Harlequin*, **17**, cat. 33). Soon after this, Picasso enlisted Gonzalez's aid once again, and in the course of 1930 to 1932, they worked together on a series of large constructions assembled of scrap iron, the most ambitious of which was the *Woman in the Garden*. This collaboration, which extended over a period of four years, was enormously stimulating for both men, for Picasso no less than for Gonzalez.

At the same time that his sculpture took on new vigor, the pace of his life quickened. Gonzalez completed an impressive number of sculptures in 1929,[37] the same year in which he exhibited his iron constructions for the first time— in the Salon d'Automne—and signed a three-year contract with the Galerie de France.[38]

Now Gonzalez was a sculptor, with something of a new public personality. The critic Vauxcelles claimed to have discovered the "charming sculpture of a young Catalan," when in fact he had already "discovered" him in 1921.[39] Whereas Gonzalez had previously been known variously as a painter, metalsmith, and jeweler, and had been appreciated for his versatility,[40] he now wished to conceal his identity as a craftsman, even though in fact his craft provided his living to the end of his life.[41]

Developments in Gonzalez's personal life, too, augured well for his new career. Despite the world financial situation which steadily deteriorated after 1929, Gonzalez and his family enjoyed a measure of prosperity during the first years of the decade. The whole family, including his two sisters, his daughter, and his companion Marie-Thérèse Roux, whom he married in 1937, worked together in the family métier to satisfy the commissions of a growing clientele.[42] The death of his mother in 1928,[43] although a loss for the family, eventually lightened Gonzalez's financial obligations and gave him more freedom to pursue his new-found career.

Although Gonzalez was never able to sell enough of his sculpture to make a substantial addition to his income, he did have regular one-man exhibitions, and by the mid-thirties had participated in several group shows of avowedly avant-garde persuasion. During the period of his contract with the Galerie de France (to the end of 1932) he had several one-man exhibitions, and he participated in the Salon des Surindépendants in 1931, 1932, and 1933. About 1932 or 1933, he was discovered by Zervos, who on several occasions exhibited his work in the Galerie des Cahiers d'Art and, in lieu of exhibition catalogues, published illustrations of his sculpture in *Cahiers d'art* in 1934, 1935, and 1936. Beginning with the Cahiers d'Art auction exhibition in 1933, which included the sculpture of Lipchitz, Giacometti, Laurens, as well as Gonzalez, he was regularly invited to participate in groups of avant-garde tendency. In 1934 he was included in the "Exposition de la sculpture contemporaine" at Georges

Petit, and in the small but select exhibition organized by Giedion-Welcker in Zurich, "Was ist Surrealismus?" In 1935 he participated in the exhibition "Thèse, antithèse, synthèse" in Lucerne; in 1936, in the comprehensive "l'Art espagnol contemporain" at the Jeu de Paume; and in 1937, in the "Origines et développement de l'art international indépendant."

While Gonzalez established a reputation among other artists, if not the general public, he seldom took part in their discussions or group activities, and remained independent of movements and dogmas. Possibly because he had been isolated from an avant-garde milieu for so many years, and was in any case reticent in the presence of strangers, Gonzalez shied away from the collective demonstrations and *prises de position* which were such an integral part of the art life of the thirties.

Many of the artists whose company he valued were long-standing friends from earlier days, including Brancusi, Severini, Jacques Villon, Mercereau, Despiau, Raynal, and Zadkine.[44] Among his long-term friends, he remained closest to Picasso. Although they had no need to continue the frequent visits of the period of their collaboration, Gonzalez did see Picasso regularly. As tokens of his esteem, in 1936 he wrote an article on Picasso's sculpture[45] and prepared a radio broadcast which was a personal reminiscence of his friend.[46]

Another artist whom Gonzalez saw regularly after about 1926 was his old friend Torrès-Garcia. Since Gonzalez had last seen him in Barcelona before the war, Torrès-Garcia had left Barcelona and had lived in the United States for two years. When he arrived in Paris in 1924, he was in about the same position vis-à-vis the avant-garde as was Gonzalez. Neither Surrealism nor Constructivism suited him, and his polemics against total abstraction were particularly evident to his new friend Michel Seuphor. Although in the early thirties his painting became more abstract and more geometrically ordered, Torrès-Garcia was never to waver in his insistence that even the most abstract art must be based on nature.

Torrès-Garcia enters our narrative, however, not because of this conversion, but because he seems to have been instrumental in directing Gonzalez's attention toward the ideas and activities of the abstract artists associated with the group Cercle et Carré which he and Seuphor organized in 1929. True to character, Gonzalez never joined this group,[47] although he may have attended an occasional meeting. He did, however, meet two of the principals, Vantongerloo and Hélion, whom he continued to see regularly.[48] He may also have become acquainted with Mondrian, Arp, Ozenfant, and Léger at this time, if he had not met them previously.

Because a man was very often judged by the company he kept, Gonzalez was generally considered an independent artist with no important connections with the dominant styles of his time. The painter Tutunjian described him as being divorced from the artistic movements and never in the "arbre généologique."[49] At about the time that the critics were beginning to take notice of

Gonzalez's "abstractions," he was indeed using some of the Constructivist methods, but in appearance his sculpture was becoming more and more Surrealist, as he turned from a more neutral "Cubist" style to the expressive and metamorphic imagery of the late thirties. And as if to confound any generalization which could have been made about his stylistic affiliations, Gonzalez exhibited the naturalistic *Montserrat* at the same time that the rest of his sculpture was predominantly abstract and metamorphic.[50]

After the exhibition of the *Montserrat* at the Spanish Pavilion of the Paris World's Fair of 1937, Gonzalez entirely disappeared from public view. He had no more exhibitions, and his sculpture was not illustrated in art journals until after the Second World War. His invisibility during the last five years of his life reflected his work as a sculptor, which by early 1939 had come to an almost complete halt. He continued, however, to do many drawings throughout this period. In 1934 and in 1935, Gonzalez executed approximately twelve major sculptures, while in 1937 he finished only six. For the remaining four years and some months of his life, there are only ten sculptures, some left incomplete.

In July 1939, just before France's declaration of war, Gonzalez retired with his family to a small village in the department of the Lot where he continued to draw, but was unable to do sculpture. Between late September 1939 and June 1940, the time of the so-called *Sitzkrieg*, Gonzalez was once again in Paris, but apparently completed no sculptures during this period.

A few days before the Germans entered Paris in June 1940, Gonzalez, like many thousands of Parisians,[51] again left for the South, where he stayed for almost a year and a half in the same village. Lacking any materials or equipment, he was unable to do any sculpture and had to content himself with drawing. Finally becoming restive, he decided to return to Paris with his wife Marie-Thérèse in the fall of 1941, leaving the rest of his family in the Lot. His rationale for returning to the occupied zone was that there, at least, he could get some work done.[52]

Yet in the approximately six months remaining to him before his death in March 1942, Gonzalez did only three small modeled sculptures, two of which were unfinished at the time of his death. Some friends suggest that his forge remained cold because he had a great fear of bombs falling on his highly explosive welding materials.[53] But it was probably also difficult, if not impossible, to obtain these materials because of rationing or outright proscription.

During that time he appears to have closed himself off in his house in Arcueil, refusing to see visitors for fear of reprisals, real or imagined, from the Germans. The legitimate basis of this fear was that Hans Hartung, who had married his daughter Roberta in 1937, was at that time in the Lot, and was officially considered a deserter by the Germans (he had volunteered in France, and had lost a leg in serving his adoptive country). Gonzalez was therefore understandably sensitive to any contact which might in any way have called attention to his knowledge of Hartung's whereabouts.[54]

If one had to sum up in a few words the tenor of the last months of Gonzalez's life, fear, discouragement, and demoralization would be the most appropriate. There seems little doubt that this demoralization was the real cause of the slackening of his work, quite aside from the external restrictions during the time that he was in the Lot and in occupied Paris. Zervos, who attended his funeral, suggested that he lost his nerve, and his friend Henri Goetz indicated much the same thing when he remarked that although Gonzalez died of a heart attack, in a more profound sense it was the war which killed him, and that he died a broken man.[55]

It may one day be demonstrated that the Second World War claimed many such victims, people, like Gonzalez, who could no longer muster sufficient moral resistance to cope with living. As early as the summer of 1938—after the Austrian *Anschluss* and before Czechoslovakia's dismemberment at Munich— Anaïs Nin observed that there was "collective anxiety, panic, fear, unrest, hysteria."[56] After Munich, she remarked that it mattered little that there had not been actual war; "a great many people died psychically—a great many faiths died. The veil of illusion which makes human life bearable was violently torn."[57]

Following Gonzalez's sudden death on March 27, the funeral itself was sadly appropriate to the circumstances in which he died. With the rest of the family in the South, his wife Marie-Thérèse was left alone. Because of the numerous difficulties of the Occupation, few friends were able to attend the funeral. The painter Fernandez recalls that he, Picasso, Zervos, and his brother Marian Zervos "stood in" for the family and received the condolences of the two or three friends who were able to come. Picasso, who was deeply moved by Gonzalez's death, was still not immune to the incongruities of the situation: on their way to the cemetery they passed a roadworker who piously removed his hat, whereupon Picasso remarked, "Nous sommes en plein Courbet!"[58]

Picasso's lasting statement on the effect of his friend's passing came only days later, when he painted his *Nature morte au crâne de boeuf* (**5**), which he more than once has explained as a homage to Gonzalez.[59] It is a dramatic painting in which the bull's skull, as Sterling suggested, "has replaced the traditional death's head;"[60] the brilliant oranges and fuchsias of the background seem lurid in contrast with the blacks and dark browns of the lower part of the picture. According to Fernandez, the skull rests on a coffin, and the brilliant colors of the background were inspired by the stained glass windows of the small Romanesque church in Arcueil where the services took place.[61]

NOTES

1. Julio Gonzalez, "Picasso sculpteur et les cathédrales," [1932]. Manuscript in the estate of Mme. Roberta Gonzalez. Unless otherwise noted, all Gonzalez quotations are from this essay. The full text is translated and published in Appendix I, p. .

2. Alejandro Cirici-Pellicer, *El Arte modernista catalán*, Barcelona, 1951, p. 311.

3. The first time that Julio's name appears

5. Picasso, *Nature morte au crâne de boeuf*, April 5, 1942.

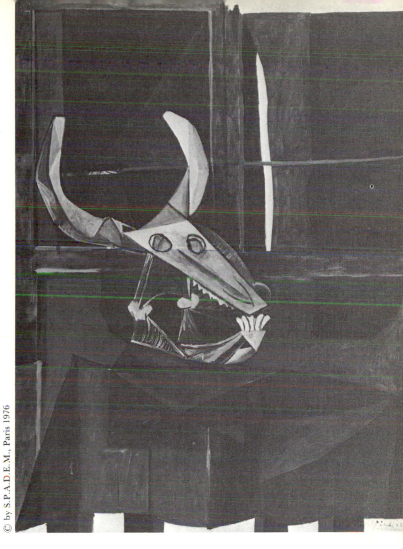

is in the Catálogo de exposición di bella artes y industrias artísticas, 1892, with an entry of "varios ramitos con insectos, en hierro."

4. World Colombian Exposition, Chicago, in Andrew C. Ritchie, *Julio Gonzalez*, New York, 1956, p. 4. Exhibited was a "branch of flowers of forged and beaten iron."

5. For the background and history of these exhibitions, I have used Cirici-Pellicer, *El Arte modernista catalán*, pp. 302–4; and Bohigas-Tarrago, "Apuntes para la historia de las exposiciones oficiales de arte de Barcelona de 1890–1900," *Anales* (de Museo de Arte Moderno), Barcelona, Vol. 3, 2 abril 1945, pp. 95–112. Bohigas states that José Luis Pellicer, as president of the Circul, had a good deal to do with the initial organization of the expositions.

6. 426 Calle de la Diputación is the address given by Juan Gonzalez (opposite an entry of a piece of sculpture) in the Catálogo de la Primera exposición general de bellas artes, 1891. According to a cousin of the family, now living in Barcelona, Sra. Marota Pellicer, their workshop was in a separate place.

7. The address given in the catalogue of 1892, as in all succeeding years, is 6 Rambla de Catalunya, Gracia.

8. In the *Veu de Catalunya*, Vol. 6, no. 19, March 8, 1896, one reads, "In the square of San Pere of this city the existing fountain has been changed into another of wrought iron in Gothic style that acquaints us with the good taste of the architect Mr. Falqués." This notice was brought to my attention by Sr. Enrique Jardi-Casagny of Barcelona.

9. Claudio Castelucho was a painter, born in Barcelona, who moved to Paris and around the time of the First World War opened an artist's supply store on the Rue

de la Grande Chaumière which was one of the best in Paris. In 1967 I visited the store and spoke with Castelucho's daughter, who was about to retire from managing the shop.

10. No. 181 in the catalogue, *La Donation Gonzalez*, Paris, 1966. The piece is 25 cm. long and is dated c. 1895.

11. Sandcasting lends itself to relatively coarse or large forms, as opposed to the more difficult technique of *cire perdu*, traditionally favored for sculpture, which can accommodate more delicate and complex forms. The Gonzalez family was probably not equipped to do pieces in the lost-wax process, since we read in the catalogue of the fine arts exhibition of 1891 that Juan Gonzalez's sculpture of a cock was cast at the foundry of Masriera, which was so equipped.

12. It should be added, however, that in hammering any metal cold, it becomes progressively hardened and therefore brittle, due to changes in the crystalline structure. The corrective for this is a periodic annealing, or heating.

13. I am indebted to Sra. Rosa Granes, of the library of the Museo de Arte Moderno of Barcelona, who took the time to look through the records of La Lonja for mention of Gonzalez.

14. This information and the photograph of the work have kindly been communicated to me by Sr. Enrique Jardi-Casagny of Barcelona.

15. Illustrated in *Manifestación artística del Ateneo Barcelones*, Barcelona, 1893, p. 48.

16. José Rafols, in *Modernismo* (Barcelona, 1949), has described Marquina as writing in a pantheistic philosophic vein (p. 143). He helped translate the poetry of Verlaine published in *Luz* (p. 142) and was an important contributor to *Pel y ploma* (pp. 163–64).

17. Most members of the Cénacle contributed to *Luz*, which was begun in 1898 and continued a year later by *El quatre gats*; and *Pel y ploma*, begun in 1899. All these magazines were published in Barcelona. Their fellow contributors included Rusiñol, Nonell, Picasso, Regoyos, Casas, Opisso, and Canals.

18. Joaquin Torrès-Garcia, *Historia de mi vida*, Montevideo, 1939, pp. 73–75.

19. Since various members of the family were frequently in Barcelona up to about 1915, there are many letters, which have been preserved by Mme. Gonzalez. They have proved most useful in establishing many details of the narrative which follows.

20. Hilton Kramer, *Julio Gonzalez*, New York, 1961, p. 19.

21. Jaime Sabartés, *Picasso, documents iconographiques*, Geneva, 1954, p. 55.

22. Correspondence in the collection of Mme. Gonzalez.

23. The inscription reads, "A souvenir for Julio Gonzalez from your friend Picasso." Daix dates this drawing to 1901 or 1902 (Pierre Daix and George Boudaille, *Picasso, the Blue and Rose Periods*, New York, 1966, p. 143), but it was almost certainly done during the spring or summer of 1902; this was the only time during this period when Gonzalez and Picasso were both in Barcelona.

24. Roberta Gonzalez, "Julio Gonzalez, My Father," *Arts*, Vol. 30, no. 5, Feb. 1956, pp. 22–23.

25. This is Hans Hartung's evaluation, suggested to me in an interview of July 1967. Hartung married Gonzalez's daughter Roberta in 1937 and lived with the Gonzalez family for some time after that.

26. Although Gonzalez and Picasso may be presumed to have separated by 1909, Penrose recounts that Picasso modeled his Cubist *Head of Fernande* of that year in Gonzalez's studio (Roland Penrose, *Picasso, His Life and Work*, New York, 1962, p. 240). Penrose gives no source for this statement, and I have been unable to verify it elsewhere. It should be added that Picasso would not have needed Gonzalez's equipment or technical advice to model this piece, such as was the case in their later collaboration.

27. In a broadcast of 1950, for example, Mme. Gonzalez stated, "Disabled by the loss of his beloved brother, my father isolated himself and ceased working at his art." (A copy of this broadcast has kindly been communicated to me by Mme. Gonzalez.) This idea has been perpetuated in a good

deal of the Gonzalez literature, for example, Ritchie, *Julio Gonzalez*, 1956, and Kramer, *Julio Gonzalez*, 1961. In order to substantiate this, however, one would have to say that before Juan's death, Gonzalez had begun to establish himself, or at least showed great promise as the artist and painter which he wished to become. Such is not the case.

28. Correspondence in the collection of Mme. Gonzalez.

29. Correspondence in the collection of Mme. Gonzalez. In two letters of 1908, Durrio writes about details of a project which they were working on together. Frequent references to Torrès-Garcia in Juan's letters to Julio (1906–07) and a later letter from Torrès-Garcia in Mallorca to Gonzalez, suggest that Torrès-Garcia had an established working relationship with the Gonzalez workshop.

30. Gonzalez submitted sixteen pieces of jewelry and three repoussé heads in 1913, the last Salon before the war. When the Salon resumed after the war, in 1919, he exhibited continuously throughout the twenties, excepting 1925 and 1926.

31. A document in the collection of Mme. Gonzalez, apparently connected with his identification papers and dated March 1924, lists Gonzalez as a "bijoutier."

32. As a *sociétaire* in the Salon d'Automne, Gonzalez consistently listed himself as a painter and decorative artist.

33. Arc welding, a more recent development, uses the same fusion principle. Instead of gas, the heating agent is an electric current passed through the metal. This has also found its way into the sculptor's studio, as for example, that of the late David Smith.

34. Letter dated June 4, 1918, in the collection of Mme. Roberta Gonzalez, who kindly translated it from Catalan into French.

35. Torrès-Garcia, *Historia de mi vida*, p. 278.

36. This took place about 1921. Mme. Roberta Gonzalez, *Arts*, 1956, p. 24.

37. Gonzalez dated many of his sculptures of 1929, a habit which he unfortunately did not continue.

38. The contract, which is in the collection of Mme. Roberta Gonzalez, stipulates that "all production" is to be turned over to the gallery.

39. From a review in *Carnet de la semaine* of December 1930. Vauxcelles had previously commented on Gonzalez's repoussé masks in *Excelsior*, April 13, 1921. Vauxcelles no doubt thought Gonzalez to be young, since he appeared to be starting out on his career.

40. Mercereau and Raynal were particularly enthusiastic about his many talents, and it was Mercereau, of course, who first urged him to exhibit in the Salon d'Automne.

41. Many amusing anecdotes are told about Gonzalez's secretive activities. His friend Henri Goetz recalls the time when an acquaintance visited him while Gonzalez was there. The friend noticed some Gonzalez jewelry belonging to Goetz, and made a light-hearted remark about their primitive design, while Gonzalez forced himself — red-faced — to keep silent (interview, March 1, 1967).

42. Interview with Mme. Roberta Gonzalez.

43. Gonzalez's mother was considerably younger than her husband, Concordio, who died in 1898. She was eighty-two at the time of her death.

44. Mme. Roberta Gonzalez, *Arts*, 1956, p. 24.

45. Gonzalez, "Picasso sculpteur," *Cahiers d'art*, Vol. 11, 1936, pp. 189–91.

46. Jan. 13, 1936, on Radio Barcelona (Paris). It was given on the occasion of a Picasso exhibition organized by the A.D.L.A.N. group in Barcelona. A recording of the broadcast is in the collection of Mme. Gonzalez, and an English translation of the transcript is in the collection of the Museum of Modern Art, New York.

47. Michel Seuphor has recounted the story of this group in *Le Style et le cri*, Paris, 1965, pp. 108–23. When questioned about Gonzalez's participation, Seuphor claimed never to have met him (interview, July 19, 1967).

48. Interview with Mme. Gonzalez and Hélion.

49. Interview with Tutunjian, May 24, 1967. Although he did not know Gonzalez personally, they had several friends in common, among them Hélion.

50. As is clear from a survey of the Catalogue, Gonzalez executed many pieces in a more or less realistic mode, the finest being the *Torse*. But this aspect of his art had not been revealed to the public up to the time of the *Montserrat*.

51. By the time the Germans entered Paris on June 14, there were only 700,000 Parisians left, of a normal population of 2,880,000 (Gérard Walter, *La Vie à Paris sous l'occupation: 1940–1944*, Paris, 1960, p. 54).

52. Interview with Mme. Gonzalez.

53. Zervos, in particular, suggested this in an interview of Feb. 20, 1967.

54. The correspondence between Gonzalez and his family (in the collection of Mme. Gonzalez) in the South strikes a tragic note. Being allowed only postcards, which of course were censored, the family had to resort to code language and indirect references, particularly when referring to Hartung.

55. Interview of March 1, 1967.

56. Anaïs Nin, *Diaries*, New York, 1967, Vol. II, p. 292.

57. *Ibid.*, p. 309.

58. Interview with Louis Fernandez, May 18, 1967.

59. Fernandez also mentioned this; the published references are too numerous to list, but include Sterling, below.

60. Charles Sterling, *Still Life Painting from Antiquity to the Present Time*, New York, 1959, p. 109.

61. Interview with Louis Fernandez, May 18, 1967.

Gonzalez's Collaboration with Picasso and the Development of Open-Form Sculpture in Paris

By the time Gonzalez began working with Picasso in 1928, he had already been encouraged by friends, among them the sculptor Gargallo and the painter Colucci, to use his craft to create direct metal sculpture. The sculptures which appear to have been done before he began working with Picasso, however, are all reliefs either based on the techniques employed in the early repoussé masks and heads, or using cutout planes. While Gonzalez may already have had the intention of continuing his sculpture in iron, it was only after he began working with Picasso that he moved away from the prettiness of this early work and began creating the larger and more truly sculptural *Harlequin* and *Baiser* of 1930, and the *Femme se coiffant* of 1931. There is no doubt that his work with Picasso had a completely transforming effect on his art, his life, and his stature as an artist.

In an equally dramatic way, Picasso's sculptural vision grew from the first small constructions of wire and painted metal of 1928 and 1929, which closely paralleled his paintings of those years, to the assembled sculptures of 1930 and 1931, such as the *Painted Head* (**9**) and the *Woman in the Garden* (**10**) which were independent creations having few specific relationships with his painting.[1]

When Picasso began his work with Gonzalez, he was returning to sculpture after an absence of almost fifteen years. At first, his general idea was to realize a colossal monument, or series of monuments. Although such a project did not materialize at this time, the many sculptures and paintings of the late twenties suggestively titled "Project for a Monument" testify to his keen interest which

21

was thwarted only because, as Picasso put it, "nobody's ready to commission one from me."

It was for the purpose of executing some of these projects in iron wire that Picasso initially approached Gonzalez for technical help. He thereby unknowingly initiated what was eventually to be a collaboration extending over a period of four years.

Although the fact of this collaboration has been generally known for some time, there has never been any clear statement in the literature concerning Gonzalez's contribution to this enterprise. Giedion-Welcker states that "Gonzalez worked with Picasso, 1929–32, teaching him technical improvement of his then strictly Constructivist work;"[2] while Barr writes, "With the help of his old friend the sculptor and master 'blacksmith' Gonzalez, Picasso made several wrought iron constructions. . . ."[3] Penrose, who was personally close to Picasso, makes only the general statement that "Gonzalez was an excellent craftsman in metal and with him Picasso explored new ways of constructing figures in this medium of sculpture;"[4] and elsewhere he writes, "At Boisgeloup with Gonzalez beside him and the necessary facilities, sculpture in iron began to show new possibilities,"[5] implying that Picasso had his own smithing equipment.

It appears, however, that Picasso turned to his friend for technical assistance precisely because he was unfamiliar with metalworking techniques, and did not have the appropriate equipment for soldering or welding. Mme. Gonzalez and Zervos assert that Gonzalez actually executed Picasso's sculptures and that Gonzalez was paid for this work.[6]

Furthermore, the wire constructions of 1928 and 1929 were almost certainly done in Gonzalez's small studio on the Rue de Médéah; Picasso did not acquire the chateau at Boisgeloup until the early thirties, and his painting studio in the apartment next to his living quarters on the Rue La Boëtie would not have been appropriate for such work.

In the case of the larger assembled iron sculptures done between 1930 and 1932, the problem is slightly different. Zervos and Mme. Gonzalez, as well as Gonzalez's friends Xceron and Colucci, claim to remember Gonzalez and Picasso working on the largest of the assembled sculptures, the *Woman in the Garden*, in Gonzalez's studio in Paris.[7] This is supported by a note from Picasso to Gonzalez of 1931 saying, simply, "Tomorrow I shall come," and another of July 3, 1931, reading in part, "I couldn't go to the studio this morning and this afternoon not knowing if you will be there I won't go!"[8] However, Penrose's implication that Picasso had metalworking materials at Boisgeloup, and, with Gonzalez, worked there on his metal sculpture, is at least indirectly supported by Mme. Gonzalez's recollection that Gonzalez would frequently go to Boisgeloup alone; it was her inference that he went there to work, and not simply to visit, since neither she nor other members of the family were ever invited.[9]

The most persuasive evidence we have that Gonzalez began working on Picasso's constructions in the spring of 1928 and continued in the fall and into

the winter of 1929, consists of Picasso's notes to Gonzalez, and his numerous studies and drawings for sculpture published in Zervos's oeuvre catalogue.

There are six letters and post cards from Picasso to Gonzalez written between 1928 and 1932.[10] Most are short notes arranging meetings either at Gonzalez's studio on the Rue de Médéah or at Picasso's apartment on the Rue La Boëtie. In the first note, Picasso wrote:

May 14, 1928
I have received your letter telling me of the sad news of the death of your mother. Be-lieve me I am very sorry for you and your sisters, but for you whom I love, I am doubly sorry. I'm not going to see you for fear of disturbing you. Concerning you, I send you a check since I don't have any ready cash.

From this, one can infer that they had been working together until then, and that their work was interrupted for the time being. Since Picasso left Paris for the summer, they probably only resumed work in the fall.

The sketchbooks which Zervos has published in the oeuvre catalogue illustrate studies and drawings for wire sculptures dated March, April, and May of 1928. These studies continued during the summer, when Picasso was in Dinard, and into the fall, when he completed the *Construction* (**6**) and other wire constructions related to the drawing studies.[11]

The spirit of these drawings — precise and geometric — Gonzalez translated

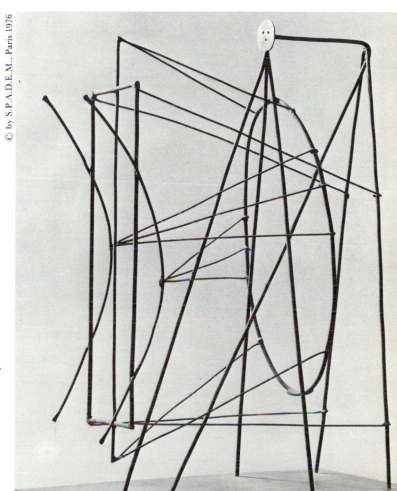

6. Picasso, *Construction*, 1928.

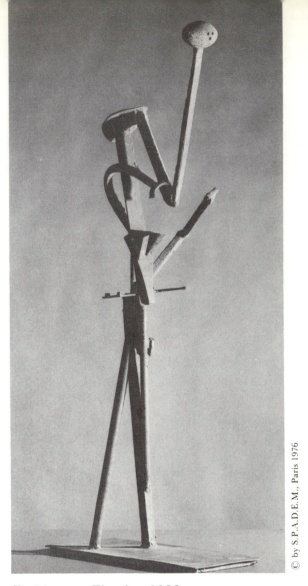

7. Picasso, *Figurine*, 1929. **8**. Picasso, *Head*, 1930.

admirably, more so than Picasso would have been able to, judging from his own figures done in bent and twisted wire.[12] Zervos described Picasso making such a figure: "Picasso picks up a piece of iron wire which is lying on the ground and sets to twisting it, talking all the while. Without his having anything particular in mind, in a few minutes the iron wire has received the impress of a great sensibility."[13] The constructions which Gonzalez did for Picasso, on the other hand, were carefully planned, judging by Picasso's numerous studies. They were constructed of heavy wires which would have needed tools, rather than a simple twist of the hand, for their shaping. The wires appear to be soldered, rather than welded together.

After this first series of small constructions which he worked on in 1928 and during the first part of 1929,[14] Picasso briefly turned away from sculpture, at the same time that Gonzalez, for the first time, devoted himself wholeheartedly to his new métier. Sculpture, however, was never far from Picasso's mind. He still longed to create a monument, but had to be satisfied with painting, rather than sculpting it.[15]

In 1930 Picasso returned to sculpture and again enlisted Gonzalez's aid in executing a series of assembled iron sculptures. Over the next two years, they worked together on the *Figurine* (**7**), or *Christmas Tree*, as it is sometimes called, *Head* (**8**),[16] *Painted Head* (**9**),[17] and the *Woman in the Garden* (**10**). All these sculptures are assembled from pieces of scrap iron; Mme. Gonzalez recalled how the two of them would go on expeditions, rummaging through junkyards to find the right scrap which could take its place in a sculpture. Assemblages of found objects were not new to Picasso, and, as Barr points out, go back to the time of the Cubist collages of 1912–14.[18] Picasso had practiced this method most recently during the summer of 1930, when he created several relief assemblages of shells, gloves, felt, and other found objects which he then covered with sand.[19]

With the new series of constructions in iron, sculpture had at last come into its own in Picasso's art. It was no longer an extension of painting, depending on the latter's illusionary, conceptual devices, as were the Cubist reliefs and the wire models. These constructions of the early thirties have those qualities which

9. Picasso, *Painted Head*, 1930.

10. Picasso, *Woman in the Garden*, 1930–1931.

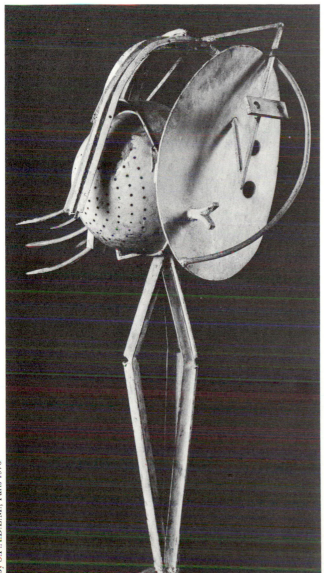

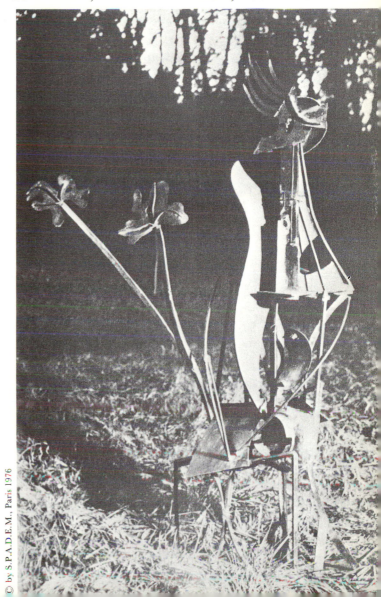

thereafter distinguished and characterized Picasso's sculpture: the use of real objects, which effect a "double metamorphosis,"[20] as he called it, and which thereby give to the sculpture a concrete and tangible reality. By using such metaphors as nails for eyes, as in the *Woman in the Garden*, coil springs for hair, or a colander for a head, as in the *Painted Head*, Picasso drew attention to their essential formal and tactile qualities. With few exceptions, Picasso began with the object and let this be the starting point of the sculpture.[21] He thereby gave back to sculpture that directness and primary object quality which he apparently felt to be lacking in his initial idea for the *Head of Fernande*.

Among the iron constructions, the *Woman in the Garden* is the most ambitious and complex. Gonzalez says that Picasso made "thousands of studies," and that "he worked on it long months at a time. . . ."

In viewing this sculpture, one is constantly beset with unsettling surprises, discontinuities, and paradoxes, more so than with any of Picasso's previous sculpture. The head is of particular interest from different points of view: from one side it is a flat, open-mouthed profile with wind-blown hair; from another aspect, it becomes a featureless rounded oval. In his comments on Picasso's projects for a monument of 1928, Zervos remarked that it was the positive inclusion of space, or "these perforations of the mass [which] form innumerable views of the monument in creating successive displacement of its parts."[22] Practically speaking, this is made possible by the technique of assemblage. Assembled of disparate parts, rather than formed of a single mass, this is sculpture of juxtaposition which is no longer bound by a continuous "skin" of bronze or marble. It remains for the eye to join together this countless number of "points in the infinite," as Gonzalez phrased it.[23]

By 1932 when Picasso had finished his *Woman in the Garden*, he had carried his own experiments in iron sculpture to its conclusion. With Gonzalez to aid him, he had, in the space of a few years, brought into being a new concept of sculpture only partially realized in his earlier reliefs and constructions done between 1912 and 1914. However, as often happened in Picasso's art, his sculpture in the later part of 1932 underwent a sharp change of direction. Shortly after finishing the *Woman in the Garden*, he turned to a more familiar medium and in the short space of a few months modeled the series of plaster heads of his mistress, Marie-Thérèse Walter.[24]

Having considered the chronology of Picasso's development during the period of this collaboration, we should now turn to its larger implications: What did this collaboration mean to both men? And what did each contribute to the enterprise?

Picasso's first wire constructions of 1928 and 1929 replaced, as Gonzalez put it, "essential lines" on the canvas with iron bars; they were three-dimensional reproductions of the highly structured paintings of those years. A comparison of Picasso's studies and the finished constructions indicates that Gonzalez carefully translated into iron, designs which previously had been worked out in

drawings. At this point, Gonzalez's creative participation was clearly minimal.

But it was precisely this first stage of their collaboration which for Gonzalez was pivotal; as was pointed out in the first chapter, 1929 was the crucial year in which he came to terms with himself and wholeheartedly devoted himself to sculpture.

Among the many sculptures Gonzalez completed in 1929, the *Don Quixote* (**11**, cat. 23) indicates most clearly the direction in which he would develop, and anticipates some of the problems Picasso dealt with in his assembled iron sculpture of 1930 and 1931. The *Don Quixote* follows directly out of the analytically constructed *Couple* (**28**, cat. 11), but with a new and self-conscious attention to the void. Reminiscent of Gargallo's decoratively stylized figures (**12**), the empty space of the *Don Quixote*, like a persistent afterimage, explicitly suggests the

11. Gonzalez, *Don Quixote*, 1929 (cat. 23).

12. Gargallo *Prophet*, 1933.

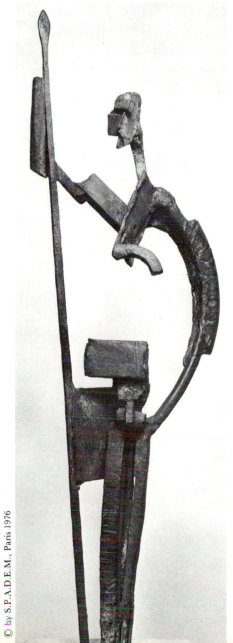

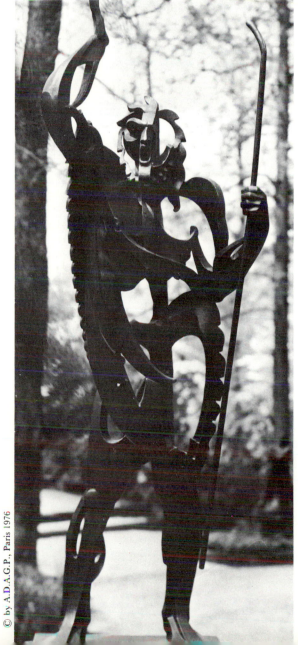

missing torso. What could easily pass unnoticed, however, is the small head; it is really two heads, or two different representations of a head — the one cubic, volumetric, and deeply shadowed, the other a flat cross section. The uneasy juxtaposition of such purposefully dissimilar forms recurs many times in Gonzalez's later sculpture, and is also comparable to the head in Picasso's *Woman in the Garden*.

With the *Harlequin* of 1930 (**17**, cat. 33), Gonzalez took an even greater step towards achieving a "union of real and imagined forms."[25] The whole structure has been loosened, and the individual pieces appear to be precariously joined and in a state of tenuous equilibrium. The static shaped void of the *Don Quixote* has yielded to a more dynamic space.

Such was partially Picasso's intention in the wire constructions and other projects for a monument of 1928, although it was only fully realized in the *Woman in the Garden*. According to Zervos, the idea was to "lean the monument on space," so that, by "successive displacement of the parts," space should penetrate rather than oppose the mass.[26] Although this was Picasso's intent, it was only in 1930 that he was fully to realize this idea. By this time, he was more willing to be guided by intuition and the dictates of found objects, whose endless fascination he recently had rediscovered. More importantly, his technical assistant of little more than a year before had himself become an accomplished master, and was able to contribute more than his expert craft.

In working together, visiting each other's studios, and through long conversations,[27] the two men conducted a laboratory where ideas could be exchanged, worked out, or rejected, with each free to pursue his independent path. In writing of Gonzalez, the critic Hilton Kramer has recalled Picasso's earlier collaboration with Braque, suggesting the "irony we scarcely dare face: that the man who has been so celebrated for his individualism, for the heroism and singularity of his genius, may after all have reached the two greatest moments in his career when he was able to submit his talents to the discipline and sensibility of colleagues who were less reckless and more detached in their approach to art."[28] And similar to that earlier collaboration, Picasso established in these years the basic framework which largely determined his sculpture in the succeeding years. The incorporation of found objects which effect a double metamorphosis, and the technique of assemblage: this forms the groundwork of Picasso's later sculpture, carried out in every conceivable medium. While both these ideas had made intermittent appearances in Picasso's art, they only seem to have crystallized during the period in which he was working with Gonzalez.

For Gonzalez himself, Picasso set an example of courage and self-assurance, qualities which had previously eluded him. During the years they were working together, Gonzalez harmonized the two principal currents of his life's endeavor. In bringing together his desire for artistic expression with his mastery of metal-smithing, he was better able to direct his energies toward a realization of his innate talent.

That there had been little in Gonzalez's temperament or training to encourage this sort of concentration throws even more light on Picasso's catalyzing role in redirecting Gonzalez's efforts. Many years before, Juan Gonzalez had spoken with some truth in telling his brother, "You have more talent than I, but you'll never make use of it."[29] For many years Gonzalez did in fact spread himself thin by dividing his time between painting, sculpture, various decorative arts projects, and whatever odd jobs he could pick up along the way. At least one critic in the early twenties recognized his "poetic talent," but raised the question, "Why does he disperse himself so much?"[30]

While it was Picasso's initial insight that opened the door for both men, Gonzalez should not be faulted for having failed to realize that his own artistic aspirations would remain unfulfilled as long as he insisted upon a separation between his identity as artist and metalsmith.

There were other sculptors whose early careers were marked by a similar diversity of activities, and who also experienced difficulties in reconciling their separate identities as artists and metalworkers. Alexander Calder, twenty-two years Gonzalez's junior but his exact artistic contemporary, had something of the same struggle in arriving at his abstract mobiles of the early thirties. Having been trained as an engineer, Calder began his career as an artist by doing humorous portraits and figures in iron wire, shortly after his arrival in Paris in 1926. In spite of his obvious mechanical ingenuity, it took several years and the "necessary shock"[31] of a visit to Mondrian's studio for Calder to realize that "wire, or something to twist, or tear, or bend,"[32] was a more congenial medium of expression than oil paints. Even so, he did not immediately acknowledge the continuity between the earlier caricatures and abstract constructions: when a selection of the portraits was included in his first exhibition of abstract sculptures in 1931, Calder wrote, "Pay no attention to the portraits, the gallery insisted that I include them."[33]

The American sculptor David Smith, in an article on Gonzalez, posed the problem most succinctly in stating that for him, "iron working was labor, [while] I thought art was oil paint." "When a man is trained in metalworking and has pursued it as labor with the ideal of art represented by oil painting, it is very difficult to conceive that what has been labor and livelihood is the same means by which art can be made."[34]

In spite of the overwhelming impact Picasso had on his friend during the time of their collaboration, there are, in fact, few specific stylistic parallels between Gonzalez's sculpture, and Picasso's painting and sculpture during this period. The principal exception to this is Gonzalez's *Harlequin*, which is discussed in the next chapter. As an illustration of the fundamental differences in their approach to abstraction, we may compare Gonzalez's full-size sculpture of 1931, *Femme se coiffant* (**37**, cat. 51) with any number of Picasso bathers of the same period.

The single most important difference is their differing methods of abstraction. Picasso arrives at his metamorphic forms by a thorough transformation and

reorganization which succeeds in making a very incisive comment on the female anatomy. Gonzalez, on the other hand, literally abstracts, or lifts out, certain significant lines and configurations from the original model, as a comparison with the more realistic study demonstrates (**39**). The disposition of the rods of the right leg, for example, were derived from the inside contour of the leg, and the various jagged outlines at the top of the sculpture are directly traceable to the jutting elbows and hanging hair of the same naturalistic study.

There is another basic distinction to be made between Picasso's and Gonzalez's work which goes beyond matters of style. As a general rule, and even when Gonzalez's sculpture came closest to Picasso as with the *Harlequin*, there is none of that strident and demonic quality which is so characteristic of much of Picasso's painting and sculpture throughout the later twenties and the thirties. The stark and anguished scream or cry of Picasso's painting of *Harlequin* (**20**) contrasts sharply with the tempered and even humorous expression of Gonzalez's *Harlequin* (**17**, cat. 33). Again, the mordant wit of Picasso's *Woman in the Garden* contrasts with the quieter lyricism of Gonzalez's otherwise comparable *Femme se coiffant* of 1931.

In addition to the decisive effect which Picasso had on Gonzalez's work, there were other events which catalyzed both Picasso's and Gonzalez's developing ideas about open-form assemblage sculpture. Far from being an isolated, fortuitous event, their collaboration took place at a time when several other artists were working along similar lines.

Even before Gonzalez began working with Picasso in 1928, another Spaniard, the sculptor Pablo Gargallo (1881–1934), had encouraged Gonzalez to use his smithing skills to create direct metal sculpture. Gargallo and Gonzalez had known each other since their first years in Paris together, and although their friendship was never intimate, they continued to see each other from time to time.[35] At about the time of the First World War, Gargallo began making small masks of thin sheets of iron and copper, assembled by mechanical devices such as riveting and crimping. At this point these stylized caricatures were ancillary to his principle work, modeled and occasionally carved sculpture in a neo-classical style not unlike Maillol's.

Gargallo had been living in Barcelona during and after the First World War, but in 1924 he returned once again to Paris, where he remained until just before his death in 1934. Shortly after his return to Paris, Gargallo asked Gonzalez if he would give him some smithing lessons.[36] Gonzalez showed him the rudiments of oxygen welding, which was still a fairly new technique, unknown outside of the industrial milieu in which Gonzalez himself had learned it.[37] He probably also taught Gargallo the basic processes of forging and traditional welding techniques. Although Gargallo never developed the acute sculptural vision of Gonzalez, and his metal sculpture is more notable for its pleasantly decorative design that its powerful form, he was an accomplished craftsman who made ample use of Gonzalez's technical assistance.[38]

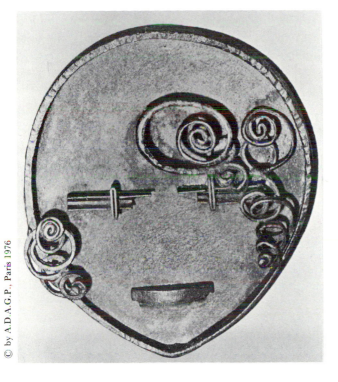

13. Gonzalez, *Petit masque baroque*, 1927 (cat. 5).

While there appear to be few specific stylistic similarities between the metal sculpture of Gargallo and that of Gonzalez, there are certain general parallels in their work of the late twenties. Those sculptures of Gonzalez which incorporate sinuous or curling lines may be traceable to Gargallo, since such elements are so characteristic of his work. The decorative curls of the *Petit masque baroque* (**13**, cat. 5) and the hollowed-out torso of the *Don Quixote* (**11**, cat. 23) are both reminiscent of Gargallo.

If Gonzalez was in any way attracted to Gargallo's work, it was probably less the style of Gargallo's metal constructions than the example he set as a sculptor in metal who at that time was gaining recognition. To a large extent, Gargallo has been forgotten today, but in the late twenties and thirties he was considered an avant-garde sculptor, and his work was exhibited frequently enough for him to become fairly well known. His metal sculpture was exhibited in the Salon d'Automne in 1926 and again in 1927. Five of his metal sculptures were illustrated in *Cahiers d'art* in 1927,[39] and he was included in the pace-setting exhibition of contemporary sculpture at the Georges Bernheim Gallery,[40] which also bought his bronze masks from the past several years.[41] In 1929 he was included in the second exhibition of sculpture at the Bernheim Gallery[42] and in the "Exposition des dessins des sculpteurs" at the Galerie de France. "Les chefs de fil de chacune des tendances . . . actuelles," was how one review described the participating artists, Brancusi, Despiau, Gargallo, Laurens, Lipchitz, and Maillol.[43]

Besides Gargallo's success, there were other developments Gonzalez would have known about which could only have encouraged him. In 1925 an acquaintance of his, José de Creeft, known principally as a carver, assembled a remarkable collection of stovepipes and other cast-off pieces of junk, titled it *Le Picador* (**14**), and exhibited it in 1926 in the Salon d'Automne, where it was quickly seized upon as the latest scandal and was widely publicized in newspapers and reviews from Paris to Mexico City.[44] Although he made other figures in this genre, including the Hirshhorn *Bird* of 1927 and a *Maternité*, now lost, both exhibited in the Salon d'Automne in 1928, de Creeft considered them as little more than an amusing diversion from his serious work as a carver.

When Alexander Calder first arrived in Paris in 1926, one of the first artists he met was de Creeft. He no doubt saw the *Picador*, and we are told that de Creeft encouraged Calder to exhibit his mechanical toys in the Salon des Humoristes in 1927.[45] Calder eventually developed these into an elaborate circus production which by 1930 had won the admiration of many artists. Although Gonzalez may not have seen a performance of this circus — Calder claims not to have known him until later in the thirties[46] — it is reasonable to suppose that he heard about Calder's circus, possibly through his friend, the composer Edgar Varèse, who did attend[47] (and whose wire portrait Calder did in 1931).

In a vein only slightly more serious, but obviously related to Picasso's constructions of 1928 and 1929, as well as to Gonzalez's first iron sculptures, were Calder's constructions in wire and wood which he first exhibited in February 1929 at the Galerie Billiet, and his large wire figure entitled *Spring* (**15**), exhibited at the Indépendants in 1929[48] and at the Surindépendants in 1930.[49]

From these humorous portraits and figures in wire, Calder's sculpture rapidly developed into wire abstractions composed of circles and other geometric elements. Calder readily acknowledges Mondrian's catalyzing role in this new departure.[50]

Calder, as well as Gargallo and de Creeft, may also have been affected by the Constructivist theories and sculpture of Gabo and Pevsner. In 1923 Pevsner came to live permanently in Paris, and the following year the two brothers had a small exhibition at the Galerie Percier — the same gallery that was later to show Calder and Gonzalez. This exhibition concentrated on their abstract reliefs, and constructions in plastics and metals, executed during the past several years. In 1927 their ideas were introduced to a larger public when Diaghilev commissioned them to do the sets and costumes for the ballet *La Chatte*. The whole stage was given over to interlocking three-dimensional shapes of both transparent and opaque materials which were spatially integrated with the movements of the dancers.[51]

Whether or not Gonzalez was familiar with, or even aware of Gabo and Pevsner's work at this time is a moot point. The sculpture of Jacques Lipchitz, however, had a definite, if indirect, impact on Gonzalez. As Lipchitz tells it,

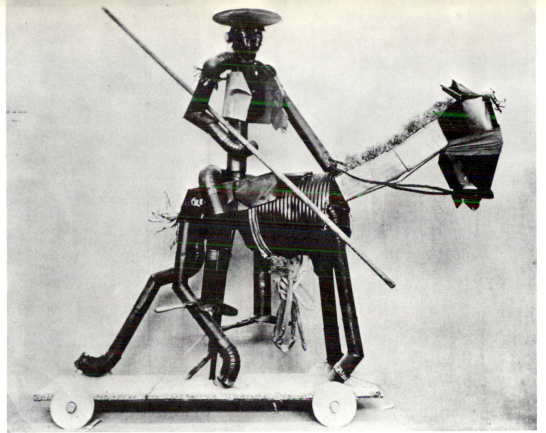

14. de Creeft, *Le Picador*. 1925.

15. Calder, *Spring*. 1925.

16. Lipchitz, *Harlequin with Banjo*, 1926.

it all began in the middle of a Sorbonne lecture he was attending in 1925. He was suddenly seized with a new idea for his sculpture, and hastily left to begin work on a little maquette fashioned out of cardboard. From this initial idea developed his open-form "transparencies" (**16**) which were constructed of thin strips of wax, and then cast in bronze.[52] Exploiting the new "quarries of the air,"[53] Liptchitz sought to free himself of his own — and tradition's — sculpture of "weight and support."[54] Lipchitz later remarked that one of these sculptures, *Pierrot Escapes*, is "myself escaping from the imprisonment of Cubism"[55] — the Cubism which for Lipchitz still was sculpture of mass, weight, and opaque volumes.

As Lipchitz saw it, these transparencies solved two perennial problems of the traditional sculptor:

> *From the beginning, one thing had tarnished my joy in working: an opinion — of Leonardo da Vinci on sculptors and sculpture. This pointed out to me how we are slaves of the material, and of the impossibility for the hands to follow the palpitations of our heart and the mad rush of our imagination. I was sad until the Day when Providence inspired these airy things, these transparent objects which can be seen from all sides at once.*[56]

For the next two years, Lipchitz was preoccupied with these transparencies. Like any discoverer, he was "up in the clouds," and "felt like he could fly."[57]

It may, in fact, have been these transparencies which spurred Picasso to begin his own wire constructions, which in turn was to lead to his collaboration with Gonzalez. Lipchitz recounts that on New Year's Day of 1927, Picasso dined with him, after which they both went to his studio, where Picasso greatly admired the new sculptures, asking, "but why haven't they been grabbed up [by collectors]?"[58]

Gonzalez himself would have had ample opportunity to become familiar with Lipchitz's transparencies, even if he did not have the occasion to see them in Lipchitz's studio. As early as 1926, illustrations of the flat, planar type appeared in *Cahiers d'art* and *l'Amour de l'art*;[59] they were very likely shown in an exhibition of his work at the Galerie Bucher in March 1927;[60] and the linear transparencies were illustrated in *Cahiers d'art* in 1928.[61] In 1929 Vitrac published a study of Lipchitz which focused on the transparencies, and in 1930 the retrospective given him at the Galerie Bucher included a selection of these sculptures; again, they were illustrated in *Cahiers d'art*.[62]

Such was the supporting milieu in which Gonzalez began a second artistic career as an avant-garde sculptor and "first master of the torch," as David Smith phrased it.

NOTES

1. For a more extensive account of this collaboration from the point of view of Picasso's sculpture, see Josephine Withers, "The Artistic Collaboration of Pablo Picasso and Julio Gonzalez," *Art Journal,* Winter 1975–76, pp. 107–14.

2. Carola Giedion-Welcker, *Contemporary Sculpture*, New York, 1960, p. 333.

3. Alfred H. Barr, *Picasso, Fifty Years of His Art*, New York, 1946, p. 171. Barr was referring to the *Woman in the Garden*; he makes no mention of Gonzalez's collaboration in connection with the wire constructions of 1928 (ibid., p. 153).

4. Roland Penrose, *The Sculpture of Picasso*, New York, 1967, p. 12.

5. Penrose, *Picasso, His Life and Work*, New York, 1962, p. 241.

6. Interviews with Mme. Gonzalez and Zervos, 1967. See, however, the Introduction to Appendix I, which suggests an explanation for the fact that Gonzalez wrote of Picasso, rather than himself, as executing

the wire constructions and the *Woman in the Garden.*

7. Interviews, 1967. See Appendix II.

8. Both letters are in the collection of Mme. Gonzalez; see note 10.

9. Interview with Mme. Gonzalez, 1967.

10. These six letters, and a seventh, of 1922, are in the collection of Mme. Gonzalez.

11. The earliest drawing for iron sculpture published by Zervos is a study closely resembling the *Painted Iron Head*, dated March 20, 1928. For the same day there is a whole series of drawings for wire constructions (*Picasso: Oeuvres*, Paris, 1955, Vol. 7, nos. 145–69), which are continued in April and May (*Oeuvres*, Vol. 7, nos. 190–208).

12. Illustrated in Daniel Henri Kahnweiler, *Les Sculptures de Picasso*, Paris, 1949, pp. 16–19, where they are dated 1930 and 1931.

13. Christian Zervos, "Picasso à Dinard, été 1928," *Cahiers d'art*, Vol. 4, 1929, p. 5.

14. Another note from Picasso to Gonzalez dated March 26, 1929, arranges a meeting.

15. These paintings include the following illustrations in Zervos, *Oeuvres*, Vol. 7: nos. 242 (Feb. 12, 1929), 272 (June 10, 1929), 273 (1929), 274 (June 11, 1929), 275 (May 13, 1929), 290 (1929), 300 (Feb. 1, 1930), 302 (Feb. 2, 1930), and 304 (Jan. 4, 1930). Most of them are heads in a metamorphic style, with a low horizon line and clouds in the background to give a feeling of monumentality.

16. Although sometimes dated 1931, this was first illustrated in Eugenio d'Ors, *Pablo Picasso*, Paris, 1930, pl. 48, where it is dated 1930.

17. Brassaï, who worked closely with Picasso in making his photographs, seems to have been the only one to understand the "secret" view, in which the projecting arc encloses the face on the left side. These photographs were first published in *Minotaure*, Vol. 1, June 1933.

18. Barr, *Picasso, Fifty Years*, note to p. 164.

19. For example, *Construction with Glove*, dated on back August 22, 1930; illustrated in Barr, *Picasso, Fifty Years*, p. 164. This and similar assemblages are illustrated in Kahnweiler, *Picasso, Sculptures*, pl. 78–84; however, Kahnweiler dates them all in 1933.

20. Picasso's often-repeated remark about the *Bull's Head* of 1943, which was assembled from the seat and handlebars of a bicycle, is equally true of all his assembled sculpture. He called this a "reversible sculpture" — once having been transformed into a bull, it was also possible to be turned back into a seat and handlebars. This metamorphosis could go on indefinitely. See Barr, *Picasso, Fifty Years*, p. 241, and Françoise Gilot, *Life with Picasso*, New York, 1965, p. 321.

21. Gilot, *Life with Picasso*, p. 317.

22. Christian Zervos, "Projets de Picasso pour un monument," *Cahiers d'art*, 1929, pp. 342–44.

23. See Appendix I, p. 134. Gonzalez was not specifically referring to this sculpture here, but to open-form sculpture and drawings in space.

24. Most, if not all, of these sculptures were done in the last half of 1932. Barr suggests that he was busy painting in the spring, and turned to sculpture after the June exhibition at Georges Petit (*Picasso, Fifty Years*, p. 178). All of them were published in *Minotaure*, Vol. 1, June 1933, from photographs taken by Brassaï in December 1932 (see *Picasso and Co.*, New York, 1966, pp. 15–16).

25. In this passage from "Picasso sculpteur," Gonzalez was speaking of the various ways in which space could be incorporated into a sculpture.

26. Zervos, *Cahiers d'art*, 1929, p. 342. The full quotation reads as follows: ". . . au lieu d'opposer cette masse à l'espace, comme une pyramide, il [Picasso] a préféré avec juste raison appuyer son monument sur l'espace et en même temps le faire pénétrer par cet espace même. En sorte que, au lieu d'entrer en antagonisme avec l'espace, le monument puisse vivre en lui."

27. Judging by Picasso's notes to Gonzalez, they met on many occasions simply to talk things over. In the note of July 3, 1931,

previously mentioned, he writes, ". . . on Monday I will return to Paris [from Boisgeloup] and I'd like to see you — come at 1 o'clock (and wait for me if I'm still not at home) so that we can talk;" another note of 1932 reads, "Do you want to come tomorrow morning to my house? I'd like to see you and speak with you. If you can, come."

28. Hilton Kramer, *Julio Gonzalez*, New York, 1961, p. 32.

29. Interview with Mme. Gonzalez.

30. Review of his exhibition at the Galerie Povolovzky, in *L'Imagier*, March 11, 1922. This exhibition included paintings, drawings, sculpture, jewelry, and various decorative pieces in silver, gold, iron, wood, and lacquer.

31. Quoted by James Johnson Sweeney in *Alexander Calder*, New York, 1951, p. 26.

32. Quoted in *The Painter's Object*, ed. Myfanwy Evans, London [1937], p. 63.

33. Sweeney, *Calder*, p. 27.

34. David Smith, "First Master of the Torch," *Art News*, Vol. 54, no. 10, p. 36. In this article on Gonzalez, Smith relates his own experience during the years he was studying painting at the Art Students League, the while working in a welding shop to earn money: "Before I had painted very long, I ran across reproductions in *Cahiers d'art* [1936] of Gonzalez's and Picasso's work which brought my consciousness to this fact that art could be made out of iron."

35. Interviews with Gio Colucci and Mme. Gonzalez.

36. Interview with the artist's daughter, Mme. Pierrette Gargallo-Anguierra, March 7, 1967. Mme. Gargallo was quite young at the time of her father's death in 1934; this and other recollections come to her from her mother. The first sculpture Gargallo exhibited which seems to be a product of Gonzalez's tutoring is the half-lifesize *Harlequin* in iron and lead, exhibited in the spring of 1925 in the Salon des Tuileries.

37. However, the techniques of autogenous welding were by this time widely applied to decorative metalwork. But as demonstrated in the Exposition des Arts Décoratifs in 1925, the design and production of such metalwork was by then more of an industry than a craft such as Gonzalez had learned in Barcelona. See Henri Clouzot, "La ferronnerie d'à présent," *L'Art vivant*, Vol. 6, 1930, p. 926.

38. It is one of the ironies of history that Gargallo began to enjoy some financial success in the late twenties, and was able to buy some expensive metalworking equipment which made possible some of his large-scale projects. On the other hand, Gonzalez, whose sculpture so far outstripped Gargallo's in inventiveness and formal power, was constantly plagued by financial problems, and was never to have any but the most ludicrously basic equipment, which he either manufactured himself or bought at great sacrifice. Some of Gonzalez's handmade tools are included in the Donation Gonzalez made to the Musée d'Art Moderne in Paris.

39. E. Tériade, "Pablo Gargallo," *Cahiers d'art*, Vol. 2, 1927, pp. 283–86.

40. For a review and installation view of the exhibition, see "Première exposition annuelle d'un groupe de sculpteurs." *Cahiers d'art, Feuilles volantes*, Vol. 2, no. 10, 1927, p. 4. Included in the exhibition were: Laurens, Maillol, Tombros, Brancusi, Despiau, Gargallo, and Zadkine.

41. José Camon-Aznar, *Picasso y el Cubismo*, Madrid, 1956, p. 257.

42. The participants in the second exhibition included Gargallo, Giacometti, Laurens, Brancusi, Lipchitz, Maillol, and Despiau. See the review of the exhibition by C. Einstein in *Documents*, Vol. 1, 1929, p. 391.

43. Zervos, "Exposition des dessins des sculpteurs," *Cahiers d'art*, Vol. 4, 1929, p. 419.

44. Interview with the artist, November 4, 1965. Although de Creeft regarded his *Picador* as a joke, he still had this piece, which is some five feet tall, prominently mounted in his New York studio, surrounded by boards displaying clippings from many newspapers and magazines dating from the time of its exhibition. De Creeft recalled that both Gonzalez and Picasso saw it: Gonzalez was pleased, while Picasso was angered —

possibly, says de Creeft, because he objected to a spoof on a subject which for him was sacred.

45. From the Chronology established by Sweeney, *Alexander Calder*, New York, 1943.

46. I wish to thank Miss Bernice Rose of the Museum of Modern Art for asking Calder about this when she interviewed him in Saché, France, in 1969.

47. From the Chronology in the catalogue published by the Guggenheim Museum, *Alexander Calder*, New York, 1965. Gonzalez's friendship with Varèse is attested to by Mme. Gonzalez and Mrs. Varèse. Although he had been living in America for a number of years, Varèse was in Paris for a period spanning the late twenties and early thirties; during this time, he saw Gonzalez from time to time (interview with Mrs. Varèse).

48. Sweeney, op. cit., p. 24.

49. Association Artistique des Surindépendants, *Catalogue*, Paris, 1930.

50. Sweeney, op. cit., pp. 26–27.

51. Ruth Olson and Abraham Chanin, *Gabo and Pevsner*, New York, 1948, p. 56. The ballet toured Monte Carlo, Paris, and Berlin.

52. Irene Patai, *Encounters: The Life of Jacques Lipchitz*, New York, 1961, pp. 236–37. Substantially the same story was given by Lipchitz in an informal talk at Columbia University, December 12, 1967.

53. Roger Vitrac, *Jacques Lipchitz*, Paris, 1929, p. 8.

54. Henry Hope, *The Sculpture of Jacques Lipchitz*, New York, 1954, p. 13.

55. Hope, *Jacques Lipchitz*, p. 13.

56. Quoted by Waldemar George, "Jacques Lipchitz, père légitime des transparences," *Art et industrie*, Vol. 27, no. 24, 1952, pp. 28–29.

57. Hope, *Jacques Lipchitz*, p. 13.

58. Lipchitz recalled this in an informal talk given at Columbia University, December 12, 1967. Picasso probably had another opportunity of seeing these soon after this. In March 1927 Jeanne Bucher held a joint exhibition of Picasso paintings and drawings and Lipchitz sculptures, at the Galerie de la Renaissance; there is no catalogue of the exhibition, but it is reasonable to suppose that Lipchitz's transparencies were shown (exhibition information from the archives of the Galerie Jeanne Bucher, Paris, 1967).

59. André Salmon, "Nouvelles sculptures de Jacques Lipchitz," *Cahiers d'art*, Vol. 1, 1926, pp. 162–65. Ten ill. Waldemar George, "Bronzes de Jacques Lipchitz," *L'Amour de l'art*, 1926, pp. 299–302. Eight ill.

60. Information from the archives of the Galerie Bucher.

61. Vicente Huidobro, "Jacques Lipchitz," *Cahiers d'art*, Vol. 3, 1928, pp. 153–57. Five ill. of which two are transparencies.

62. "100 Sculptures de Jacques Lipchitz (1911–1928)." According to the Gallery's guest book, Arp and Giacometti attended the *vernissage*. Five transparencies of a total of seven sculptures illustrated appear in Tériade, "A Propos de la récente exposition de Jacques Lipchitz," *Cahiers d'art*, Vol. 5, 1930, pp. 259–65.

III

Gonzalez's Sculpture: 1929–1931

During 1930 Gonzalez worked on an iron construction to which he gave the Cubist title of *Harlequin* (**17**, cat. 33). It was his most advanced sculpture up to that point, and even in retrospect remains an exceptional work. Its nominal subject, its increased size, its three-dimensionality, its abstractness, and its curiously disjointed composition had not appeared in Gonzalez's previous work. This Cubist subject *par excellence* never again appeared in Gonzalez's work.

He has conjured up the image of Harlequin through the use of evocative shapes and symbols, rather than representational means. The elements—an iron plate cut out in a diamond pattern, a partially transparent triangle indicating the bicorn hat, a masklike face with pug nose dislodged from and set at an angle to the funnel-shaped head, enclosing arcs suggesting spindly arms—all evoke the puckish spirit of Harlequin.

Although firmly based on the ground, this sculpture appears to be precarious and disjointed in the articulation and joining of its parts. Composed of both transparent and opaque forms, the parts appear to be haphazardly attached at fortuitous angles. Because the individual components are disjointedly assembled, the "next view" is always a surprise. How one part relates to another and how the whole is constructed can only be understood by walking completely around the sculpture, as one part hides another, or appears to change angle or position as one moves around the piece. All these things make of this piece a conundrum, a tantalizing mystery. Because one can not "know" this sculpture in some fixed and immutable form, it remains just beyond the reach of intellectual possession.

Two other constructions done at about the same time deserve mention here, as they appear to be quite closely related to the *Harlequin*. The *Composition* and *Baiser*, first exhibited along with the *Harlequin* in May 1931 at the Galerie de

39

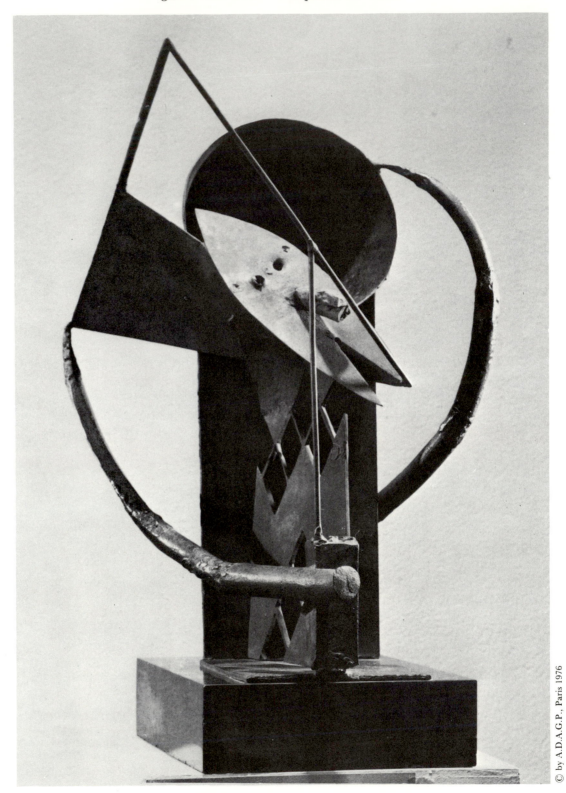

17. Gonzalez, *Harlequin*, 1930 (cat. 33).

France, have unfortunately disappeared. While it is difficult to discern the *Baiser*'s (**19**, cat. 50) composition in old photographs, the *Composition* (**18**, cat. 49) can more clearly be seen as a bowl-shaped head with flat sheets and linear arabesques, composed in a way similar to the *Harlequin*.

In the critical early phase of Gonzalez's development as a sculptor, the *Harlequin* seems to make its appearance fully formed, with little apparent preparation, few anticipatory clues, and no hesitation in its execution. It is difficult to tie it to earlier endeavors, nor are we helped in this by comparing it with the drawings of the period; if Gonzalez did make preparatory drawings for this sculpture, and there is no reason to suppose he did not, they have been lost from view. Similarly, this exceptional piece had no precedent in the sculpture of the many other artists who were at this moment experimenting with open-form "transparent" sculpture, such as Lipchitz, Picasso, and Calder.

How, then, did Gonzalez arrive at the idea for this sculpture? A few years

18. Gonzalez, *Composition*, early 1931 or before (cat. 49).

19. Gonzalez, *Le Baiser*, 1931 (cat. 50).

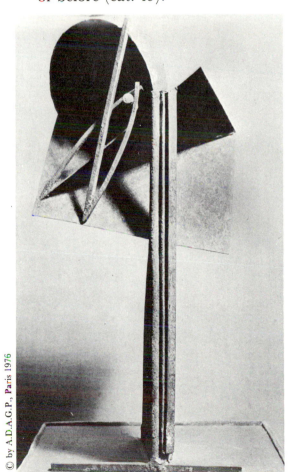

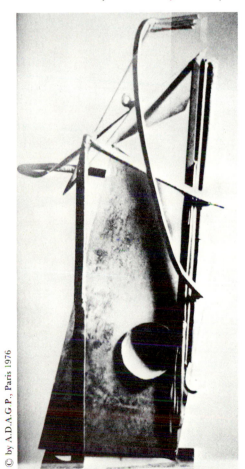

later, he wrote, "With these paintings . . . it is only necessary to cut them out —
the colors are the only indications of different perspectives, of planes inclined
from one side or the other — then assemble them according to the indications
given by the color, in order to find oneself in the presence of a 'sculpture.'"
Although he was speaking of Picasso's early Cubist constructions, it can be
argued that this is exactly what Gonzalez has himself accomplished with the
Harlequin. In spite of the fact that the *Harlequin* was executed soon after the time
that Gonzalez worked on Picasso's wire constructions of 1928 and 1929, its
relationship to Picasso's painting of the period is far more revealing than to his
sculpture. The subject itself, the alternation of opaque and transparent forms,
the syncopated rhythms of the arclike forms and the counterpoint of graphic,
linear forms against flat geometrically-shaped planes all suggest that this
sculpture is an imaginative transposition or recreation of Picasso's painting of
the same period.

Between 1926 and 1930, Picasso painted several Harlequin's heads which
have many features in common with each other and with Gonzalez's sculpture.
They are all quite abstract and in some cases their true identity is obscured.
They represent Harlequin's insignia — bicorn hat, mask, and diamond-
patterned costume — in an emblematic and highly stylized manner. Of the
eight harlequin paintings Picasso executed during these four years, the one
which is closest to Gonzalez's sculpture was done at about the same time as
Gonzalez's figure, in March of 1930 (**20**). This link with Picasso's painting of
1928–30 seems to indicate that the basic ideas realized in Gonzalez's *Harlequin*
and Picasso's painting were generated in their talks together, but that Gonzalez,
at that particular moment at least, was more prepared than was Picasso, to
embody these shared ideas in sculpture. The difference in the tenor of expression
is, however, worth noting. Where Picasso's figure appears to emit an anguished
scream, Gonzalez's *Harlequin* has that lightly humorous quality which is a
consistently noticeable characteristic of his work.

As has been pointed out elsewhere, 1929 was the year in which Gonzalez
came to terms with his identity as a sculptor, as indicated by the large number
of sculptures he completed, his first public showing of the new iron constructions,
and his signing a three-year contract with the Galerie de France. One public
indication of the speed with which Gonzalez matured as an artist is the difference
in the sculptures shown at the first three exhibitions held at his new gallery. The
first exhibition, held in February of 1930, was apparently composed primarily
of relief sculptures such as the *Tête d'homme* in bronze, the *Profil au chapeau* (**21**,
cat. 3), and various relief figures of women carrying baskets. The pieces in his
second exhibition, in late 1930, were all rather small, including eleven heads or
masks, and four reliefs and figure sculptures. The majority were worked in
bronze, rather than iron. Those that we can identify include the *Masque
espagnol* (**22**, cat. 32) the relief *Tête d'homme* (cat. 28) and the Winston-Malbin
Baiser (**35**, cat. 34), certainly the most abstract of this group. They were described
by Vauxcelles, quite accurately, one might add, as "charming."

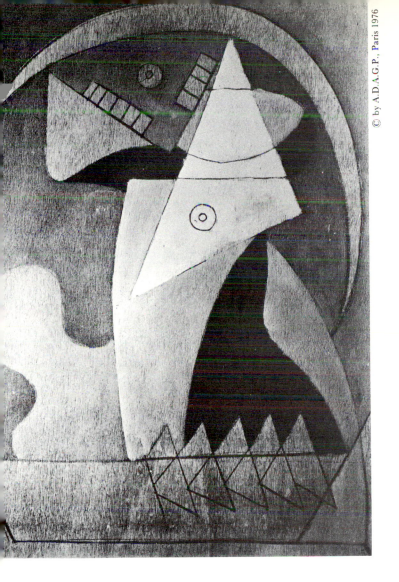

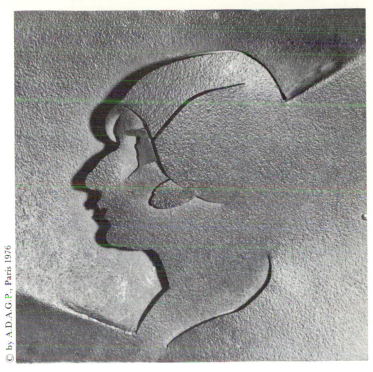

20. (left) Picasso, *Harlequin* (known also as *Monument, Tête de femme*), March 1930.
21. (top) Gonzalez, *Profil au chapeau*, c. 1927 (cat. 1). **22** (bottom) Gonzalez, *Masque espagnol*, 1930 (cat. 32).

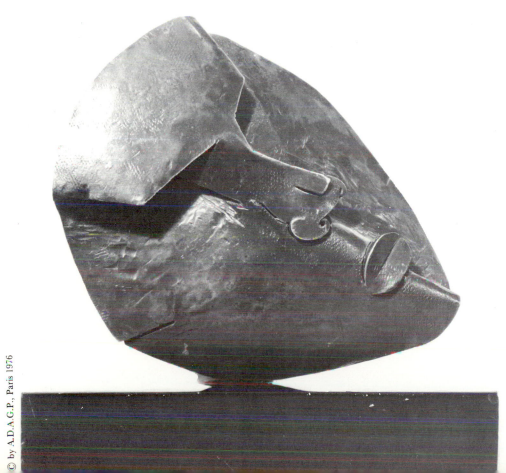

But then in May of the following year, Gonzalez presented quite another view of his work. Although some of these earlier pieces were included, the overall impact of this exhibition was of a spare, ascetic, "metaphysical" sculpture, an "art of abstention," as was suggested in Farnoux-Raynaud's preface to the catalogue. The key pieces in this exhibition included the *Femme se coiffant* (**37**, cat. 51),[1] the Winston-Malbin *Baiser* (**35**, cat. 34), and the *Harlequin* (**17**, cat. 33); smaller pieces included the *Couple* (**28**, cat. 11), the *Vénus* (**102**, cat. 12),[2] and the *Don Quixote* (**11**, cat. 23). In the preface, Farnoux-Raynaud went on to say, "he applies himself to tracing the boundaries of his domain, and in choosing only the essentials. If he creates 'with forms which have weight,' as Eugenio d'Ors would say, he only wishes to press on the nerve ends. . . . Asceticism, intellectual speculation, here are the two components in the work of Gonzalez."

Gonzalez had several other opportunities to exhibit his work in this year, culminating in the Salon des Surindépendants in the fall, to which he sent eight sculptures in forged iron. The press characterized these pieces as being in a "nervous style," "synthetic," constructions in which "effects of light and dark are brought into being with line and movement." As often happens, a negative review most succinctly pointed to Gonzalez's new direction: Gustave Kahn wrote in *Mercure*: "It should be said to Gonzalez, who has already proven his talent with his jewelry and sculpture, and recently with his simplified and hieratic works, that he's on the wrong track and that his arabesques in forged iron remain altogether obscure in their intention and that their purely linear development is not plastic."[3]

If the *Harlequin* appears out of nowhere, the *Tête en fer poli* (**23**, cat. 24) of the same period is more typical of Gonzalez's work at this point. In common with the overwhelming majority of sculptures executed between 1928 and 1930, it is a bas-relief mask of an extreme simplicity executed in a crisp and elegant fashion. With the exception of the thin vertical line indicating the nose, the whole piece was cut, bent, and raised from a single flat piece of iron. It is a technical tour de force which Gonzalez repeated many times, as for example with the *Tête aiguë* (**32**, cat. 36), the *Petit masque découpé du Montserrat* (cat. 29), the *Petit masque Don Quixote* (**26**, cat. 30), the *Masque My* (cat. 14), the *Masque espagnol* (**22**, cat. 32), the *Visage intérieure* (cat. 15), and the two still-life compositions (**30**, cat. 20, 21).

Many looking at the *Tête en fer poli* will immediately be reminded of African sculpture, and indeed the comparison is appropriate. The elongated oval head with sharply pointed chin, the long thin nose, and the cheekbones rendered as a vertical break in the facial plane joining up with the eyebrows, all these paraphrase Senufo masks and other carvings of the Ivory Coast. The stylized hair sprouting out of the forehead, and the hornlike lateral projections also call to mind motifs found in many African masks.

There are several other masks and heads done about this time which have

44

similarly close ties with African sculpture. The thin straight nose, the almond shaped eyes, and the lack of a mouth of the *Japanese Mask* (**24**, cat. 22), as well as its slight asymmetry, resemble certain masks from Central Africa and the Congo, including the funerary images of the Bakota, and the masks and heads of the Warega, Fang, and Bakwele (**25**). These masks are generally characterized by a flat or slightly concave face; the nose is a thin, usually unbroken vertical; and the mouth is either small or altogether absent. The nose and eyes, and sometimes the brows, are carved in relief and form the principal accents, while the mouth and bony projections, such as forehead, cheeks, and chin, are commonly suppressed.

The allusions to African art are more generalized in the small *Mask of Don Quixote* (**26**, cat. 30). The concavity of the face, and its dissociation from the single plane of the nose and forehead, are broad paraphrases of motifs common throughout African sculpture.

Beyond these broad similarities, there are important differences. The eyes of the *Tête en fer poli*, which are joined into a single slit, and the nose, which is connected to the eyes rather than the brows, would both be out of place in African sculpture. The vertical line representing the eyeball in the *Japanese Mask*, which is a portrait of the artist Foujita, is not a formal device derived from African masks, but rather a humorous reference to Foujita's astigmatism.[4]

The real question, however, is not what Gonzalez borrowed from African sculpture, or how faithful he was to his model, but why he was attracted to it in the first place, what he gained by emulating it, and how it relates to his own

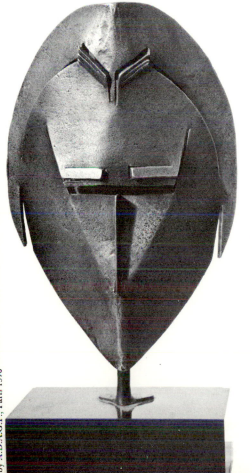

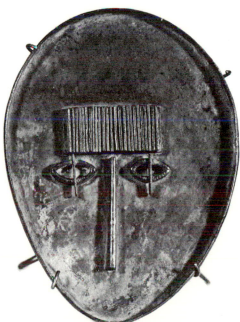

23. (left) Gonzalez, *Tête en fer poli*, 1929 (cat. 24). **24**. (center) Gonzalez, *Masque japonais*, 1929 (cat. 22). **25**. (right) *Kwele mask*.

work. It is probably no accident that he was attracted to many of the same models as were Picasso and Modigliani, especially Ivory Coast sculpture. What appears certain, however, is that Gonzalez seized upon African sculpture at the same moment in his own career, and for substantially the same reasons, as had Picasso, Modigliani, and Brancusi in theirs.

For the Western observer, there seems to be an emotional containment and psychological objectivity in African art which contrasts sharply with his own tradition of a more subjective and emotional representation. These general characteristics, as Goldwater has suggested, rather than any specific formal motifs, were the qualities many artists appreciated when they borrowed motifs from African masks. Goldwater has written, "The formal influence [of African art] is limited to exaggerated simplification . . . rather than any real assimilation of the style of African sculpture. . . . The affinity between primitive art and Cubism . . . is not that one of pure form which is so often alleged."[5]

African art came into the lives of Picasso,[6] Brancusi, Modigliani, and Gonzalez at that moment when they were searching for more objectivity in their art. For Picasso it was the sentimentality of the Blue and Rose periods, for Brancusi the modeling of Rodin, for Modigliani the psychological intensity of Toulouse-Lautrec, and for Gonzalez a contrived elegance, which immediately preceded their involvement with African art, and from which they each endeavored to escape. African art hastened their attainment of this goal.

For Gonzalez an elegant simplicity of execution replaced complication and fussiness. A surprising number of the heads and masks, for instance, while fully three-dimensional, are ingeniously fashioned from a single sheet of metal. One feels the harshness and resistance of iron, and its rough, pitted surfaces, instead of the fleshy softness and dull sheen characteristic of the early bronze repoussé masks. The only reference which Gonzalez made to primitive art, appearing in his unpublished article on Picasso's sculpture, tends to support the idea that it was, generally speaking, the directness of technical approach of African art which aroused his special interest.

In defending the new sculpture of space, he remarks: One could object that this kind of sculpture is limited, [but] it is no more so than the other (the full); there, the artist must express himself by other means. The Oceanian sculptor, who has only a tree trunk for carving his totem, must press the arms to the body which is what gives the statue its force and beauty: he succeeds in expressing himself; in the same way, the Negro makes the thighs of his seated fetish too short, his tree trunk not permitting him any more.

In this kind of distortion, the expressive qualities are generated by the requirements of the material, rather than being arrived at directly, or arbitrarily imposed. The "force and beauty" of these primitive totems, Gonzalez suggests, is a result of this inner harmony of expression and the artist's submission to the requirements of the material.

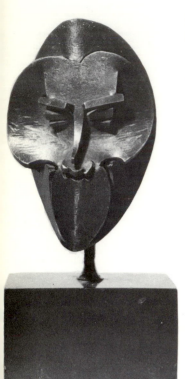

26. Gonzalez, *Petit masque Don Quixote,* 1929 (cat. 30).

Henry Moore observed that Gonzalez's welding technique allowed him to bring "a lot of disparate elements together and [make] one single unified thing out of it."[7] He had the intuition that "Gonzalez must have known that Negro figure [in the Musée de l'Homme] that has the butcher's hooks and bits of chain hanging from its hat, and a skirt made of a bit of waste tin. That's the sort of thing that opened his eyes and taught him to look around."[8]

The free adaptation and incorporation of African sculptural motifs was only one of several supports which Gonzalez used at this time to consummate his break with the past. That past was an accumulation of many unconscious habits and conventions, perpetuated because he had been isolated from an artistic milieu which would have caused him to question his procedures or stimulated him to change. Gonzalez was not always successful in ridding himself of these conventions, and occasionally such a conventional motif appears in an otherwise masterful construction — the ribbon motif in *Tête de la petite Montserrat* (**27**, cat. 45) is such an example. But these occasional blemishes are negligible beside the remarkably creative use which Gonzalez otherwise made of his own past. It will be a recurrent theme in this study that this combination of traditional ideas and a contemporary aesthetic is precisely what made of Gonzalez a radical artist of his time.

Such an example is the small *Couple* (**28**, cat. 11) of 1929, probably one of the very first completely three-dimensional sculptures which Gonzalez executed in forged iron. Like the women combing their hair and the maternities, this was a theme which appeared throughout Gonzalez's life, both early and late. A comparison with the *Couple* (**29**) of 1914 is most instructive in pinpointing the radical synthesis of a traditional theme with an austere formal treatment.

Kramer has identified the style of the later *Couple* as

being a species of figurative Cubism akin to some of Archipenko's earlier work. His sculptures in this vein . . . are far more analytical, in both a conceptual and a plastic sense, than the sheet iron reliefs. Each component of the figure is "abstracted" and purified into a negotiable plastic weight. The figure is then reconceived in terms of

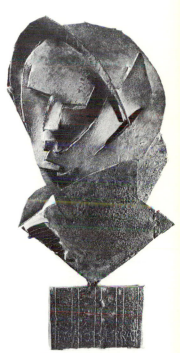

27. Gonzalez, *Tête de la petite Montserrat*, c. 1930 (cat. 45).

29. Gonzalez, *Le Couple*, c. 1914.

28. Gonzalez, *Le Couple*, 1929 (cat. 11).

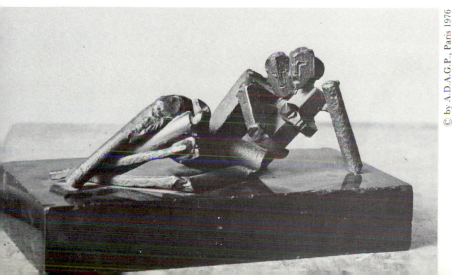

these weights while at the same time its identity as a figure is reinforced with both an anatomical and kinetic logic.[9]

Much like the tubular females of Léger, whom Gonzalez is said to have particularly admired,[10] the Cubist *Couple* is transformed by the rods and cubes of which it is assembled in such a way that what was initially a tender, private theme is transmuted by the very austerity and detachment of its execution. Lyricism is prevented from becoming sentimentality. From the ostensible disparity between the subject and its mode of representation is derived that sense of mystery which is the essence of Gonzalez's poetry.

The thematically more neutral masks, heads, and occasional still lifes, however, form the great preponderance of his output at this time. Gonzalez may have made this choice for many of the same reasons that the Cubists had suppressed any obviously narrative or emotionally charged subject matter. In any case, we can most readily pinpoint the particular ways in which Gonzalez adapted Cubist ideas by taking a close look at these constructions, and comparing them with Cubist painting and sculpture.

It is undeniable that Cubism, even as late as 1930, was primarily a pictorial tradition and that many of the Cubist devices which Gonzalez incorporated in his sculpture have a basis in pictorial sensibility. This is as true of the large open-form sculptures of the thirties, which from the very beginning were appropriately described as "drawings in space," as it is of the reliefs and masks done between 1928 and 1930.

There are many sculptures of this period which do not appear to merit special attention today, or, differently stated, they are not in fact the sculptures on which Gonzalez's primary reputation rests. These sculptures are varied in style and quality and yet they already embody many of the ideas and principles which Gonzalez realized more fully and successfully in the years immediately following this.

One may well ask why the smaller reliefs so far outnumber the larger constructions. The very limitations of dimension and scale may have been attractive to a sculptor who was feeling his way along an unfamiliar path. With such small-scale projects, Gonzalez could conveniently explore many formal problems which were then carried over to the larger constructions.[11] Other, more complex problems, such as the three-dimensional articulation and relationship of forms, and multiple views, could be set aside.

The *Nature morte II* of 1929 (**30**, cat. 21) is most obviously a picture relief with a close figure-ground relationship and enclosing frame. The technique of *découpage* is not used for the sculptural purpose of giving depth to the different planes. Rather it is used for the pictorial purpose of circumscribing each form with an edge. There is very little displacement in depth of the separate cutout planes. Strictly speaking, this is a drawing which happens to be executed in iron. Significantly, at about this time Gonzalez even made a complementary

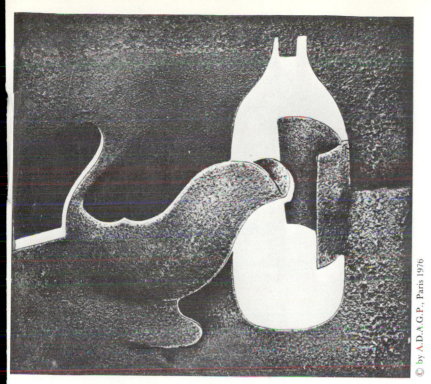

30. Gonzalez, *Nature morte II*, 1929 (cat. 21).

31. Gonzalez, *Masque de Pilar "dans le soleil,"* 1929 (cat. 26).

experiment with intaglio relief prints using an iron plate in which the lines were deeply etched into the plate.[12]

In the *Masque de Pilar "dans le soleil"* (**31**, cat. 26), Gonzalez has suppressed this ground while holding onto other pictorial devices such as perspective foreshortening and parallel planes. The surfaces of this mask are also pictorial. They are pictorially as well as literally flat, and describe flat shapes rather than volumes. Studying the head of his sister in strong sunlight had this effect of flattening out the facial contours and exaggerating the differences between hollows and projections. The flat patterning which Gonzalez arrived at in this fashion has, as he would say, the "mysterious . . . and diabolical air" of some strange carnival mask. The way in which Gonzalez abstracted this relief from a portrait study of Pilar is characteristic of Gonzalez's method. It is neither a reductive abstraction nor a Matissian "refinement of sensation." It is a process by which certain elements are selected from the whole and then rendered as a schematic design.

The *Tête aigüe* (**32**, cat. 36) reveals yet another aspect of Gonzalez's work. As a mask, there is no suggestion of a solid core or other structure behind or beneath it. The compression and change of planes of this single iron sheet define the structure of the piece. The surfaces of the *Tête penchée* (**33**, cat. 44) and the *Tête en profondeur* (**34**, cat. 41) are similarly structural. The "nerve ends" of these heads are precisely in those areas of planar change, the edges, the joints, the conjunctions. The uninflected places in between count for less.

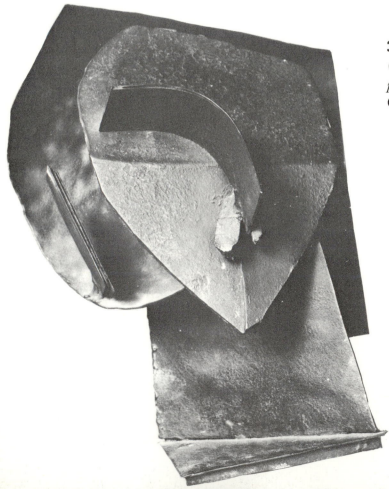

32. (top left) Gonzalez, *Tête aigüe*, 1930 (cat. 36). **33**. (top right) Gonzalez, *Tête penchée*, c. 1930 (cat. 44). **34**. (left) Gonzalez, *Tête en profondeur*, 1930 (cat. 41).

We should conclude this survey of Gonzalez's "Cubist" sculpture with a look at the Winston-Malbin *Baiser* of 1930 (**35**, cat. 34). This dated sculpture was in the exhibition at the Galerie de France in late 1930, and was very probably the most abstract piece in that show. In contrast to so many of the heads and masks of this period, the *Baiser*, its title notwithstanding, appears to be an abstract formal study of ovals and rectangles with little of the evocative poetry which so strongly informs such sculptures as the Duisberg *Tête* (**36**, cat. 48) or the *Masque de Pilar "dans le soleil"* (**31**, cat. 26). It is geometric, precise, and controlled, and is possessed of all the formal rigor of a Constructivist work. It would have been quite at home in the pages of the rigorously nonfigurative magazine *Cercle et Carré*, recently begun with the help of Gonzalez's friend, Torrès-Garcia.

Yet the title of this piece should not be overlooked. At the same time that it is a Constructivist composition of interlocking curved lines and rectangular planes, it also represents the overlapped heads of an embracing couple. The formal separation of shape-as-line from mass-as-plane is a device which was also used in altered form in the *Harlequin*. With the juncture of such a theme with a Constructivist style, we encounter the same phenomenon in even more abstract guise that we observed with the small *Couple*.

35. (left) Gonzalez, *Le Baiser*, 1930 (cat. 34).
36. (right) Gonzalez, *Tête*, c. 1930 (cat. 48).

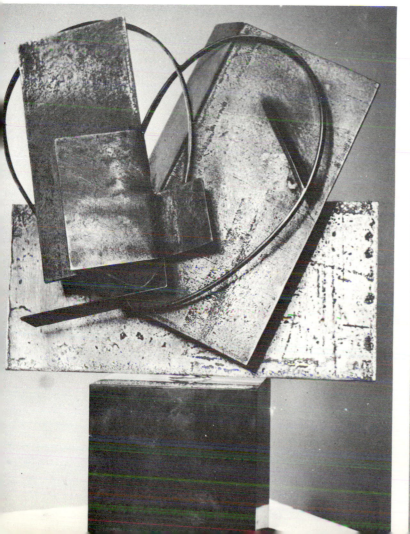
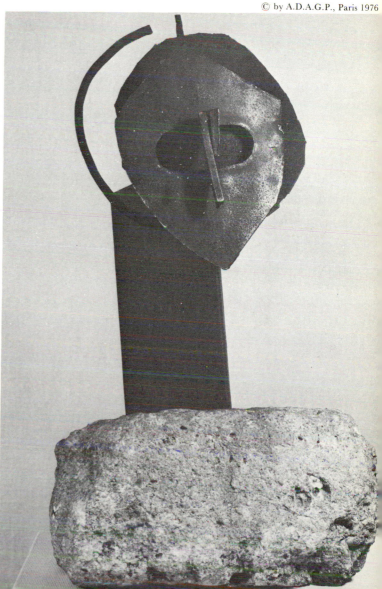

NOTES

1. This piece did not appear in the exhibition catalogue by name, unless we are to say that one of the two sculptures listed as "composition" is indeed the *Femme se coiffant*. However, Gonzalez's own list of sculptures sent to the gallery includes "un grand figure."

2. This small figure, apparently lost to us today, may well be the sculpture referred to as a "femme assise," mentioned in Gonzalez's list of sculptures sent to the Galerie de France in 1931.

3. Quoted in Pierre Descargues, *Julio Gonzalez*, Paris, 1971, p. 142.

4. This interpretation of the mask was suggested in an interview with Mme. Roberta Gonzalez. It appears to be confirmed by photographs of Foujita, who wore thick glasses and had straight-cut bangs covering his forehead.

5. Robert Goldwater, *Primitivism in Modern Art*, New York, 1938, p. 125.

6. Elsen suggests that Picasso was once again "susceptible to ideas and qualities found in African tribal art," in the late twenties, i.e., at the time that he began working with Gonzalez (Albert Elsen, "The Many Faces of Picasso's Sculpture," *Art International*, Vol. 13, no. 6, Summer 1969, p. 28).

7. Philip James, ed., *Henry Moore on Sculpture*, New York, 1966, p. 198.

8. James, *Moore*, p. 201.

9. Hilton Kramer, *Julio Gonzalez*, New York, 1961, p. 32.

10. Response to a questionnaire addressed to Mme. Gonzalez, 1966.

11. More than once I have heard observers express disappointment at the small scale of much of Gonzalez's sculpture. The explanation, I feel, is quite simple, and is partly related to the experimental nature of the medium. It would be unusual for any sculptor in a comparable situation to encumber himself unnecessarily with the technical problems entailed in large-scale works. Compare, for example, the early work of Calder or David Smith. The limitations of his equipment also play their part here. The question as to the extent his early training had on the scale of his work is discussed in Chapter VII.

12. Collection Mme. Gonzalez.

IV

Gonzalez's Sculpture: 1931–1935

By any chronological reckoning, the large *Femme se coiffant* in the Musée National d'Art Moderne of Paris belongs with the sculptures we have discussed in the previous chapter: it was made during the time Gonzalez was still working with Picasso on his *Femme au jardin,* and was first exhibited alongside the *Harlequin* and *Baiser* in 1931. Yet it seems in better company with the three other full-size figures of the same subject which Gonzalez created in 1934, 1936, and 1937. Like stately beacons marking the way, these large abstract constructions, based on the classic theme of the woman at her toilette, mark the decade at regular intervals.

The Paris *Femme se coiffant* (**37**, cat. 51) is the first full-size construction which Gonzalez undertook. Willfully disregarding any elegance of form, he created a loose-jointed and awkward creature, earthbound in spite of its dainty pins. By contrast, the *Femme se coiffant* (**55**, cat. 86) of 1934 in the Moderna Museet of Stockholm, is a precisely organized assemblage of vertical struts and sweeping arcs. The center of gravity seems to have been shifted upward, to a nebulous position somewhere within these sweeping arcs, making the figure appear to be weightlessly suspended.

The third figure (**92**, cat. 108) of 1936, in the Museum of Modern Art in New York, while equally abstract, is yet more human. Here, Gonzalez concentrated on giving expression to the kinesthetic qualities of the gesture and posture of a woman combing her hair: the downward pull of the back of the leg, the arched back, the pull of the bent neck against the falling tangle of hair. The last of these, the *Femme au miroir* (**109**, cat. 117), was begun soon after the New York sculpture and was completed in 1937. This, too, is a distillation of gesture transposed into swelling plantlike forms.

Between 1931 and 1935, Gonzalez was more productive than at any other

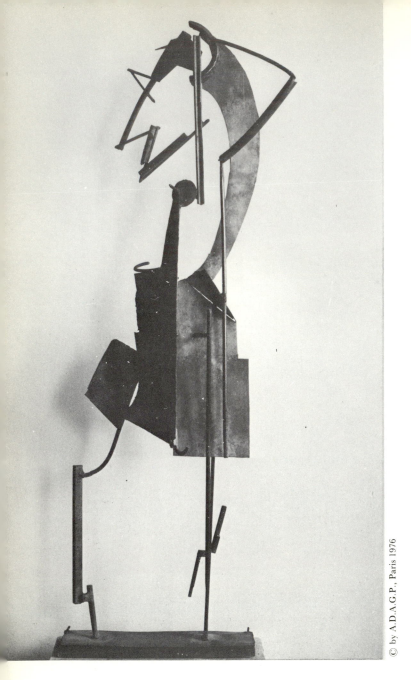

37. (top left) Gonzalez, *Femme se coiffant*, 1931 (cat. 51). **38**. (top right) Gonzalez, *Femme s'habillant*, c. 1930. **39**. (bottom) Gonzalez, *Etude pour "Femme se coiffant,"* c. 1931.

period of his life. In each of these years, he completed more sculptures than at any other time. During this period he also considerably broadened his contacts with other artists, and he got extensive exposure in the galleries and art journals. While he continued for a while to exhibit at the Salon des Surindépendants, he also participated in at least seven other group exhibitions in galleries and museums, and had five one-artist shows. Toward the end of 1933, he moved his studio from the cramped quarters on the Rue de Médéah to a much larger space of his own design in Arcueil. It was also during this same period that Gonzalez created most of the large filiform sculptures for which he is probably best known.

Most of the major sculptures Gonzalez made in 1931 and 1932 continued to be assembled of scrap iron which, with their pieced-together look and pitted surfaces, give them a rugged appearance. Three of the most interesting of these constructions are the *Rêve*, the *Suissesse*, and the *Grande trompette*.

The *Rêve* (**40**, cat. 54) is loosely assembled and does not have the crisp and tight construction so characteristic of the "Cubist" masks and reliefs. The points at which the parts join and the angles which they articulate are fortuitous;

40. Gonzalez, *Le Rêve*, 1932 (cat. 54).

41. Gonzalez, *La Suissesse*, 1932 (cat. 55).

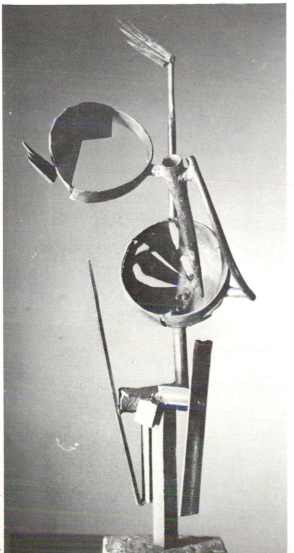

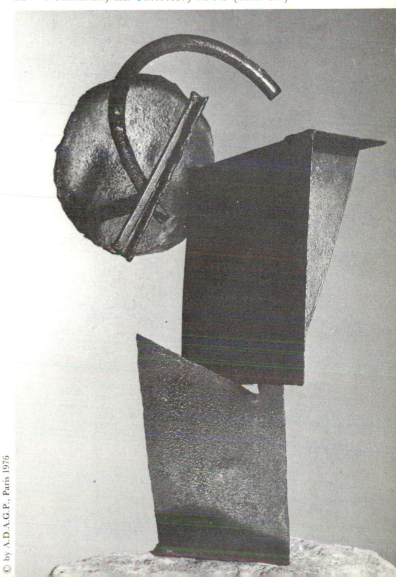

there is no systematic axis or stable fulcrum; even the central column is broken and displaced at two different points. Although the sculpture is, in fact, stable, the parts are neither symmetrically placed nor otherwise balanced relative to the base, with the result that there is no one focal point.

Roberta Gonzalez recounts that for many years Gonzalez referred to the *Rêve* as either the "Dream" or as the "Kiss," adding her own interpretation that it can be considered as either the actual kiss or a woman's dream-memory of her absent lover. Although this is her own interpretation, it does have an authentic ring to it. It can, in any case, be read as a standing figure with a pin-point head and wind-blown hair, and then, arcing out from the center, a double head composed of positive and negative shapes enclosed within a circle. The single head is not unlike that of the silver *Standing Figure* (**47**, cat. 60) of the same year, and the double head schema becomes clearer in reference to the similar treatment of *Les Amoureux II* of 1933 (**46**, cat. 66).

The *Grande trompette* (**42**, cat. 56), named, no doubt, for the inverted projecting cone, includes many of the same motifs as the *Rêve*, assembled in a different way: the hollow half-spheres, the cones, and the suggestion of hair strands attached at an angle. While the leading edge of the head of the *Grande*

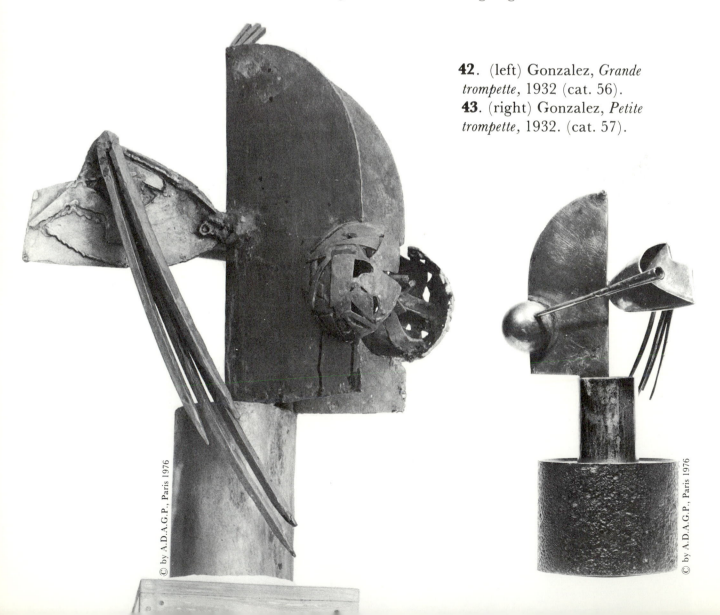

42. (left) Gonzalez, *Grande trompette*, 1932 (cat. 56).
43. (right) Gonzalez, *Petite trompette*, 1932. (cat. 57).

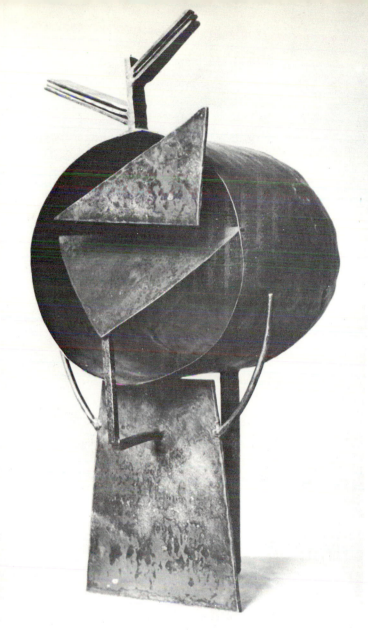

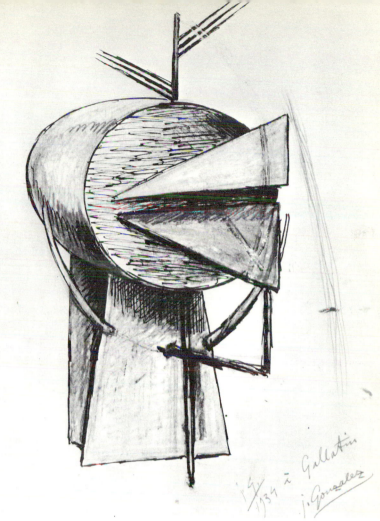

44. (left) Gonzalez, *Tête dite "le tunnel,"* 1933-1934 (cat. 71). **45**. (right) Gonzalez, *Tête dite "le tunnel,"* 1934.

trompette is centered on its cylindrical base, the profile face and its accompanying hair strands are barely attached and appear to be flying off. This sculpture is quite dense and space-filling in a way which cannot be fully appreciated in photographs. What can be seen, however, is that there is no one dominant silhouette or outline, and because of the opaque forms, many parts of the sculpture are obscured from view and are only revealed as one moves around the sculpture. It is a phenomenon which we have encountered with the earlier *Harlequin*. In addition, the convex and concave forms and the projections and recessions allow a fluid and plastic interplay between solid and void.

The space-forming possibilities of a hollow shaped void occurred to Gonzalez at about the same time, and the drawings would indicate that he considered this a logical extension of the same basic principle of giving a positive and almost tangible weight to space. The space of the *Tête dite "le tunnel"* (**44**,

cat. 71) is enclosed in such a way as to darken it completely. It was such a dramatic enveloping of space which no doubt won him Maurice Raynal's sobriquet of the "plasticien du vide." Raynal continued, "Audacity has pushed Gonzalez to no longer consider the void as some sort of framed mirror . . . but also as a sort of solid element on which one can freely build."[1] In an even more explicit reference to this idea, Jakowski wrote, "When Gonzalez encloses space, assassinating light, there is never any shadow, it is always night."[2] The effect of this enclosed and darkened space in the *Tunnel*, and in the two versions of the *Amoureux* (**46**, cat. 65, 66), is a neat turnabout of the more traditional dictum that sculpture is modeled by *light*, creating a chiaroscuro effect.

The small Philadelphia *Standing Figure* of 1932 (**47**, cat. 60), is one of a very few signed and dated pieces. It is also one of the first abstract constructions which Gonzalez executed in silver, a material for which he had a special fondness. The eight sculptures Gonzalez is known to have executed in silver[3] are among his most attractive and charming works. If his finances had permitted, he would probably have worked more frequently in silver, and perhaps in other precious metals.[4] In these small works, Gonzalez's sensibility as a jeweler reigned supreme;[5] both the scale and technique of these little gems were finely adjusted to the precious material.

46. Gonzalez, *Les Amoureux II*, 1933 (cat. 66).

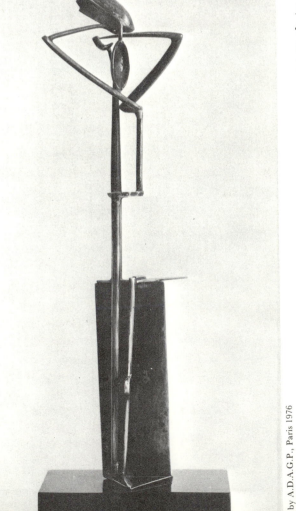

47. (left) Gonzalez, *Standing Figure*, 1932 (cat. 60).
48. (right) Gonzalez, *Tête longue tige*. 1932 (cat. 59).

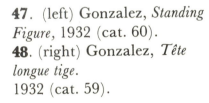

Many of the silver sculptures are companion pieces to larger works done in iron. The *Petite trompette* (**43**, cat. 57), however, is a particularly close offspring of the *Grande trompette*. Gonzalez very probably executed the large version first, and then, as a reprise, followed with the version in silver. Where the edges and surfaces of the *Grande trompette* are seared and melted by the torch, these purposeful crudities have been banished from the smaller version. It is more than a question of rendering a sculpture in miniature. The small sculpture has none of the haphazard and fortuitous qualities of its larger companion — Gonzalez probably would have considered this out of place in a piece of this size — and the surfaces have a greater degree of finish. A similar precision and delicacy characterize the Philadelphia *Standing Figure*, which may be seen as a companion piece to the *Rêve*.[6]

The spare calligraphic style of the Philadelphia *Standing Figure* is also used to good effect in the three silver heads of the same period (**49**, cat. 63; **50**, cat. 61; **51**, cat. 62), as well as the iron *Tête longue tige* (**48**, cat. 59). The outline tracery of this head only becomes a grinning mouth, pinpoint eye, and hair if one mentally "fills in" the missing head. It is a more abstract and economical version of the wire portraits which Calder did in the late twenties. In all of these heads, line is used to describe the outer contours of an "absent" form.

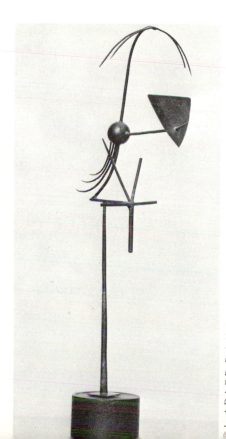

49. (left) Gonzalez, *Tête dite "le pompier,"* 1933 (cat. 63). **50**. (right) Gonzalez, *Petite tête au triangle*, 1932–1933 (cat. 61).

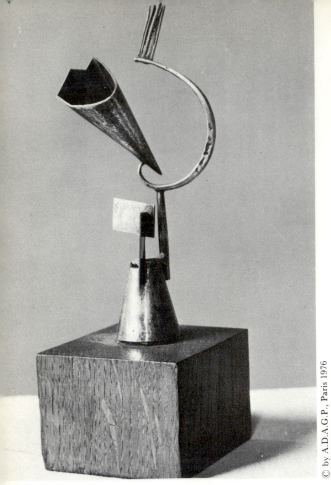

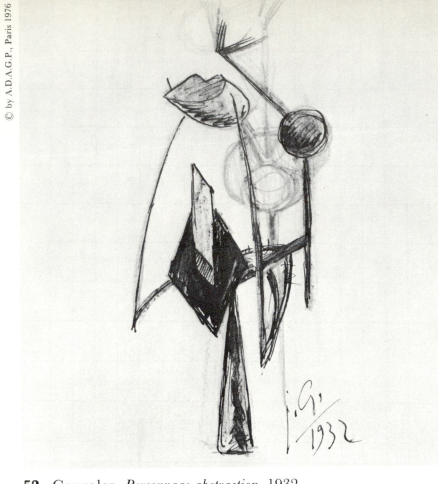

51. Gonzalez, *Tête*, 1932–1933 (cat. 62).

52. Gonzalez, *Personnage abstraction*, 1932

When Gonzalez moved into his new studio in Arcueil at the end of 1933, one of the first sculptures to be completed there was probably the *Daphné* (**53**, **54**, cat. 81). It is the largest piece (142 cm.) he had attempted since the Paris *Femme se coiffant* (170 cm.) and is the clearest expression to date of some of his most effective sculptural ideas.

First, the title itself evokes Ovid's story of metamorphosis in which the beautiful wood nymph was transformed into a tree in order to escape her amorous pursuer, Apollo. The myth itself has all the ingredients of the kind of abrupt and radical transformation to which the Surrealists were attracted.[7] In Gonzalez's version, however, a further transformation has taken place, removing his figure from the veristic and concrete mode from which the Surrealist images typically gained their "marvelous" potency. What has been emphasized, at the expense of mimetic detail, is the nature of Daphne's new form. Figuratively speaking, the lithe and freely moving wood nymph has been transformed into the stiff and rigid gesticulations of the sculpture *Daphné*. This striking image has its true sequel in the many metamorphic creatures of the second half of the decade, such as the cactus figures. The only other figure of this general type in the first part of the decade is the hybrid *Danseuse à la palette* (**58**, cat. 84).

The formal characteristics of the *Daphné* are equally striking. The out-

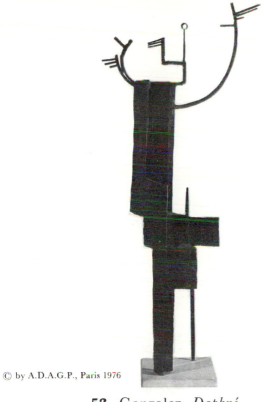

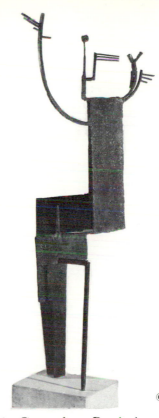

53. Gonzalez, *Daphné*,
1933–1934 (cat. 81).

54. Gonzalez, *Daphné*.
Alternate view of
Fig. 53.

stretched arms and small head are graphic, linear, and clearly legible from almost any vantage point. We see, in other words, the beginning of the "drawings in space" which Gonzalez referred to in his essay on sculpture, and which is the salient characteristic of most of his major pieces of the mid-thirties. By contrast, the rest of the figure is constructed of planes forming open angles; what holds the eye is the way in which the spatial relationships of these planes and the overall silhouette constantly change in moving about the piece. It is a masterful illusion made more piquant by the fact that the gesture of the arms and head remain constant.

If indeed the *Daphné* was completed early in 1934, it established a formal motif which Gonzalez worked into most of the major figure sculptures in the course of the next few years. The combination of vertical plate forms and linear arcs also forms the basis of the Stockholm *Femme se coiffant* (**55**, cat. 86). Here the contrast between closed and open forms is lessened, while the same combination of vertical struts below and freely sweeping curves above, is maintained. The large version of the *Maternité* (**66**, cat. 83), the *Figure debout* (**68**, cat. 92), *Femme à la corbeille* (**62**, cat. 85) and even the New York *Woman Combing Her Hair* (**92**, cat. 108) likewise fit into this schema.

When the lower part of the figure also cuts loose and is less obviously a vertical support structure it becomes a dancer! The contrasting treatment of the upper and lower parts of the body is then replaced by the complementary

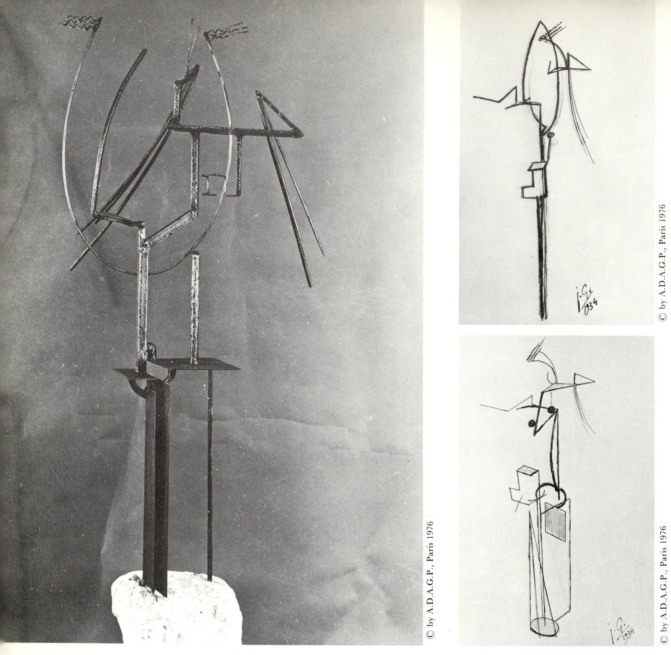

55. (left) Gonzalez, *Femme se coiffant*, 1934 (cat. 86). **56**. (top right) Gonzalez, *Study for "Femme se coiffant,"* 1934. **57**. (bottom right) Gonzalez, *Study for "Femme se coiffant,"* 1934.

gestures of outflung arms and legs. The oval-shaped torso of the *Danseuse à la palette* (**58**, cat. 84) is echoed in the curved radii of her arms and legs, just as the rectilinear torso of the *Danseuse à la marguerite* (**100**, cat. 116) is repeated in the bristling and rigid arms and legs.

With the exception of those few pieces which Gonzalez dated, most of the sculptures before 1934 can only be dated approximately. Beginning in 1934, however, we can date many of the sculptures with a great deal more assurance. The key to this lies in the drawings. Gonzalez had, of course, drawn all of his life, even during those periods when he did little other artwork. There are many

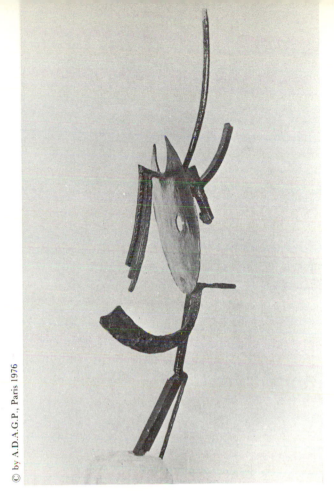

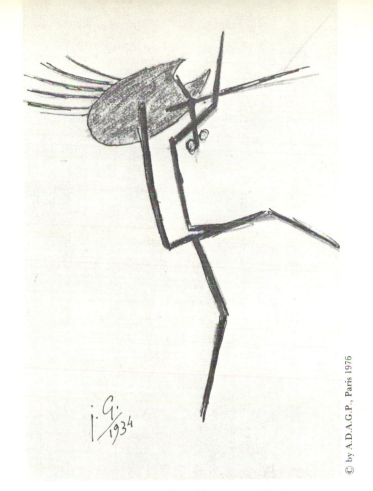

58. Gonzalez, *Danseuse à la palette*, 1934 (cat. 84).

59. Gonzalez, *Study for "Danseuse à la palette,"* 1934.

60. Gonzalez, *Study for "Danseuse à la palette,"* 1934.

61. Gonzalez, *Petite danseuse*, 1934–1935 (cat. 88).

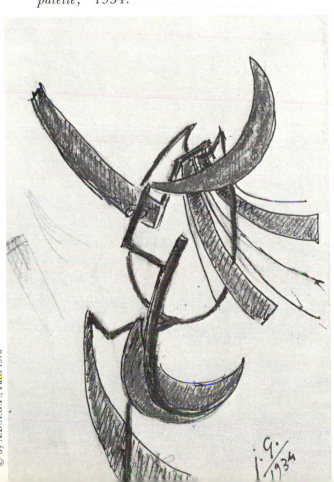

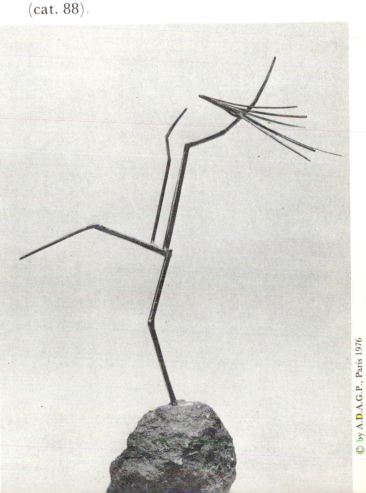

differences between the earlier drawings right up through 1933, and those done thereafter, which makes of the later drawings an effective tool for dating the sculptures and for providing many clues as to their formal interrelationships.

The critical difference is that the drawings after 1933 are dated by year, and often by month. While some of the earlier drawings are dated, to be sure, it is frustratingly infrequent. Everything about the drawings of 1934 and after suggests that Gonzalez quite consciously took a more serious attitude toward his drawings, both as a record of his sculpture and as works of art in themselves. The later drawings are executed with finer materials, including an impressive array of handmade papers, inks, chalk, and pastel; they are more thoughtfully worked out; and there is a great increase in their number. Of particular value for an understanding of the sculpture are the series of studies for sculptures. For the Stockholm *Femme se coiffant* there are some eighteen studies; for the *L'Ange* there are nineteen sequentially numbered drawings; for the New York *Head*, four numbered drawings; and numerous drawings exist for the *Tête au miroir*, the New York *Woman Combing Her Hair*, the *Femme au miroir*, and the cactus figures.[8] In addition to these groups and series of drawings there are one or two dated drawings each for the *Tunnel*, both versions of the *Maternité*, *Danseuse à la palette*, *Figure debout*, *Prière*, *La Giraffe*, both versions of the *Femme assise*, *Grande faucille*, and *L'Homme gothique*.

Following quickly after the *Daphné*, Gonzalez worked on three large filiform sculptures, all completed in 1934. If he did not actually work on the *Femme à la corbeille* (180 cm.), the Stockholm *Femme se coiffant* (122 cm.), and the *Maternité* (132 cm.) concurrently, both the sculptures and the many drawings for these constructions strongly suggest that he based them on very similar ideas.

The wittily topheavy *Femme à la corbeille* (**62**, cat. 85) is the most recognizable image of the three, and its ancestry can be traced back to an early drawing done before the First World War (**63**). The use of line to describe the outer contours of an ''absent positive'' which was remarked with the *Tête longue tige* and again with the *Femme à la corbeille* is slightly changed in the *Maternité* (**66**, cat. 83), which might better be described as a linear diagram. Although it is not immediately apparent, Gonzalez may have intended an evocation of the sculpted Virgin which stands at the portal of the Gothic cathedral (**67**). He had an abiding love of Gothic art, and in his ''Picasso sculpteur et les cathédrales,'' his remarks were at times very perceptive. Interpreted in this way, our twentieth-century Madonna becomes a graphic translation of the elaborately engineered drapery folds of her thirteenth-century counterpart. The abrupt dislocation in the center replaces the sinuous contraposto of her ancestor, while the paired circles stand at the same time for the breasts and the head of the child. A very Cubist Madonna indeed!

The Stockholm *Femme se coiffant* (**55**, cat. 86) is the most abstract and transposed of the three figures, and, probably not coincidentally, Gonzalez did many more studies for his than for the others. In one of these (**56**), Gonzalez used the

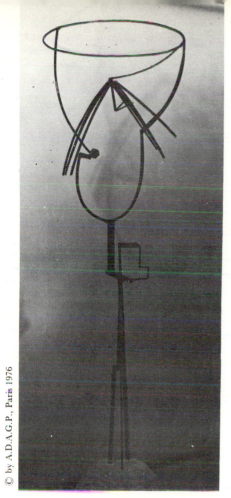

62. (top left) Gonzalez, *Femme à la corbeille*, 1934 (cat. 85). **63**. (top right) Gonzalez, *Femme à l'amphore*, c. 1910. **64**. (bottom left) Gonzalez, *Femme à l'amphore*, *No. 1*, 1930 (cat. 37). **65** (bottom right) Gonzalez, *Study for "Femme à la corbeille,"* 1934.

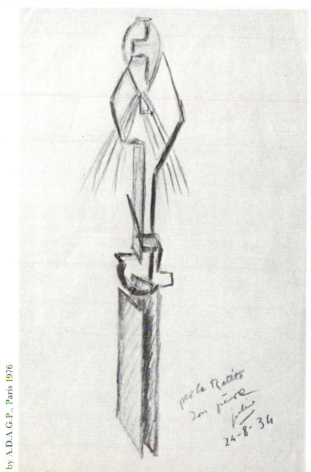

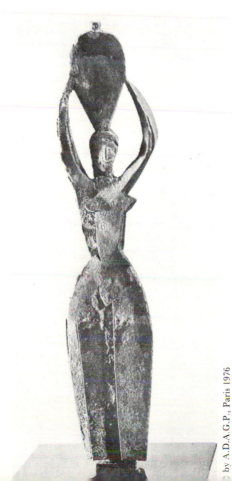

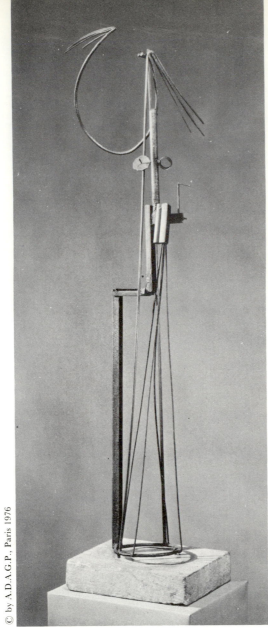

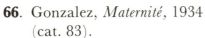

66. Gonzalez, *Maternité*, 1934 (cat. 83).

67. *Madonna*, West façade of Reims cathedral, 13th century.

narrow base, the rectangular outcropping at the hip, and the closed lozenge above the torso of the *Femme à la corbeille*, and at one point he thought of incorporating the "skirt" of the *Maternité* (**57**). He eventually devised instead a rectangular "table" composed of plates and rods which serves as the base for the double open curves of the arms and hair. In all three figures, the hip joint is consistently the major accent and the hair is given a similar treatment, with the amusing addition, in the Stockholm *Femme*, of the marcelled strands.

In retrospect, 1935 appears to have been a good year for Gonzalez. His work was more visible than ever, and began to be shown outside of Paris, in Zurich (end of 1934),[9] and in Lucerne (March 1935). He continued to be sponsored by the Cahiers d'Art gallery and magazine.

Gonzalez continued to synthesize and refine his filiform sculpture with a

heightened assurance and sense of humor. In its original form, the ambitious *Figure debout* (**68**, cat. 92) was a two-figure sculpture, unusual for Gonzalez. It was titled "Les Acrobates," and combined a standing figure (the *Figure debout*) with another flung out at an angle from the upper part of the sculpture. The drawing (**69**) was probably a working study and seems to be fairly close to the completed sculpture. It shows us that Gonzalez was intent on further extending his linear forms into space and creating a dynamic effect. The "Acrobates" was shown in 1936 at the Jeu de Paume exhibition, "L'Art espagnol contemporain," and perhaps shortly after this Gonzalez decided that the flying figure was too unstable. He separated the two figures, and the second is now known as *La Prière* (**70**, cat. 93). The open, extended forms of the "Acrobates" and the upper parts of the remaining *Figure debout* give to the space a certain extension in all dimensions which is measured, given definition and scale, but is not enclosed or given finite shape as in some of the earlier pieces.

68. Gonzalez, *Figure debout*, 1935 (cat. 92).

69. Gonzalez, *Les Acrobates*, 1935.

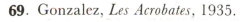

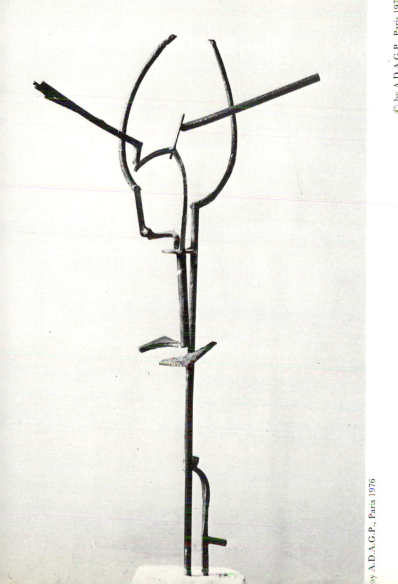

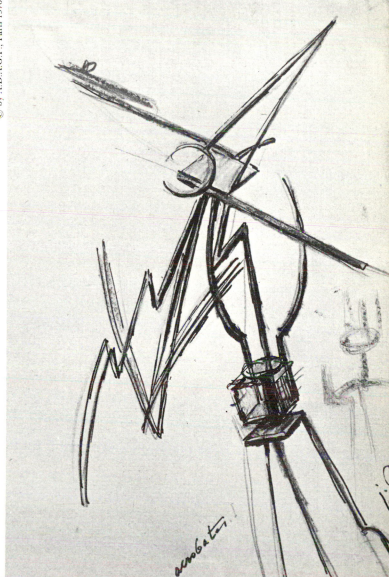

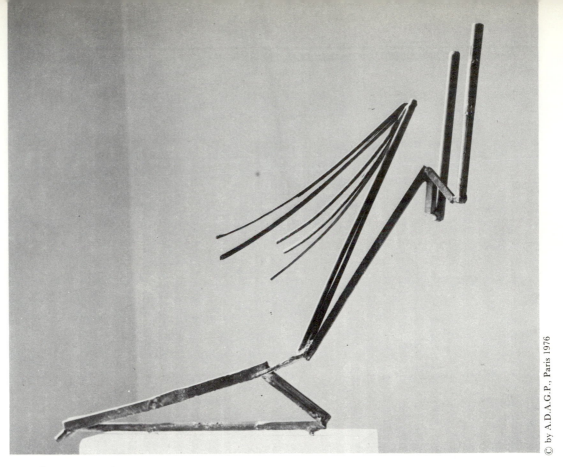

70. Gonzalez, *La Prière*, 1935 (cat. 93).

In 1934 he had done the biomorphic *Téte au miroir* (**71**, cat. 80), which draws on the same sort of puckish humor as Miró's works of the same period. In 1935 he took up the same theme again with the New York *Head* (**73**, cat. 95), sometimes referred to as the "Snail."[10] Gonzalez's proverbial concern with detail and fidelity to nature is nowhere more evident than in this head, in which an abstract and transposed image is combined with vividly menacing jaws and teeth. One is reminded of the story told by Gonzalez's painter friend Henri Goetz, who recounted in an interview that Gonzalez once got what was for him a quite expensive tool in order to get just the toothy effect he desired. The large enclosing arc of this head is constructed as a hollow arc and describes not one, but two different paraboloidal curves, giving a dynamic thrusting appearance which is intercepted by the mouth. The spiky teeth, hair, and eye stalks counterpoint the cleanly formed arc, and the disklike center formed of a jumble of short rods lends a textural interest which is echoed in the dull, grainy patina.[11]

Where the spiky forms of the New York *Head* only hint at an alternate persona, *L'Ange* (**74**, cat. 94) has a more obvious double, and even triple, personality. Gonzalez originally called this *L'Insecte*, and one can indeed see here the alert upright posture and quivering antennae of the praying mantis.[12] Mme. Gonzalez recalled that Picasso rebaptized it — probably with tongue in cheek — with its present title. At the same time, this hybrid creature belongs with the other dancers which Gonzalez created between 1934 and 1937, and is closest in form and gesture to the *Danseuse à la palette* (**58**, cat. 84). With the exceptional

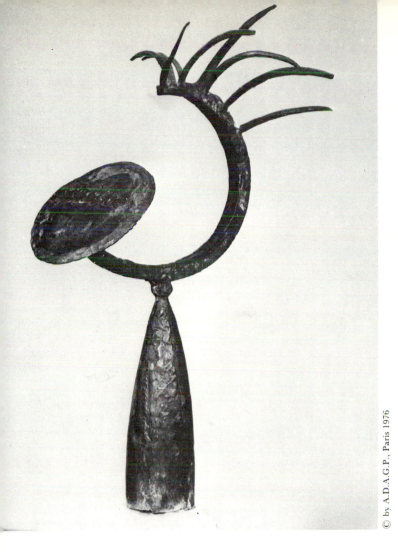

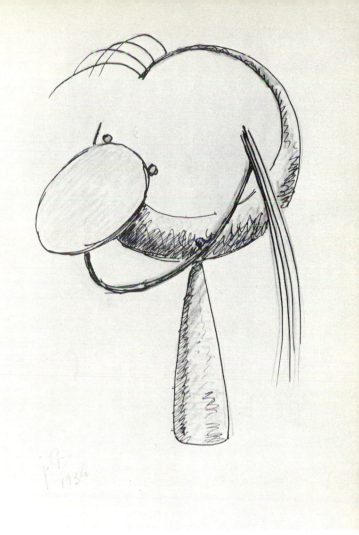

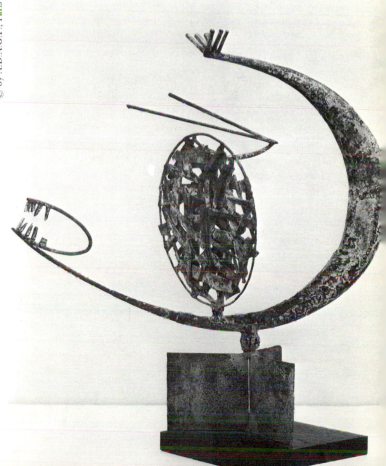

71. (top left) Gonzalez, *Tête au miroir*, 1934 (cat. 80). **72**. (top right) Gonzalez, *Tête au croissant No. 1*, 1934. **73**. (bottom) Gonzalez, *Head*, 1935 (cat. 95).

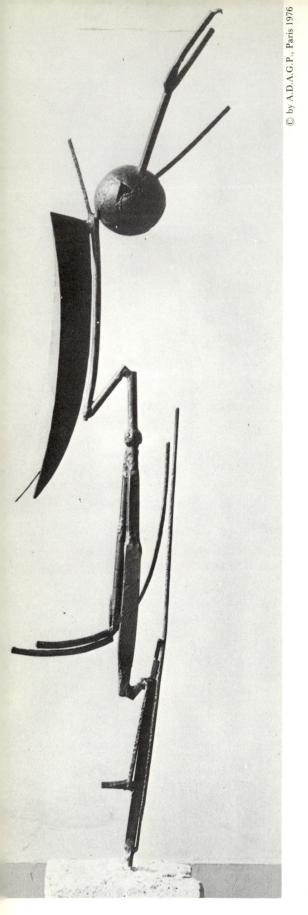

number of studies which Gonzalez made for this piece, we can see that the "antennae" mounted on a spherical head, the thin stalk-like support, and the back-swung leg remained constant throughout, while the wings and the syncopated breaks in the middle only appeared at a fairly advanced stage.

Sometime during the course of 1932, Gonzalez wrote an essay which he intended to publish under the title "Picasso sculpteur et les cathédrales." Although the manuscript is not dated, we can conclude that it was written at about this time. The last "entry" is for the last day of 1931; and in *Les Hommes du jour*, May 11, 1933, a M. Civry heralds its publication with these words: "Gonzalez is about to publish a work on the little-known sculpture of Picasso, a study which will be like a beam of light. . . . This will be a book which will be much-discussed, and about which I am pleased to be able to announce the imminent publication." In other words, it was written, or at least completed, not long after his collaboration with Picasso, and at a time when he had recently finished the Paris *Femme se coiffant*, the *Grande trompette*, and some of the smaller filiform constructions such as the *Tête longue tige* and the abstract silver heads, but before the larger filiform constructions of 1934.

Although the title suggests that Gonzalez intended to suggest parallels between Picasso's sculpture and the Gothic cathedrals, these two subjects were treated quite separately. There are in fact three topics. First, Gonzalez deals at some length with Picasso's career as a painter and a sculptor, giving special attention to his Cubist reliefs in cardboard and tin done between 1912 and 1914, the wire constructions of the late twenties, and the *Woman in the Garden*, which he identifies as the *Monument to Apollinaire*. Second, there are many general remarks on open-form sculpture, which, aside from their relevance to Picasso, may be interpreted as a statement of what Gonzalez himself wished to achieve with his sculpture. Last of all, Gonzalez made extended reference to Gothic architecture and architectural sculpture.

The dominant theme running through this essay is Gonzalez's justification of open-form sculpture, which he refers to both as "perforated" sculpture, and as sculpture "sans block" or not having mass; he writes of the "marriage of material and space," of "forms in space," of "drawing in space," and of space as being a proper and indeed essential material of the sculptor.

In chronicling Picasso's career from his first days in Paris up to 1931, Gonzalez represents his sculptural achievements as being periods of great significance in his development, requiring intense struggle and effort. He writes that in 1911

Previous page:
74. (top left) Gonzalez, *l'Ange*, 1935 (cat. 94). **75**. (top center) Conzalez, *Etude pour "l'Ange,"* 1935. **76**. (top right) Gonzalez, *Etude pour "l'Ange,"* 1935. **77**. (bottom left) Gonzalez, *Etude, pour "l'Ange,"* 1935. **78**. (bottom right) Gonzalez, *Etude pour "l'Ange,"* 1935.

Julio Gonzalez: Sculpture in Iron

. . . in order to give air to his paintings, it occurs to [Picasso] to execute these separately with cut-out papers.

The alert is given! He doesn't stop, he works more than ever, he searches always, he contrives to make little boxes out of cardboard [which are] joined together with strings. He succeeds in making works which are full of emotion with a new technique: these assembled papers give the impression of things carved in rock.

1914

After this, with primitive tools, scratching his hands a thousand times with a stubborn tenacity, he makes his first [constructions] in sheet metal, as beautiful as they are original, the powerful and masterly still lifes.

He had just created his first sculptures. One can imagine the satisfaction which a real artist would feel in creating these works, but, when the painter Picasso, recalling this period of his life, still says of himself: "I have never been so pleased! that was my point of departure. The departure on a new road to follow, I was happy." [If he can say that,] it surely means that this was of great importance to him! . . .

In only a few years, he found, created, invented [and] drew new forms (we speak of sculpture), new planes, opposition of planes, perspectives, forms in space. He continues to paint, but, he thinks only of sculpture, because each color for him is only a means of distinguishing one plane from another, the light from the shadow, or yet other forms.

At a later point in the essay, Gonzalez illustrates his contention that Picasso "thinks only of sculpture" even when he is painting, by describing the translation of one of his paintings into sculpture:

These essential lines, these tracings of paint on the canvas, purely sculptural in conception and realization, will one day be replaced by Picasso with iron bars which he will take and arrange in such a way as to interpret the subject of one of his paintings.

From his specific remarks on Picasso as a sculptor, Gonzalez turns to a general discussion of open-form sculpture, of "forms in space," and occasionally uses his observations on Gothic sculpture and architecture to illustrate his points. Both the cathedral spire and the stars, or the "points in the infinite," he writes, are "precursors of this new art: *To draw in space.*"

The real problem to be solved here is not only to wish to make an harmonious work, of a fine and perfectly balanced whole — No! But to get this [result] by the marriage of material and space, by the union of real forms with imagined forms, obtained or suggested by established points, or by perforations, and, according to the natural law of love, to mingle and make them inseparable one from another, as are the body and the spirit.

As an example of this union, he cites as historical precedent the open but massive forms of the Roman triumphal arch and the delicate tracery of the Gothic rose window.

In several instances, Gonzalez refers to the spatial element of the sculpture as the spiritual or divine component. In the passage quoted above, he likens the union of material and space to the inseparability of the body and spirit. Further on, he refers to "working with the ennobling space."

As if anticipating criticism of the new sculpture of space, Gonzalez writes, "One could object that this kind of sculpture is limited, [but] it is no more so than the other (the full)." At a later point, he gives an instance in which, as he claims, closed-form sculpture of mass actually falls short of the new sculpture of space:

> *A statue of a woman can also be a woman (a portrait) which one should be able to see from all sides; from all aspects, she is a representation of Nature.*
>
> *But, if in a certain attitude, she is holding an olive branch, she is no longer a woman. She has become the symbol of Peace. [Once she has] become a symbol, do not walk around her, for as soon as you no longer see the attribute, she again becomes [simply] a woman. So this classic art, which was thought complete, actually is not simply because of its* solid *material.*

Taken as a whole, Gonzalez's essay is a defense and an apology for open-form sculpture, or the new sculpture of space. He deals at some length with the aesthetics of this sculpture, compares it with the more conventional sculpture of mass, in one case suggesting its superiority to that sculpture. He buttresses his "defense" both with historical precedent — Roman architecture, and medieval architecture and architectural sculpture — and examples of Picasso's constructed sculpture.

Whenever Gonzalez referred to space in his essay, he appears to have envisioned it as a positive element of the sculpture, and as such, having qualities or characteristics peculiar to itself. He speaks of the stars as "points in the infinite which are the precursors of this new art: *to draw in space.*" In this metaphor, the emphasis is on space as having extension, which can be measured by these stars, or "points in the infinite." Gonzalez saw this stellar metaphor as a model for the new art — drawing in space. As applied to his sculpture, such a drawing can be envisioned as a sort of three-dimensional calligraphy, whose steel lines chart the spatial dimensions.

Gonzalez also writes of space as being a palpable entity, having a definable shape. Space can be used as the nucleus of the sculpture. As Gonzalez phrased it, "Our material, then, being space, [the] block can be formed around a void [which taken together] form a single block." His reference to the "union of real forms with imagined forms" implies also that space is an entity, in this case a complement of the "real" or solid forms. In his "Réponse à l'enquête sur l'art

actuel," published in *Cahiers d'art* in 1935, Gonzalez again implied this in his self-proclaimed goal "To project and design in space with the help of new methods, *to utilize this space, and to construct with it, as though one were dealing with a newly acquired material*"[13] (italics added).

Gonzalez was quite specific about the relative values he attached to the solid and spatial elements of his sculpture. He first speaks of the "marriage of material and space by the union of real forms with imagined forms," and goes on to liken this union to that of the body and spirit.[14] Although this analogy is intended primarily to suggest the mechanism of this marriage or union, it is suggestive. In another place Gonzalez refers directly to the "ennobling space." Space, then, represents not only the absent, or imagined forms, but, being in the mind's eye, is the "spiritual" form. Its opposite is the material form, which is more real, because tangible and therefore directly perceptible. By making the two "inseparable . . . as are the body and the spirit," Gonzalez emphasized that the two forms complement each other and that the one is lifeless without the other.

In an indirect fashion, Gonzalez's metaphors and analogies suggest the perceptual level on which we are to see and understand his sculpture. Gonzalez's references to the "ennobling space," and to the stellar "points in the infinite" as precursors of the new art suggest one level of interpretation. What better metaphor is there to describe the nonsensual and essentially abstract nature of Gonzalez's sculpture than these celestial metaphors? The stars do not yield up their secrets as simple sensations, but only when interpreted within a conceptual frame of reference. Even more, relative position can be a positive hindrance. This has its parallel with the filiform sculpture which, as Gonzalez pointed out, could be seen from all sides at once, hence tending to negate this factor of relative position.

With sculpture of volume and mass, its location and density is communicated to us by a combination of kinesthetic identification and touch — both relatively primitive levels of perception. The sense of touch, whether actual or inferred, tells us in a more direct fashion than sight alone, relative position, and location. Even though a pedestal, like the frame of a picture, tells us that a sculpture is removed from our space, the sense of touch, more than any other faculty, reassures us of its corporeal existence in a dimension continuous with ours. That sculpture, unlike painting, exists in our space, and is one object in a world of objects, has been recognized ever since Galatea came to life in the arms of Pygmalion.

Gonzalez's sculpture does not seduce us in this manner. He extends no such invitation to touch his filiform sculptures, nor is it by touch that we gain our understanding of his sculpture. The immediacy of touch has been replaced by a more abstract and cerebral visual perception. These sculptures have, in effect, been removed beyond palpable sensation to a more perceptual and even conceptual realm.

NOTES

1. From the introduction to the catalogue of the exhibition held at the Galerie Percier in April 1934. The essay is reprinted in Pierre Descargues, *Julio Gonzalez*, Paris, 1971, pp. 144–46. The Galerie Percier, located on the ground floor of Picasso's apartments at 23, Rue La Boëtie, also had the first Paris exhibition of Gabo and Pevsner's work in 1924, and the first exhibition of Calder's abstract sculpture and mobiles in 1931.

2. Anatole Jakowski, "Julio Gonzalez," *Cahiers d'art*, Vol. 9, 1934, p. 207.

3. Three *Heads*, the *Standing Figure, Petite trompette, Petite paysanne, Petite Danseuse*, and *Masque argent*.

4. Interview with Mme. Gonzalez. See also Roberta Gonzalez, in *Julio Gonzalez: Les Matériaux de son expression*, Paris, 1969, (n.p.).

5. Gonzalez was an accomplished jeweler, and continued throughout this period to make jewelry to support himself.

6. Other pairs include: *Danseuse échevelée* (iron) and *Petite danseuse* (silver); *Tête couchée, petite* (plaster) and *Masque argent*.

7. Picasso's series of illustrations of Ovid's *Metamorphoses* was published by Skira in 1931.

8. For these later sculptures, it is hard to take a precise inventory. For the *Tête au miroir*, the count can vary since opinion can differ as to the relatedness of some of the studies.

9. The exhibition "Was ist Surrealismus?" was organized by Carola Giedion-Welcker, who seems to have connected with Gonzalez through Jean Arp (interview with Louis Fernandez). In any case, this association led her to include several Gonzalez sculptures in her important *Modern Plastic Art* (1937).

10. There are numerous related drawings dated 1935; the actual studies for this piece, numbered 1 through 4, are in the collection of the Museum of Modern Art, New York.

11. Anton Konrad, sculpture conservator at the Museum of Modern Art, pointed out that in this *Head* and the *Femme au miroir*, Gonzalez seems to have rubbed earth into some of the surfaces of these sculptures to achieve this warmly colored and grainy surface (interview, August 1968).

12. It is worth mentioning that insects had an important place in the Surrealists' rather eclectic bestiary. Note the many times praying mantises, ants, grasshoppers, and more fanciful species appear in the painting of Miró, Ernst, Dali, and Masson.

13. Julio Gonzalez, "Réponse à l'enquête sur l'art actuel," *Cahiers d'art*, Vol. 10, 1935, p. 32.

14. The "real" and "imagined" forms of the *Rêve* are a good illustration of this point. See above, pp. 55–56.

V

Gonzalez's Sculpture: 1935–1942

To the end of his life, drawings were a sensitive barometer of Gonzalez's thinking, and after 1935 occupied more and more of his time; he put more care into each one, at the same time that he was much more prolific. In 1935 he did a drawing in ink and pastels of a seated woman (**79**) composed of rectangular blocks. Its severe angularity is relieved only by the sprig of hair and the scrubbed texture of the oily pastel. The cubic volumes and surface texture seem novel set beside the twiggy stick figures of the drawings and sculpture of the preceding year.

The little drawing of the seated woman is not so much a proof of the shift in Gonzalez's sculptural style as a signpost which is best understood in a larger context. The *Femme assise I* (**80**, cat. 97), for which this drawing is a study, is hollow-constructed of sheets of iron patched together, with the melted residue at the edges and joints clearly in evidence. It can be taken as the aesthetic equivalent of the coarse texture of the pastel. The manipulated surface of the sculpture counteracts the purist geometry of the forms, and may be Gonzalez's alternative to the "deliberate" and "scientific" abstraction of which he was so critical. "One will not make great art in making perfect circles and squares with the aid of compass and ruler. . . . The truly novel works . . . are, quite simply, those which are directly inspired by *Nature*, and executed with love and sincerity."

The counterpoint of geometric forms and surface modulation was not, however, limited to the hollow-constructed "cubic" sculptures. The crisp, uninflected line of the "drawings in space" — the large *Maternité* is a good example — gave way to greater variation of thickness and tonal value. The flaring leg of the *Danseuse à la palette*, the swelling arc of the New York *Head*, the semi-opaque disk of this same head and of the *Giraffe* (**81**, cat. 96), and the choppy forms of the *Danseuse à la marguerite* bespeak Gonzalez's conscious desire to vary the quality of his line.

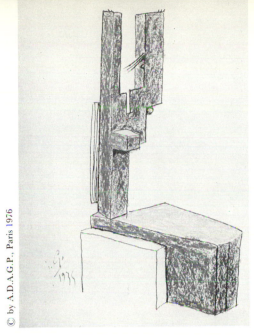

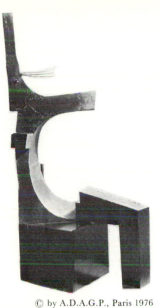

79. Gonzalez, *Femme assise vert et rouge*, 1935.

80. Gonzalez, *Femme assise I*, c. 1935 (cat. 97).

Surface as a description of form, however, gradually but insistently became a defining characteristic of the sculpture after 1934. It is possible that Gonzalez was drawn to this through his stone carving.

There exists in Gonzalez's oeuvre a group of some seven or eight stone carvings, all heads, ranging in style from the relatively naturalistic *Jeune fille fière* (**83**, cat. 74) to the abstract *Le Baiser* (**84**, cat. 106). It is difficult, if not impossible, to date these sculptures precisely. All of them, with the apparent exception of the *Baiser*[1] were carved from a friable stone picked up from a demolition site near a small property Gonzalez owned in Monthion.[2] The only direct indication we have of their dates is an exhibition review of the 1933 Salon des Surindépendants, where mention was made of Gonzalez's " 'heads' in stone casually placed on the floor in a square marked off by four pegs joined together by a flimsy cord."[3] Recent catalogues, for example the "Donation Gonzalez" published in the *Revue du Louvre*, or the Galerie de France,[4] only date them approximately between 1933 and 1937.

81. Gonzalez, *La Giraffe*, 1935 (cat. 96).

82. *Candelabra*. Traditional Catalan forged ironwork.

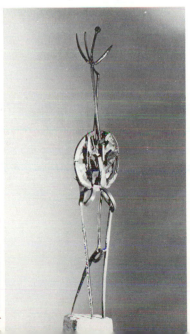

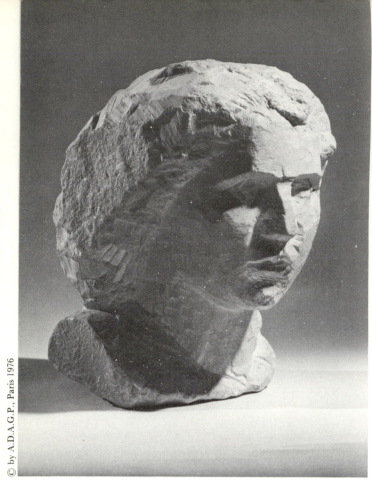

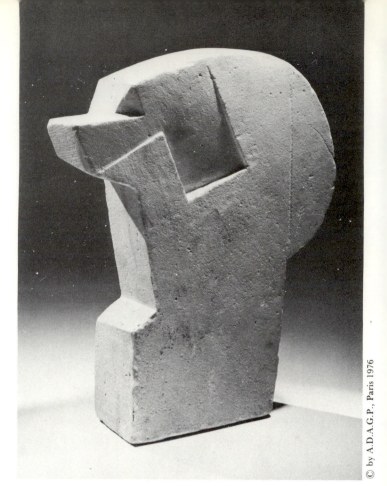

83. Gonzalez, *Jeune fille fière*, 1933–1935 (cat. 74).

84. Gonzalez, *Le Baiser*, c. 1936 (cat. 106).

86. Gonzalez, *Tête, double tête*. Alternate view of Fig. 85.

85. Gonzalez, *Tête, double tête*, 1933–1935 (cat. 75).

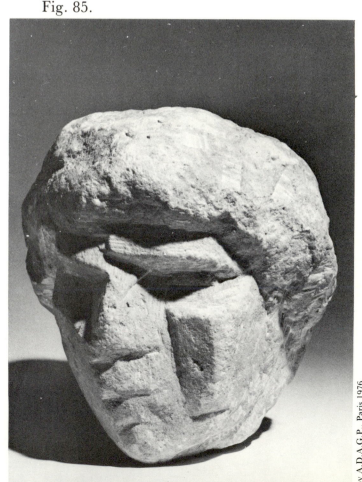

Although these carvings appear to be quite different from the iron constructions of the mid-thirties, they offer instructive parallels to Gonzalez's open-form sculpture. The discontinuity of form as perceived from various angles, previously discussed in connection with the *Grande trompette* (**42**, cat. 56) of 1932, is also a characteristic of the stone *Tête, double tête* (**85**, **86**, cat. 75). Similarly, there is a parallelism in formal motifs between the hollowed-out iron construction *Les Amoureux II* (**46**, cat. 66) of 1933 and the stone *Baiser* of about 1936.

Another perspective on the possible connections between Gonzalez's work in stone and in iron is suggested in his essay, "Picasso sculpteur et les cathédrales." In some cases he contrasts stone carving with open-form sculpture, as when he writes, "Our *material*, then, being *space*, this block can be formed around a void. . . . With sculpture of *stone, holes* are not necessary. With sculpture having to do with space, they are necessary." In another passage, however, he makes a statement which, in the context of this essay, is equally applicable to carved or constructed sculpture.

> In order to give the most power and beauty to his work, the sculptor must be aware of the exterior contour, in order to preserve its sense of mass. So it is in the center of this mass that he must concentrate all his effort, all his imagination and his science, so that its power won't be weakened.

The "mass" that Gonzalez mentions could refer both to the mass of a solid block of stone, or a "block" of space, the block which "can be formed around a void." In other words, it appears that he did not see mass, or a feeling of mass, as being an exclusive characteristic of carved sculpture; in an earlier passage in his essay, where he describes Picasso's Cubist constructions in cardboard, he remarks that "these assembled papers give the impression of things carved in rock."

Although it is possible that Gonzalez's interest in a compact and cubic sculpture style was first awakened when he began the carved heads, he made other heads and figures in a similar style in many other media. The *Tête abstraite inclinée* (**87**, cat. 64) of 1933 and the *Cagoulard* (**88**, cat. 90) of 1935 are worked directly in bronze; they have as much a sense of density and weight as have the stone carvings. The thickness of the metal and simple treatment of the *Cagoulard* is as suggestive of medieval jousting helmets as it is of the hooded monks after which it is named. The feeling of weight and solidity characteristic of these two sculptures is not unlike that of the *Baiser* of about 1936, in which forms have been incised on the stone. In a more "cubist" vein — in the literal sense, "made of little cubes" — are the faceted *Tête couchée petite* (**89**, cat. 101) of 1935–36, modeled in plaster, and the *Petit masque argent* (**91**, cat. 100) of 1935–36, forged in silver.

The largest sculpture Gonzalez worked on in 1936 was the New York *Woman Combing Her Hair* (**92**, cat. 108); this subject continued to attract him, and he

88. Gonzalez, *Cagoulard*, 1935
(cat. 90).

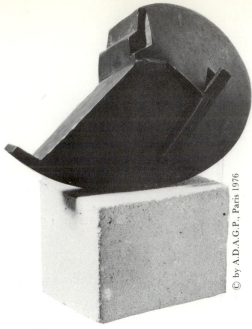

87. Gonzalez, *Tête abstraite
inclinée*, 1933 (cat. 64).

made an exceptionally large number of studies and other drawings related to
this piece. A ghost of the more skeletal *L'Ange* (**74**, cat. 94) remains in the upright
posture and poised, mantis-like arms of the New York *Woman Combing Her Hair*
The hollow construction, however, which allowed Gonzalez to swell out the
forms, gives this piece a more muscular, earth-bound feeling. In photographs,
this construction appears to be more volumetric and space-filling than it is in
reality. Gonzalez angled and mitered the planes to create an illusion of depth,
while keeping the real depth quite shallow. The curled-up iron sheet forming
the back and rump, which seems to grow so naturally out of Gonzalez's direct
manipulation of his materials, also appears rather consistently in the drawings
and studies. The result is a rigorously planar sculpture seen in three-quarter
rear view. Leo Steinberg was the first, and possibly the only writer to date to
understand so clearly Gonzalez's sense of body gesture. He wrote that Gon-
zalez's "shapes seem determined by an inward apperception of dynamic
functions, never by the look of forms externalized and thingified."[5] This sculp-
ture does give form to the kinesthetic sense of the contracted muscles of the back
and the neck pulling against the tangled fall of hair.

The Rockefeller *Reclining Figure* (**94**, cat. 107) of the same year transposes
the reverse-curve gesture of the New York *Woman* to the horizontal, and again,

89. Gonzalez, *Tête couchée, petite*,
1935–1936 (cat. 101).

90. Gonzalez, *Tête aux cubes*,
1936.

91. Gonzalez, *Petit masque argent*,
1935–1936 (cat. 100).

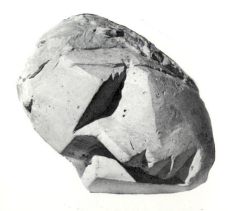

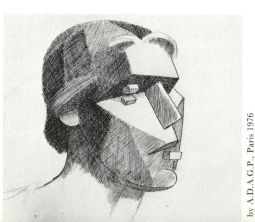

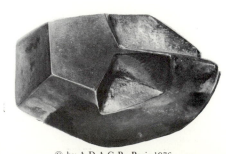

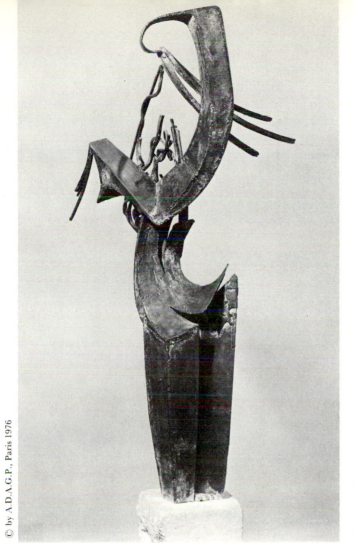

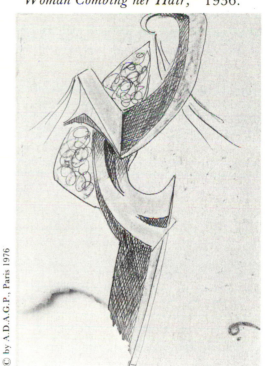

92. (left) Gonzalez, *Woman Combing her Hair*, 1936 (cat. 108).
93. (right) Gonzalez, *Study for "Woman Combing her Hair,"* 1936.

the sinuous, curving forms are made more emphatic by the same hollow-constructed forms. The sweeping curves and exaggerated gesture of the figure transcend its reclining posture, and inevitably, one is reminded of the vital tension of Gonzalez's dancers.

Gonzalez had been interested in the dance for many years, and as early as 1918 he had an opportunity to sketch a dancer who might be taken for Isadora Duncan. Significantly, it was not the fixed poses and intricate steps of the classical ballet which attracted him, but rather the more fluid and abandoned movements pioneered by Duncan.[6] About 1925 Gonzalez began visiting an academy teaching the new dance forms run by Jeanne Ronsay,[7] whom he probably met through his activities in the Salon d'Automne. Observing the movements of the dancers in this studio could have made Gonzalez more sensitive to the expressive potential of bodily movement, posture, and gesture.

This attraction to the dance inspired the first of his filiform dancers in 1934, but it did not end with the last of them, the *Danseuse à la marguerite* (**100**, cat. 116) of 1937. The exaggerated and dramatic gesture of the dance, and particularly the very direct and organic gesture of the modern dance[8] which Gonzalez evokes in his sculpture, is an ideal vehicle for the more humanly expressive mode

which he began to evolve after about 1934. In a larger sense, many of the figure sculptures of 1936 through 1939 are "dancers," and echo the open and flamboyant gesture of the *Danseuse à la palette* (**58**, cat. 84) or the petite dancer in silver (**61**, cat. 88), both of 1934.

The fusion of poetic form and bodily gesture increasingly characterized Gonzalez's sculpture. In fact, it is possible to group the individual sculptures in "families" of dancers. For the *L'Ange*, the New York *Woman Combing Her Hair*, and the *Grande Vénus*, the arched back determines the positioning of the head and extremities. Other families of dancers include three reclining figures; the *Grande faucille* and *Petite faucille* (**97**, **98**; cat. 113, 114); the *L'Homme gothique* and the *L'Homme cactus* I and II.

A comparison of the *Petite danseuse* of about 1935 (**101**, cat. 91) and the *Danseuse à la marguerite* of 1937 (**100**, cat. 116) demonstrates the finesse with which

94. (top right) Gonzalez, *Reclining Figure*, 1936 (cat. 107). **95**. (bottom left) Gonzalez, *Personnage étendu*, 1936. **96**. (bottom right) Gonzalez, *Personnage allongé*, c. 1936 (cat. 109).

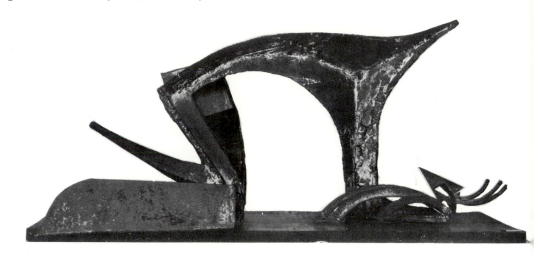

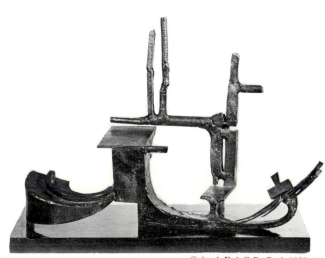

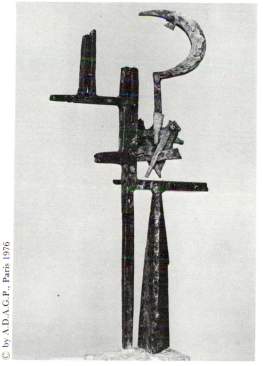

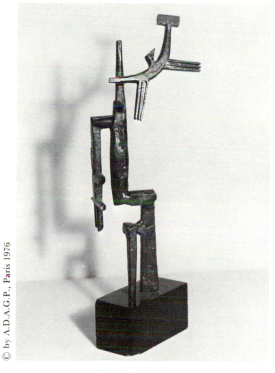

97. Gonzalez, *Grande faucille*, 1936–1937 (cat. 113).

98. Gonzalez, *Petite faucille*, 1937 (cat. 114).

Gonzalez could handle his materials in order to enhance the expression and gesture of the figure. The *Petite danseuse* was constructed in a manner similar to the early *Couple* and *Vénus* (**102**, cat. 12), of short, stubby iron rods. But instead of the somewhat anonymous geometry of the earlier pieces, the surfaces of this small figure are plastic and molten; they have the appearance of being modeled with the hand, rather than being hammered. The offhanded break at the knee joint could have been done with a flick of the finger rather than being seared by the torch. These surface qualities are congruent with the rounded forms and bouncy movement of this figure. A dancer would immediately understand the visual emphasis given the knee and hip joints of the supporting leg receiving the fall.

The *Danseuse à la marguerite*, so named because of the radiating fingers of the right hand, gives form to an entirely different body gesture. The stiff angular forms and sharp, ragged edges enhance the gesture of an expansive stretch, tensed to the end of every finger. The abruptness of assemblage plays its part here; the various bolts used in the hip joint and the fingers of both hands clearly retain their identity.

During the same period of the New York *Woman Combing Her Hair*, the dancers, and other abstract and metamorphic figures, Gonzalez also did the *Torse* (**106**, **107**, cat. 104), the largest and finest of a group of naturalistic torsos

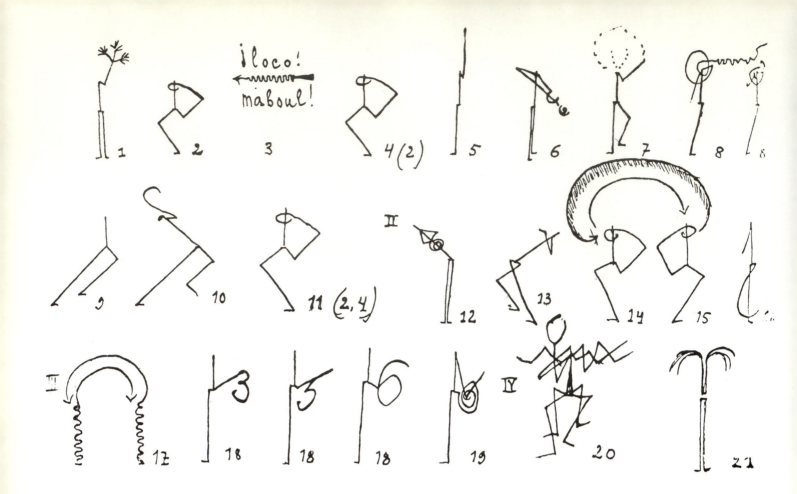

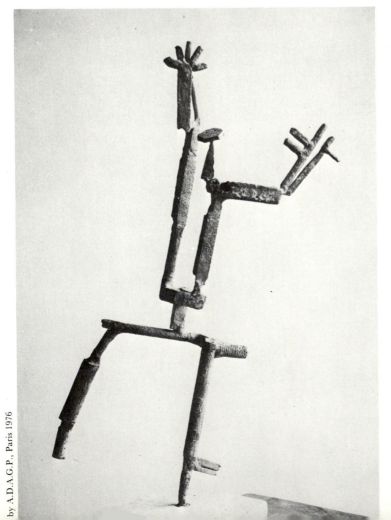

99. (top) *Jazz Dance Notations*, 1927. **100** (bottom) Gonzalez, *Danseuse à la marguerite*, 1937 (cat. 116).

Following page:
101. (top left) Gonzalez, *Petite danseuse*, 1935 (cat. 91).
102. (top right) Gonzalez, *Vénus*, 1929 (cat. 12).
103. (bottom left) Gonzalez, *Grande Vénus*, 1936 (cat. 111).
104. (bottom center) Gonzalez, *Petite Vénus*, 1936 (cat. 112).
105. (bottom right) Gonzalez, *l'Ostensoir*, c. 1937 (cat. 115).

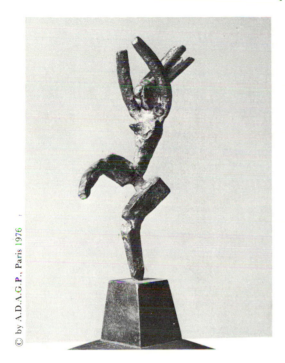

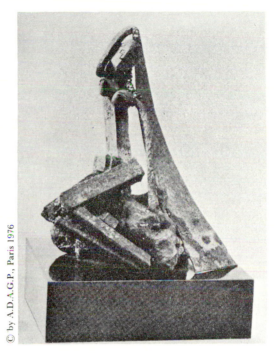

and truncated figures. It is a corroded, opened-up shell whose surfaces appear to have undergone the ravages of time. Gonzalez once again used his favored shaping technique of repoussé, hammering the sheets from the back, or inside. Rather than being neatly truncated, the top and bottom are open, and taper off in a sort of ragged crenelation; the legs are delicately balanced at three or four points of contact.

The British sculptor William Tucker's observations on Gonzalez's approach seem particularly appropriate here:

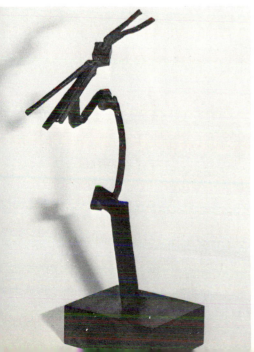

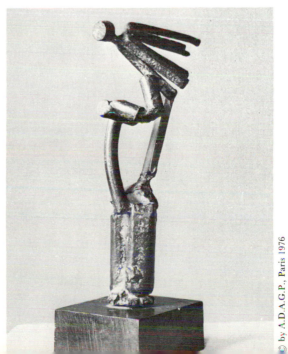

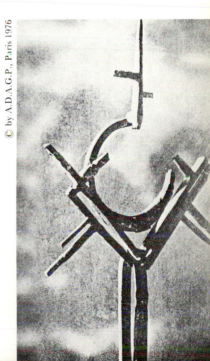

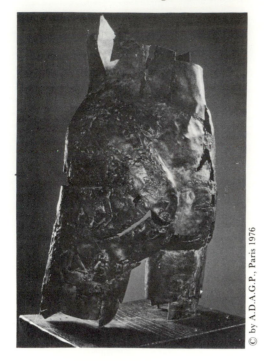

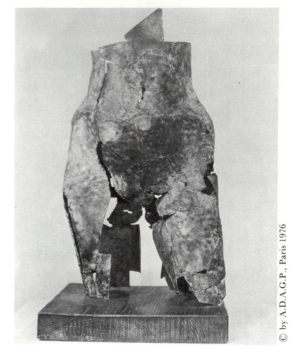

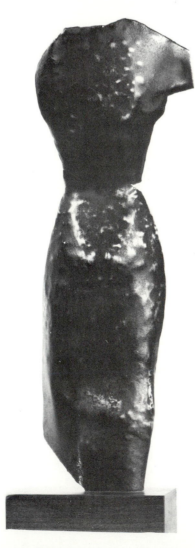

106. (top left) Gonzalez, *Torse*, c. 1936 (cat. 104). **107**. (top right) Gonzalez, *Torse*. Alternate view of Fig. 106. **108**. (bottom) Gonzalez, *Grand profil de paysanne*, c. 1934–1935 (cat. 87).

What is peculiar to Gonzalez, and the index of his unique position in modern sculpture, is the identification of drawing with making. *The seed of Picasso's original Cubist constructions in wood bore fruit in steel in the hands of Gonzalez: not only the assembly part by part, but the previous and separate shaping of parts — bar forged, drawn or bent, sheet rolled, cut or folded, volumes made by the enclosure of the void: the components thus made, joined at points or edges, and situated in relation to gravity in ways inaccessible to the traditional materials of sculpture. The action of the sculptor's tools* becomes *the form of the end material: the tensile potential of steel "as it comes" — i.e. in varieties of bar or sheet — is turned, in the sculptor's hands, to sheer invention.*[9]

One can imagine Gonzalez making this torso directly at the forge, without reference to the sketches or studies which he customarily did for the abstract pieces. To paraphrase his own remarks on Picasso's Apollinaire monument, he had sketched this subject so many thousands of times, he needed none when he set to work at the forge; his hammer alone was enough.

Substantially the same technique was used to make the *Grand profil de paysanne* of about 1935 (**108**, cat. 87) and the *Masque de la Montserrat criant* of 1937 (**119**, cat. 119). With the mask, Gonzalez began with a genre which was common throughout his career. He used the torch to partially melt and corrode away the features, making of it a powerfully expressive image. In contrast to the abstract masks of the earlier thirties, this mask recalls the softened and hammered surfaces of the early repoussé heads.

In 1936 and 1937 Gonzalez worked simultaneously on two life-size sculptures,[10] which, as it turned out, were to be his last large-scale works. They could not have been more different. The one was the realistic figure of the *Montserrat*, the other was the completely abstract and metamorphic *Femme au miroir*. As a subject for drawings as well as sculpture, both these themes had figured prominently in Gonzalez's work for many years. The woman at her toilette served as the theme for three other major abstract sculptures of the thirties, as well as for numerous realistic drawings dating back to the early years of the century.

But as a metamorphic figure, the bulbous, plantlike forms of the *Femme au miroir* (**109**, cat. 117) set this apart from the antennaed, insectlike metamorphic creatures of such sculptures as the New York *Head*, the *L'Ange*, and the New York *Woman Combing Her Hair*. The transformation was completed with the two cactus figures, begun in the following year. They were executed in the course of 1938 and 1939, after which Gonzalez did no more wrought iron sculpture.

The prickly biomorphism of Gonzalez's cactus figures (**110**, **111**; cat. 121, 122) is one of his most original inventions, and, as with the late Montserrats, these cactus men were Gonzalez's outraged response to the war. Where the expressive meaning of Gonzalez's earlier metamorphic and hybrid figures is benign and even humorous, the cactus figures are expressive of a more sinister

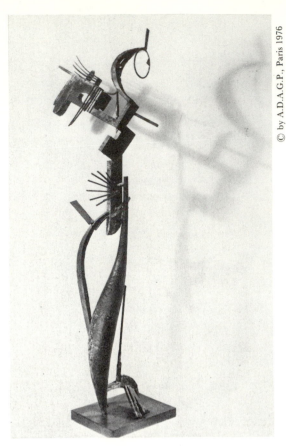

109. Gonzalez, *Femme au miroir*, 1937 (cat. 117).

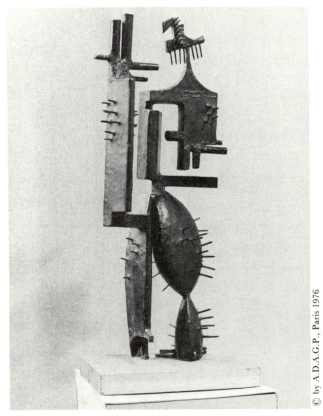

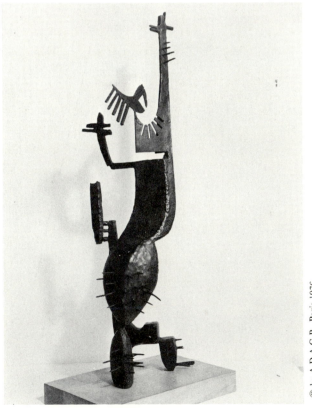

110. Gonzalez, *l'Homme cactus I*, 1938 (cat. 121).

111. Gonzalez, *l'Homme cactus II*, 1939 (cat. 122).

and demonic transformation. These screaming figures with upraised arms are dehumanized by their transformation into pulpy and spiny cactus plants. Like the barbed eyelashes of Picasso's weeping figures dating from the time of his *Guernica* of 1937,[11] the spiny nails of Gonzalez's cactus figures are repellent and give an almost physical sense of pain.

Between 1938 and 1940 Gonzalez was spending as much time with drawing as with sculpture, and it is especially the drawings which reveal to what extent this striking image of a vegetable man preoccupied and even obsessed him. The drawings convey a very direct and powerful sense of terror, pain, and despair (**112**, **113**, **114**).

It is difficult to escape the conclusion that this series of metamorphic figures reflects his emotional reaction to events around him. The persistence of screaming, terrorized beings, whether variations on the *Montserrat*, or the metamorphic creatures, is the more striking in Gonzalez's oeuvre for the fact that neither his drawing nor his sculpture had, until about 1937, been highly charged emotionally. From around 1929 to about 1935, Gonzalez's art primarily reflects a concern with formal problems, and even after this did not immediately become expressionistic. Even the *Femme au miroir* of 1937, it can be argued, is akin to the earlier sculpture in this respect. But in the case of the *Montserrat* of the same year (**115**, cat. 118), this is not true, and it is apparent that Gonzalez wished to make a statement with this large figure.

Although Montserrat is a fairly common Catalan given name, Gonzalez's consistent use of the title *Montserrat* suggests not an individual, but a generic or symbolic representation. The Montserrat, from the Latin for "serrated mountain," is a craggy and precipitous mountain near Barcelona and a traditional symbol of Catalonia. This is what Gonzalez had in mind when he described the "mystic Montserrat" as the "vassal of Spain." The traditional connection of

112. (left) Gonzalez, *l'Homme cactus I*, 1938. **113**. (center) Gonzalez, *Personnage rectangulaire*, 1938. **114** (right) Gonzalez, *l'Homme Cactus II*, 1939.

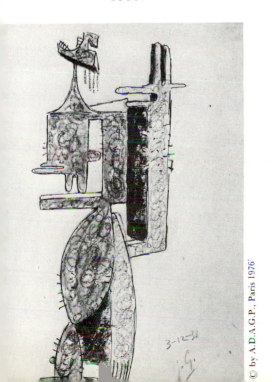
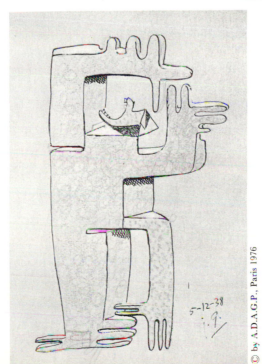
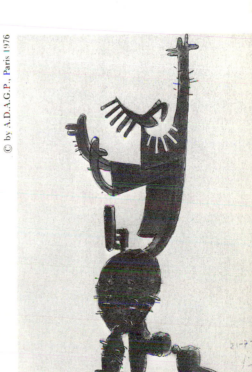

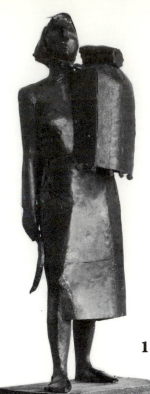

115. Gonzalez, *Montserrat*, 1937 (cat. 118).

Montserrat with Catalonia was personified in a statue of the Virgin, reputed to be of great antiquity, in the Benedictine monastery of Montserrat. In 1881 this association was made official by Pope Leo XIII, who crowned her Nuestra Señora de Montserrat, Patrona de Cataluña. She was, and continues to be, one of the most celebrated holy images in Spain and her shrine is the focus of an important pilgrimage.

With this in mind, it is reasonable to suppose that Gonzalez's mother and child, or Madonna, was intended as a secular Montserrat, patroness of Catalonia, a peasant woman with child in one arm, sickle in the other, one of the "simple peasants of rough tongue" of which he wrote with such feeling. There is some evidence that Gonzalez called this sculpture simply a "maternité" during the time he was working on it,[12] a title which he had previously given to two of his abstract constructions. But from the time it was first exhibited in 1937 it has always been called the *Montserrat*. This apparently was the only subject of a mother and child to which Gonzalez gave this title; the other sculptures of that name are single heads, or, as in the case of the *Petite Montserrat effrayée* (**120**, cat. 125), a single figure with her hands upraised.

The series of Montserrats which Gonzalez executed between 1937 and his death in 1942 is as suggestive of the changing emotional tenor of his art as the cactus figures. While the large *Montserrat* of 1937 is a proud and rather serene peasant woman, shortly thereafter this interpretation was to yield to the lacerated and screaming visage of the *Masque de la Montserrat criant* (**119**, cat. 119). In 1938 and 1939 there are many drawings of the same subject of similar

116. (left) Gonzalez, *Maternité*, 1906. **117**. (center) Gonzalez, *Femme au nourisson*, 1929. **118**. (right) Gonzalez, *Maternité*, 1931.

emotional impact done in either a naturalistic or cubistic style. Similar screaming figures continued to appear in the drawings up until the time of his death (**122**), and two of the last sculptures, the *Tête de la Montserrat II* (**121**, cat. 128), and the *Petite Montserrat effrayée* (**120**, cat. 125) of 1942, are similar in theme, if less potent in expression.

If we accept the premise that the emotionally charged cactus figures and Montserrats of the late thirties are a direct reflection of Gonzalez's own frame of mind, the most reasonable and likely explanation of his torment and anguish is the Spanish Civil War and the European political events leading up to the Second World War.

Like Picasso and Miró, Gonzalez always maintained his identity as a Spaniard — or more properly speaking, a Catalan — although he was also capable of saying that he had "left all that behind."[13] This apparent ambivalence might be interpreted as a desire to idealize his memories of, and feelings for, his native Catalonia, undisturbed by the small realities of personal contacts. For whatever reason, Gonzalez never again returned to visit Barcelona after about 1919.[14] After 1915, when the rest of his family permanently moved to Paris, he indeed

119. Gonzalez, *Masque de la Montserrat criant*, 1937 (cat. 119).

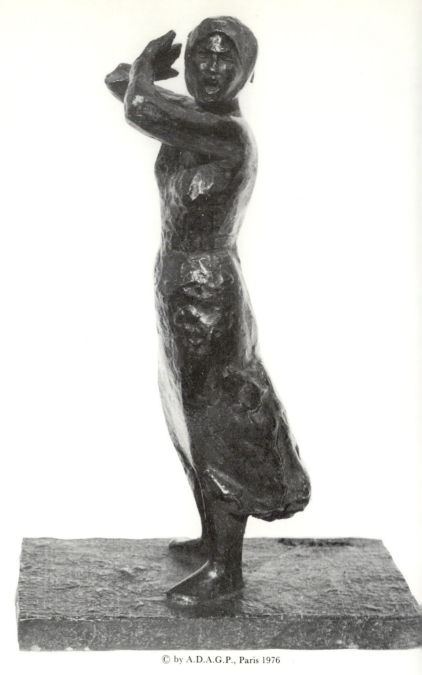

120. Gonzalez, *Petite Montserrat effrayée*, late 1941, early 1942 (cat. 125).

made his life there. His only contacts with Spain were his friends in Paris, who, like himself, had settled there more or less permanently.

At the same time, he continued to nourish nostalgic memories of Catalonia, which surfaced in a spontaneous fashion in his "Picasso sculpteur et les cathédrales." Interestingly, he made of Picasso a Catalan in order to introduce a subject which was evidently very close to his heart. Gonzalez wrote that he "can only speak of the city where he passed his youth, of its simple peasants of rough tongue, of its blue sea. He is the direct son of this land through his *heart*, through

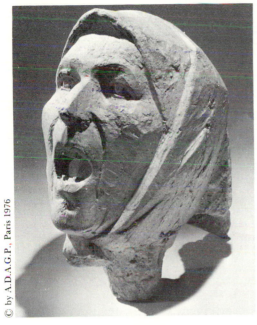

121. Gonzalez, *Tête de la Montserrat criant II*, 1942 (cat. 128).

122. Gonzalez, *Tête de la Montserrat criant*, 1938.

his *works*, and through his *direct ways of realizing them*. . . . As with his proud brothers . . . [he] laughs in order not to cry: *Like a pure Catalan*."

To the extent that Gonzalez identified himself as a Catalan, he could only have been doubly sickened at the denouement of the Civil War, for in addition to the widely condemned atrocities and brutalities inflicted on the civilian population, Gonzalez saw the progress toward an autonomous and republican Catalonia crushed by the Nationalists.

When the Republic was declared in 1931, one of the first things the constituent assembly did was to recognize Catalonia's longstanding demands for governmental autonomy. But from the beginning of the insurrection in July 1936, it was clear that the Nationalists would have no part of republican government or Catalan autonomy. It is therefore no coincidence that Barcelona proved one of the stronger centers of resistance. When Barcelona finally fell in late January of 1939, the Civil War was effectively over; isolated Madrid collapsed soon thereafter.

This situation, plus the well-known protests of his compatriots—Picasso, Miró, and Dali—about the Spanish Civil War, would seem to make the Spanish conflict an obvious explanation for the change in Gonzalez's art. Picasso's *Guernica*, Miró's *Still Life with Old Shoe* (1937), and Dali's *Soft Construction with Boiled Beans* (1936) specifically concern themselves with these artists' personal reactions of revulsion and outrage to the brutalities of the Civil War.

The Spanish Pavilion of the 1937 Paris World's Fair became a visible rallying point for Republican Spain. Picasso's *Guernica*, Miró's large and impressive mural *The Reapers*, and Gonzalez's life-size *Montserrat* all underscored the political nature of the Spanish exhibition. In contrast to the *Guernica*, Gonzalez's figure is, as we have noted, proud and serene, and in no way suggests the rage and anguish everywhere apparent in Picasso's mural. An appropriate description of the Montserrat might be the declaration which appeared on an "Aidez l'Espagne" poster by Miró: "In the present struggle I see, on the Fascist side, spent forces; on the opposite side, the people, whose boundless creative will gives Spain an impetus which will astonish the world."[15]

Considering what a long history this subject had in Gonzalez's own past (**116, 117, 118**), it may be a fortuitous coincidence that the theme and the style of the 1937 *Montserrat* have an indisputable resemblance to similar subjects in the "Socialist Realist" style. In our own day the strong and invincible peasant has become one of the most popular subjects of Soviet art, but even in the thirties it was a recognized Socialist theme. One of the leading Soviet sculptors of Gonzalez's generation whose work is broadly similar to the *Montserrat*, was Mukhina, who was, according to an official Russian publication, "among [the] leading Soviet sculptors who laid down the traditions that were later to be furthered and developed."[16] It was Mukhina's group of heroic peasant figures which was a prominent feature atop the Soviet pavilion[17] at the same world's fair where Gonzalez exhibited his *Montserrat*.

Even if the link between the two can only be made in retrospect, Gonzalez may well have been aware of the political implications of a style. At this time, after all, it was the Russians—alone among the world powers—who were making a substantial contribution to Republican Spain. The Spanish Communists too, in contrast to the fragmented Anarchists, were among the more clear-headed political groups organizing the defense of the Republic.

This could explain the enthusiastic reception of the *Montserrat* by the officials in charge of the Spanish Pavilion. Although it might seem that Gonzalez's heroic but undramatic realistic figure would have paled beside the more flamboyant and expressionist works by Picasso and Miró, in fact it was very well received and was reproduced in the official literature distributed by the government.[18]

Although the political events of 1937 were upsetting for Gonzalez, there was a good deal more harmony in his private life. In 1937 he married Marie-Thérèse Roux, his friend and companion of the past nine years, and his daughter Roberta married the painter Hans Hartung. The extended family—Gonzalez and Marie-Thérèse, Hartung and Roberta, and his sisters Lola and Pilar Gonzalez—all moved to the house in Arcueil which Gonzalez had built in 1933. For the first time since his brother's death in 1908, there was another man in the household, and there is no doubt that Gonzalez appreciated Hartung's companionship. The fact that Hartung was painting in a nonobjective style stimu-

lated many amicable, albeit heated discussions between the two men. Hartung's painter friend Henri Goetz recalls that although Gonzalez was not generally given to theoretical shop talk, he often debated passionately the issue of abstraction versus nature, arguing, of course, for the absolute necessity of retaining some reference to the figure.

From Hartung and Goetz we gain a frustratingly incomplete account of Gonzalez's interest in mathematically derived proportional systems. Goetz claims that at one time, Gonzalez, as well as Picasso and others, used the Golden Section in their work; exactly when, he is not sure.[19] In the early thirties, Gonzalez was briefly and tangentially associated with the Cercle et Carré, and later the Abstraction-Création groups. As Constructivists and abstractionists, these groups were sympathetic to proportional systems and numerical ratios as a method of determining composition and distribution of

123. (left) Gonzalez, *Femme assise II*, c. 1935 (cat. 98). **124** (center) Gonzalez, *l'Homme gothique*, 1937 (cat. 120). **125**. (right) Gonzalez, *l'Homme gothique*, 1937.

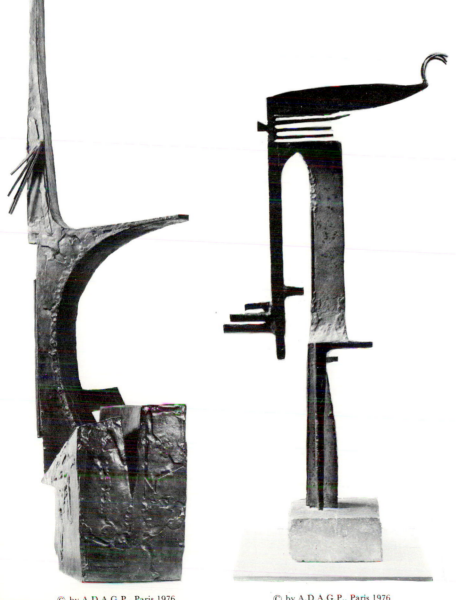

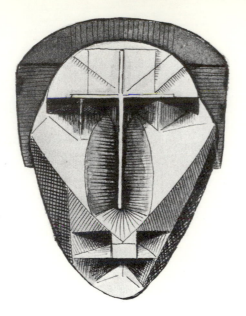

126. Gonzalez, *Abstract Self-portrait*, 1940.

elements. Gonzalez wrote in his essay of 1932 that "one will not make great art in making perfect circles and squares with the aid of compass and ruler, or in drawing one's inspiration from New York skyscrapers." This could be taken as a rejection of such theories but for his assertion that a "distortion of an optical-geometric nature" which "results from a synthesis can be both serious and beautiful. . . ." The "synthesis" he refers to is that of expression and geometry. Hans Hartung was closer to Gonzalez than Henri Goetz, yet his remarks on Gonzalez's use of numerical proportional systems do not shed a great deal more light on the subject. Possibly because it was a subject which held no great interest for himself, Hartung was only able to recall that Gonzalez was eager to explain his systems to him, but that they seemed to be both elaborate and confusing. He suggested that many of the late drawings (**126, 128**) may have been arranged according to some regulating geometry, and that their strong design may have its source in such numerical ratios.

We can only infer on the basis of their appearance those sculptures which might have been made according to some geometrical system. The interlocking arcs and right angles of both versions of the *Femme assise* (**80, 123**; cat. 97, 98) and the angular articulation of *L'Homme gothique*, dated 1937, may have been based on some such system. What is clear, however, is that much of the sculpture discussed in this chapter seems more rigorously and clearly ordered, with complications kept strictly subordinate to the overall design. The strong design of these sculptures tends to emphasize the expressive gesture of the figure. The *L'Homme gothique* (**124**, cat. 120) as well as the first version of the *L'Homme cactus* (**110**, cat. 121) appear to be constricted and boxed in, while the more flamboyant gestures of the reclining figures (**94, 96**; cat. 107, 109), and the second *L'Homme cactus* (**111**, cat. 122), constructed of interlocking reverse curves, opens up the sculpture and gives the figure a more expansive gesture.

If the series of Montserrats show a peasant woman in progressive states of

cringing terror and defeat, it can be argued that the cactus men, by contrast, express enraged defiance. The gender of Gonzalez's figure sculpture is overwhelmingly feminine, and so it is worth remarking that the cactus men stand alone with their predecessor, the Gothic standing man. Carmean has recently offered a convincing interpretation of the second cactus man as an "armed Spanish peasant," "firmly tied to the land, as the cactus . . . is rooted to the soil of Spain."

> *The* Cactus Man Number Two *remains a defiant figure, in the hands raised in a gesture of anger and in the bold upright vertical emphasis of the composition. This militancy is supported by the inclusion of the rifle leaning at the waist of the figure. . . . Attached to the end of the gun by three horizontal struts is a thick, blunt (perhaps broken?) bayonet. . . . This object, with its movement to the left and then up in a vertical passage, recalls the same path made by the arms and hands, and thus completes the gesture of defiance.*[20]

While it is true that Gonzalez's sculpture became more clearly expressionistic after 1935, it is also clear that Gonzalez continued to address himself to

127. Gonzalez, *Sculpture dite abstraite,* 1942 (cat. 129).

128. Gonzalez, *Personnage terrible II*, 1941.

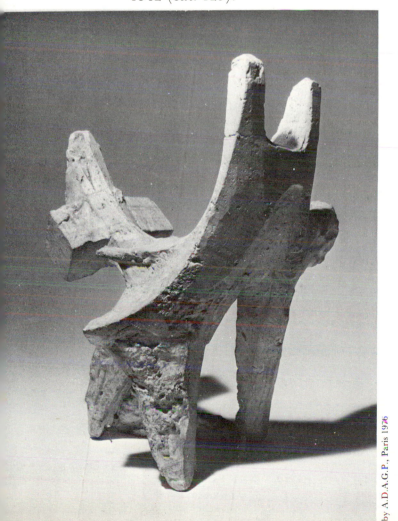

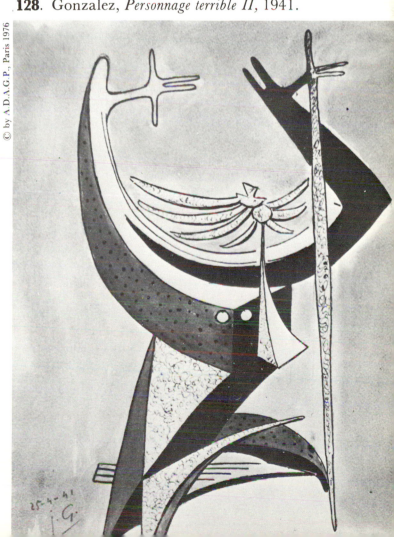

problems of form and aesthetics, as he had earlier in the decade. Gonzalez's concerns as a sculptor and an artist which he wrote down in 1932 apply equally well to his later work.

The Montserrats and the cactus figures, however, touch on larger problems and personal concerns which necessitated our discussion of these works in the context of Gonzalez's evidently pessimistic reaction to the Spanish Civil War and the Second World War. As we noted in the first chapter, Gonzalez's apparent demoralization was also reflected in the drastically diminished sculptural production of the last five years of his life. Gonzalez's great strength is as a creator of form. Our concentration on the formal and stylistic characteristics of Gonzalez's abstract constructions reflects our conviction that it is this sculpture which primarily determines Gonzalez's position in the history of twentieth-century sculpture.

NOTES

1. The texture of this stone appears of a finer grain than that of the other stone carvings. It is therefore probably of a different provenance.

2. Also spelled Monthyon. A hamlet northwest of Meaux, and some 40 km. to the east of Paris. Gonzalez bought this property about 1926, and used it as a country weekend place.

3. Liège, Nov. 29, 1933. Incomplete reference; from Gonzalez's clipping file (see Appendix II, Documentation for further information).

4. "La Donation Gonzalez au Musée National d'Art Moderne," *La Revue du Louvre*, no. 1, 1966. *Julio Gonzalez: Les Matériaux de son expression*, Paris, Galerie de France, 1969.

5. Leo Steinberg, "Month in Review," *Arts*, Vol. 30, no. 6, p. 53. This was a review of the 1956 Gonzalez exhibition at the Museum of Modern Art, the first in America. He goes on to say: "A mouth in a Gonzalez head is rendered as a tube [viz. "*Tête dite 'le pompier'*"], or a prehensile, dentured trap, depending on what the mouth thinks it is

doing. In the *Head* owned by the Museum of Modern Art, the eyes are two darting prongs, a figure so native to our sense of what sight is, that it inhabits countless metaphors of common speech. In the lovely *Woman with a Mirror* (1936) the leg-and-pelvic space is swept by a fertile shape which is both seed-pod and thigh, but more than either — the trajectory of a caress."

6. Although many artists were attracted to Duncan's dancing, we may mention the drawings of José Clara, who was a good friend of Gonzalez's, probably as far back as Barcelona days. See Clara's illustrations for Sheldon Clevey, *The Art of the Dancer: Isadora Duncan*, New York, 1928.

7. Correspondence with Mme. Craven, July 1967, who taught at this academy. She had studied with Raymond Duncan.

8. Jazz dance, which at that time was incarnated in the person of Josephine Baker, also has these qualities. An amusing and perhaps not irrelevant footnote to Gonzalez's lively stick figures is an illustrated article on jazz dance notation in *Cahiers d'art, Feuilles volantes*, Vol. 2, no. 6, 1927, pp. 4–5. See Fig. 99.

9. William Tucker, *Early Modern Sculp-*

ture, New York, 1974, p. 76.

10. Interview with Mme. Roberta Gonzalez.

11. Picasso also did a collage — the *Guitar* of 1927 — incorporating real nails with their sharp points turned outward; the effect is not unlike Gonzalez's cactus figures.

12. Interview with Mme. Gonzalez.

13. Mme. Gonzalez recalls that Gonzalez would receive letters from old Barcelona friends which he would throw away without reading, exclaiming, "I've left all that behind; my life is here."

14. There is some doubt about this visit, which would have occurred sometime soon after the war. A Barcelona cousin, Sra. Marota-Pellicer, remembers her family mentioning such a visit, and I found several drawings of that period in private collections in Barcelona, suggesting such a visit. Mme. Gonzalez, however, doubts that he left Paris at this time.

15. James Thrall Soby, *Joan Miró*, New York, 1959, p. 91.

16. *Sovetskoe Iskusstvo, 1917–1957*, Moscow, 1957, p. 18. Mukhina's work will be found in most anthologies of Soviet art, but see especially *op. cit.,* pp. 57–58 for illustration of her *Krest'anka (Peasant Woman)* of 1927, a sister of Gonzalez's figure, who stands over a bundle of wheat, her sickle placed by the side.

17. Illustration in R. Abulina, *Vera Ignat'evna Mukhina*, Moscow, 1954, (n.p.); this too will be found in many standard anthologies.

18. According to Mme. Gonzalez, Picasso complained that the *Montserrat* was "too realistic," with the result that Gonzalez requested that it be replaced with the abstract *Femme au miroir* of the same year. In a letter dated Dec. 14, 1937 (collection Mme. Gonzalez), the Commission answered, pleading that it remain in the pavilion, and assuring him that it was very popular and had already been reproduced in their literature.

19. David Smith, "Julio Gonzalez, First Master of the Torch," *Art News*, Vol. 54, no. 9, Feb. 1956, p. 65.

20. E. A. Carmean, "Cactus Man Number Two," *The Museum of Fine Arts, Houston: Bulletin*, N.S. Vol. 4, no. 3, Fall 1973, p. 43.

VI

Gonzalez and the Art of the Thirties

To this day it is impossible to fix any one stylistic label on Gonzalez's sculpture. If there is a Surrealist element in his art, there is just as surely a strong link with Constructivism. In spite of his close relationship to Picasso in the early years of the decade, it seems evident that Gonzalez did not absorb the formal syntax of his mentor and colleague, as much as he did a general idea and approach.

Gonzalez's belated career as a sculptor in welded iron was, as we have observed, catalyzed by specific historical circumstances of the late twenties, most particularly his collaboration with Picasso. In addition to this causal chain of events, there are fascinating, if somewhat more subtle, formal relationships between Gonzalez's work and that of other sculptors and painters of the thirties. It can be shown, in fact, that Gonzalez's stylistic development loosely paralleled that of a number of artists working in Paris at that time.

Lipchitz's first transparencies, which we considered in Chapter II, were open-form constructions of planar elements with perforations, like the *Homme à la mandoline* of 1925 (**129**). This type of planar construction was succeeded by compositions of ribbons, grids, and other, more linear elements (**130**). As for Picasso, there is a similar sequence, in this case beginning with his very flat and shallow paintings of 1927–28, followed by the wire cage-like constructions of 1928–29. The overall development of Gonzalez's sculpture in the late twenties and early thirties followed a similar sequence, as we have previously observed.

What, we might ask, is the significance of this sequence, and can it be considered commensurate in the work of Lipchitz, Picasso, and Gonzalez? On two different occasions, Gonzalez described Picasso's constructed relief sculptures in cardboard, and later in metal sheets, as growing directly out of his Cubist paintings; as he described it, they were a solution to certain pictorial problems

100

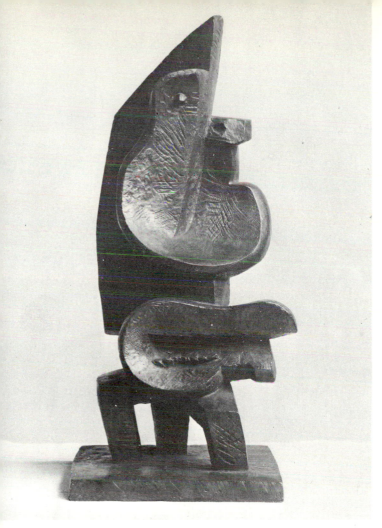

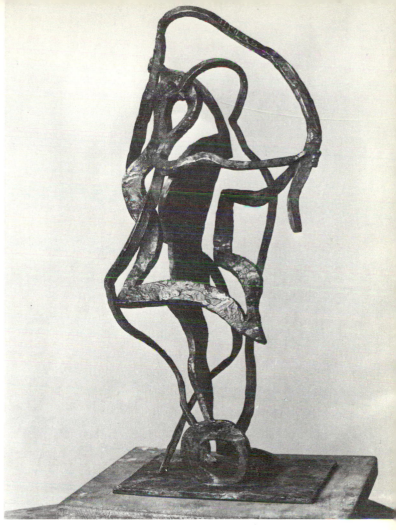

129. Lipchitz, *l'Homme à la mandoline*, 1925.

130. Lipchitz, *Acrobat on a Ball*, 1926.

indigenous to his painting of that time. This is what Gonzalez wrote about the early reliefs in his "Picasso sculpteur" of 1936:

> *In 1908, at the time of his first Cubist paintings, Picasso gave us form not as a silhouette, not as a projection of the object, but by putting planes, syntheses, and the cube of these in relief, as in a "construction." With these paintings, Picasso told me, it is only necessary to cut them out — the colors are only the indications of different perspectives, of planes inclined from one side or another — then assemble them according to the indications given by the color, in order to find oneself in the presence of a "Sculpture." The vanished painting would hardly be missed. He was so convinced of it that he executed several sculptures with perfect success.*[1]

And in his earlier essay, "Picasso sculpteur et les cathédrales," Gonzalez wrote:

> *1911: Later on, perhaps unconsciously, in order to give air to his paintings, it occurs to him to execute these [paintings] separately with cutout papers. . . .*

Julio Gonzalez: Sculpture in Iron

He contrives to make little boxes out of cardboard [which are] joined together with string. . . .

After this . . . he makes his first [constructions in] sheet metal.

To the extent that Gonzalez's constructions of about 1929 to 1931 are conceptually analogous to Picasso's earlier reliefs, these observations are also applicable to his own work. In the chapter dealing with this period, we observed that a sculpture such as the *Nature morte II* (**30**, cat. 21) of 1929 is essentially a picture, since the technique of *découpage* is not used for the sculptural purpose of giving depth to the different planes. Rather, it is used for the pictorial purpose of circumscribing each form with an edge, creating little displacement in depth of the separate cutout planes. It is a small but significant distance between this and the heads and masks of about 1930. These heads are real sculptures, albeit in relief: they are intended to be seen from one point of view; they are composed of flat planes generally parallel or perpendicular to an imaginary ground. This much they have in common with Picasso's reliefs of 1912 to 1914, and they are the type of sculpture to which Gonzalez's preceding statements are most applicable.

In this connection, we should note that this type of constructed relief sculpture, which seems to have been so attractive to Gonzalez, judging by his own work and his comments in his essay of 1932, was not unique to Picasso. Henri Laurens also created a great many constructed polychromed reliefs in a variety of materials, between about 1915 and 1920. Although they seem to have dropped from public view soon after, they once again drew critical attention in the late twenties. In 1927 Laurens' sculpture was represented, in an article and in the first contemporary sculpture show at the Bernheim Gallery, by his carved polychromed bas-reliefs (not unlike those of Lipchitz dating to the early twenties) and modeled sculpture.[2] By 1929, however, the second Bernheim sculpture show included the earlier constructed reliefs, and in 1930 *Cahiers d'art* published no less than nineteen full-page illustrations of these interesting pieces.

Sooner or later, Gonzalez probably saw Laurens' constructions, possibly in the collection of his friend Maurice Raynal, who owned such a piece.[3] It was Raynal who wrote a foreword for Gonzalez's exhibition at the Galerie Percier in 1934, and Raynal also owned one of Gonzalez's early sculptures (**36**, cat. 48).

Returning to our discussion of Gonzalez's notes on Picasso's sculpture, we find that Gonzalez again pointed out the closeness between Picasso's painting and sculpture when he returned to sculpture in the late twenties:

These essential lines, these tracings *of paint on the canvas, purely sculptural in conception and realization, will one day be replaced by Picasso with iron bars which he will take and arrange in such a way as to interpret the subject of one of his paintings. . . .*

Picasso, then, realized his most cherished dream, *that by this* incomplete art, *this attribute might be seen from all sides.*

As Gonzalez described it then, Picasso's painting and sculpture were linked at two different points in his career.

The relationship between the sculpture and the painting of these two periods had, however, shifted. In the earlier instance, Picasso's constructed reliefs are not only an extension of his painting, but they are a resolution of what was conceived of as a pictorial problem. In the later case, this is not so. In other words, that Picasso "replaced essential lines on the canvas with iron bars" is not to say that the wire cage constructions were pictorially conceived, for they were not. As Gonzalez went on to point out, one of the principal advantages of these constructions was they they could be seen from all sides.

The nature of this difference is also clear in the case of Lipchitz's transparencies. From the way in which Lipchitz described their genesis, claiming them to be a liberation from Cubism, one gathers that he regarded the transparencies as a significant departure from his previous work. Lipchitz's sculpture of the early twenties, the period preceding his transparencies, is massive and dense, and was frequently carved in stone. Many of the stone sculptures are polychromed bas-reliefs and come even closer to being a flat painted surface than do Picasso's "pictorial" reliefs of 1912 and 1914. It was this type of dense and compacted sculpture which apparently represented the "imprisonment of Cubism" from which Lipchitz wished to "escape."

While Gonzalez continued his open-form linear sculpture well into the thirties, in the early years of the decade both Picasso and Lipchitz completely turned away from this type of sculpture. At this time, Lipchitz created a baroque and rather ponderous style with a classical and mythological subject which contrasts radically with the delicate and abstract transparencies. Picasso, as we have seen in an earlier chapter, made an about-face soon after completing the *Femme au jardin*. After the massively modeled sculptures of 1932 he did little sculpture of any sort, and made no major pieces until well into the 1940s.

The single sculptor working in Paris during the twenties and thirties who is of continuous interest for Gonzalez is Giacometti. There are not only interesting visual analogies in their work, but also a close parallel in the timing and sequence of their stylistic development.

Although Giacometti was twenty-five years Gonzalez's junior, he was, as with Calder, his artistic contemporary: both were second-generation Cubists beginning their careers in the late twenties.

The majority of Giacometti's sculptures done between 1926 and 1929 are subtly modulated flat reliefs such as the *Woman* of 1927–28 (**131**) and the series of flat "heads" of 1926–28. These were succeeded by the two-dimensional linear sculptures such as the *Femme couchée qui rêve* and the *Three Personages Outdoors*, both of 1929,[4] which seem almost a prelude to the many cage constructions and other linear, three-dimensional sculptures of the early thirties, of which *The Palace at 4 A.M.* (**133**) of 1932–33 is perhaps the best known. The

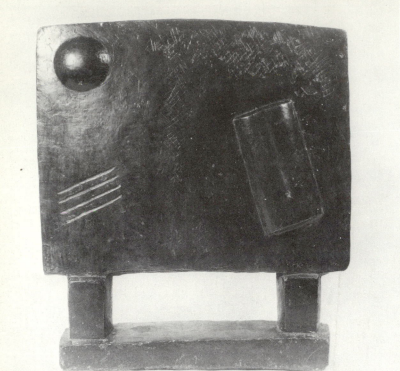

131. Giacometti, *Woman*, 1927–1928.

two-dimensional linear sculptures were first exhibited in 1929[5] and again in 1930 in an exhibition with Arp and Miró.[6] Of even greater interest for its possible effect on Gonzalez was the exhibition and illustration at the end of 1932, of what Giacometti called his "affective sculptures": these included the maquette for *The Palace at 4 A.M.* as well as other constructed cage sculptures.[7]

Giacometti's intention to create a sculpture of space, similar in this respect to Gonzalez's filiform constructions, is confirmed in subsequent statements. "Figures were never for me a compact mass but like a transparent construction," a kind of "skeleton in space."[8] As Bucarelli has suggested, it was with a Cubist aesthetic that Giacometti hoped to find a plastic space with the same substantive properties as the figure, so that the figure would neither interfere with, nor oppose, the space around it.[9] Giacometti has also written, "It is space that one hollows out in order to construct the object; in its turn the object creates a space."[10]

Many of Giacometti's "skeletal" figures and objects of the early thirties are further related to Gonzalez's sculpture in their methods of composition. In Giacometti's *Projet pour un passage* (**132**) and *Jone* of 1930, and *Femme angoissée dans une chambre de nuit* of 1932,[11] there is a certain angular, disjointed quality, one might even say a wilful awkwardness in the linkage of forms which calls to mind such Gonzalez sculptures as the *Rêve* (**40**, cat. 54), the *Grande trompette* (**42**, cat. 56) of 1932, or even the late *Femme au miroir* (**109**, cat. 117) of 1937. Almost all Giacometti's sculptures from about 1930 to 1934 — the so-called "Surrealist objects" — were constructed and assembled rather than modeled.

Towards the end of 1934 there was a radical change in Giacometti's sculpture which was signaled by several related events. In the late twenties Giacometti

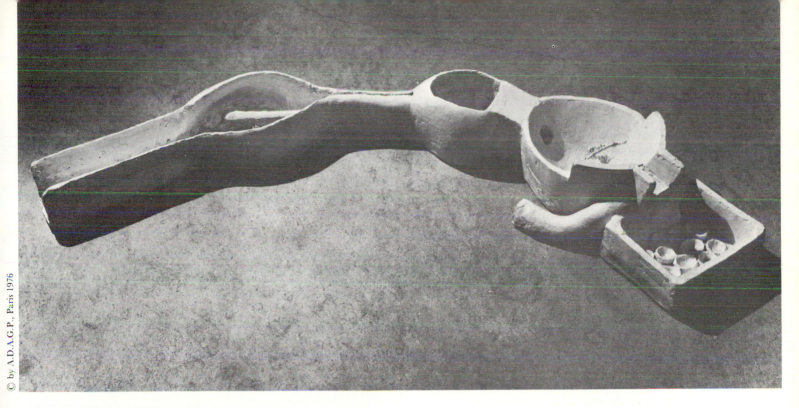

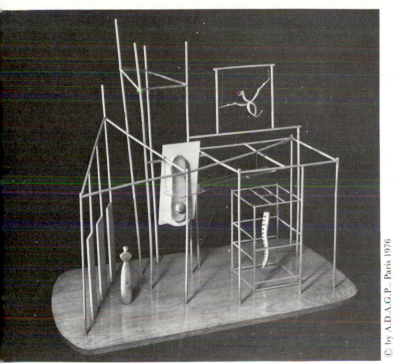

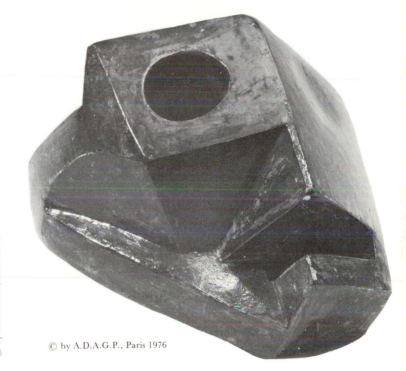

132. (top) Giacometti, *Projet pour un passage*, 1930. **133**. (bottom left) Giacometti, *The Palace at 4 A.M.*, 1932–1933. **134**. (bottom right) Giacometti, *Head*, 1934–1935.

had deliberately discontinued his use of the model, but in 1935 he once again returned to drawing after nature. This change in method was accompanied by a return to modeling in plaster, rather than assemblage, and a style which was cubic and close-form. It was this return to nature which eventually caused his sculpture to become progressively smaller. "Wanting to create from memory what I had seen, to my terror the sculptures became smaller and smaller."[12] To the Surrealists, this return to nature seemed an apostasy, and he was expelled from their group. While Giacometti did not produce much sculpture from about 1935 until well into the forties, it was a period of intense work and gestation which eventually led to his mature postwar sculptural style.

Some of Giacometti's cubic heads and figures of 1934 and 1935, for example the *Head* (**134**), are very close to Gonzalez's faceted, cubic works of 1935, particularly the *Tête couchée, petite* (**89**, cat. 101) and the *Petit masque argent* (**91**, cat. 100), but also the *Petite femme assise* (cat. 99) and even the *Petite danseuse* (**101**, cat. 91). Furthermore, Giacometti's pieces were illustrated and exhibited at about the time that Gonzalez began these sculptures. Giacometti first exhibited his new style of faceted sculptures in late 1934, and again in early 1935 in Zurich and Lucerne in exhibitions which also featured Gonzalez's work.[13] For this, if for no other reason, Gonzalez would have been sure to see the catalogues; he would have seen one of Giacometti's first cubic sculptures, *Partie d'une sculpture*, illustrated in the Lucerne catalogue, and possibly the *Head* (**134**) illustrated concurrently in *Cahiers d'art*.[14]

As we have already related, Giacometti considered his modeled cubic sculpture of 1934 and after, as a return to nature and the model. While this is not strictly true of Gonzalez, the configuration of his abstract "signs" was at that same time — about 1935 — becoming more readable in terms of the image.

The formal and aesthetic concerns which Gonzalez and Giacometti share are to some extent thrown into relief by the very difference in the general tenor and expressive quality of their work. Giacometti's Surrealist objects and cage constructions of 1932–34, while having many visual and formal similarities with Gonzalez's filiform constructions of 1933–35, are not at all the neutral or gently humorous subjects characteristic of Gonzalez's work, but are, rather, disquieting, and often suggestive of violence and sexual aggression.

Of the leading sculptors working in Paris in the twenties and thirties, Giacometti comes close enough in style and chronological development to Gonzalez as to suggest a possible influence. The work of Brancusi, Arp, and Calder is also important for Gonzalez, but is more tangential, indicating a community of aesthetic and artistic intention.

We have previously related that Gonzalez was on close terms with Brancusi and that Gonzalez's many inclined heads in stone and metal suggest Brancusi as a source. The other parallels between Brancusi's and Gonzalez's visually dissimilar work are sufficiently generalized as to suggest not a causal relationship but simply a parallel and more or less independent development.

Sidney Geist has remarked that Brancusi's highly polished surfaces were his "ultimate invention."[15] Brancusi with his polished bronzes, and Gonzalez with his linear constructions, used entirely different methods to create light, transparent sculpture. Brancusi could break down the barrier between the solid object and its ambient space, as well as circumvent any sensation of static and fixed location by polishing his bronzes to reflecting brilliance, or by occasionally placing a mirror beneath the sculpture, or in two cases, by setting the sculpture on a rotating base.[16]

Brancusi remarked that he wanted to get away from heavily loaded sculpture, and create "winged and liberating beings."[17] By freeing sculpture of its gross materiality, he wished it to enter into a more universal realm.[18] His attitude toward sculpture as an abstract and universal symbol, freed from material bonds, is revealed in his original title for *Bird in Flight*, which was "L'Oiseau, projet devant être aggrandi pour remplir la voûte du ciel."[19]

The sculpture of Jean Arp is related to that of Gonzalez in much the same way as is Brancusi's. The relationship exists on the level of general ideas and intentions, rather than that of visual or stylistic characteristics. About 1930, Arp's sculpture blossomed from the flat cutout reliefs which he had done with few significant variations for the past fifteen years, to the three-dimensional organic "concretions" which have typified his work since then. The timing of this important change to a more fluid and decidedly three-dimensional sculpture is probably commensurate with Lipchitz's and Gonzalez's shift from flat, planar reliefs to three-dimensional open-form sculpture. While the superficial aspects of Arp's concretions do not resemble Gonzalez's constructions, some of them, for example, the *Concrétion humaine* of 1936 (**135, 136**), incorporate discontinuous views and ambiguous articulations characteristic of such Gonzalez sculptures as the *Grande trompette* or the *Rêve* of 1932.

Arp's concretions are neither transparent nor open-form, yet he too saw spaces and voids as an integral part of his sculpture. In a poem of 1936, the same year as the *Concrétion humaine*, he wrote of the "empty spaces" as casting "audible shadows into the visible."

Larger and larger grew the empty spaces in the marble nests
and when at last they were full grown
they were fragrant flowers
and were plucked by costumes overladen with gold
the costumes carried them to the rose-red births
that lay on serpentine ways
and transparent serpents
and cast audible shadows into the visible world.[20]

While it is fair to say that Brancusi's and Arp's relationships to Gonzalez were parallel but essentially independent, it is more difficult to assess Gonzalez's

107

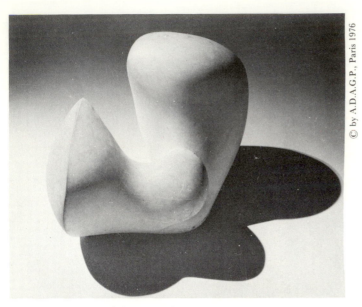

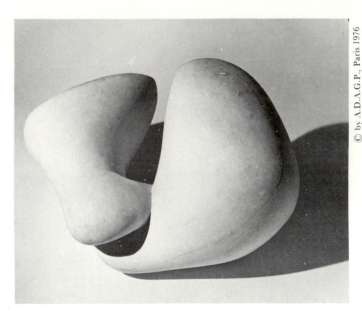

135. Arp, *Human Concretion*, 1935.

136. Arp, *Human Concretion*. Alternate view of Fig. 135.

relationship to Calder. especially since there are the specific visual analogies which are generally lacking in the case of Arp and Brancusi. Their most obvious similarity — open linear sculptures in metal — led them both to an extreme economy of means and a spare, unadorned style. On the other hand, Gonzalez remained firmly committed to representation; even if it appears as a minimal element in the sculpture, it is nevertheless basic to his art, and immediately separates him from Calder. Although he began in a figurative style (**15**), in the 1930s Calder by and large accepted the total abstraction which was an integral part of the Constructivist and Neoplastic aesthetic he initially absorbed from Mondrian.

Gonzalez's and Calder's paths crossed too many times in the early thirties for them not to have been familiar with what the other was doing. They had friends in common, including Léger, Varèse, and Miró, and they were both associated — albeit briefly — with the Abstraction-Création group. As early as 1931, when Calder and Gonzalez exhibited in the Surindépendants, they were, not surprisingly, paired off by critics reviewing the salon.[21]

It was here that Calder exhibited his first abstract constructions, suggestively titled "Espaces, Vecteurs, Densités."[22] Léger wrote of these sculptures, "Before these new works — transparent, objective, exact — I think of Satie, of Mondrian, Marcel Duchamp, Brancusi, Arp, those uncontested masters of inexpressible and silent beauty."[23]

Calder's new departure was in part inspired by his well-documented visit to

Mondrian's studio in 1930.[24] But if Mondrian considered the vertical and horizontal, and the resultant rectangle, as the ultimate expression of universal form, Calder almost immediately thought in terms of the circle and sphere: "a sphere is one of the most elementary shapes . . . like drops of water."[25] At first it was the sphere itself, formed by intersecting hoops, and soon after, with the motorized and free-moving mobiles, it was an object describing the path of a circle, an ellipse, or other closed circuits. This direction of his work is suggested in Calder's subsequent statement: "The underlying sense of form in my work has been the system of the universe. The ideal source of form is the idea of detached bodies floating in space, of different sizes and densities, perhaps of different colors and temperatures."[26]

If the polished surface was Brancusi's "ultimate invention," the freely moving mobile was certainly Calder's. The most distinctive characteristics of his style are largely summed up in the unpredictable and continuous motion of his mobiles. Yet what he achieves with these mobiles is still within the aesthetic which informed the work of Gonzalez, Brancusi, Arp, and Giacometti.

Roberta Gonzalez recounts that her father particularly liked the painting of Miró and Léger, in addition to that of Picasso and Braque, and that they were all close in spirit to his own work.[27] Judging by his sculpture, the qualities in Miró's painting which he may have especially appreciated were Miró's fantasy and humor, his mastery of line, and his consummate skill in suggesting forms, mysterious creatures, and ambiguously defined spatial depths with a minimum of means. In Gonzalez's insectlike creatures such as *L'Ange* (**74**, cat. 94) and the Stockholm *Femme se coiffant* (**55**, cat. 86), the vibrating tendrils, antennalike hairs, and stalk eyes are strongly reminiscent of similar configurations in such Miró paintings as the *Harlequin's Carnival* of 1924–25 or *Catalan Landscape* of 1923–24, the so-called "Ingres" series of 1931–33 or the *Drawing Collage* of 1933. Although Miró's painterly line is, with few exceptions,[28] always more tenuous and spontaneous than Gonzalez's rather strictly organized linear constructions, they both used line as a constructive element of the composition. In Miró's *Painting* of 1925 (**137**), as in Gonzalez's *Maternité* (**66**, cat. 83) of 1934, line is used simultaneously as an enclosing contour, as description of form itself—in this case an arm and a hand—and as a device giving movement to the composition.

Although the style of Miró's painting shifted frequently in the late twenties and the thirties, one of the most important changes came in 1934. Previous to this, most of his paintings had been characterized by flat transparent forms and delicate meandering lines on a neutral ground, not dissimilar, in this respect, to Picasso's painting of the late twenties. In 1934 the paintings became more dense and opaque with strongly modeled forms and bulbous metamorphic creatures. Dupin has observed that "The very excess of modelling recreates a kind of prison around these figures, which pure color and flat treatment [of the earlier painting] had just liberated them from." He also notes that "the use

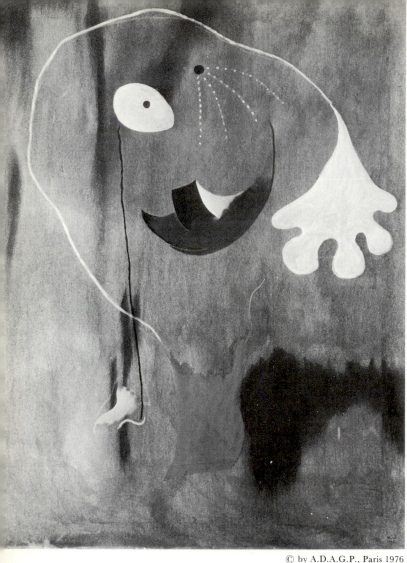

137. Miró, *Painting*, 1925.

of modelling and chiaroscuro here is closely related to the new dramatic note in expression and to its erotic undertone."[29]

There is, as yet, no adequate explanation of this dramatic shift in the style and tenor of Miró's work. That many of these pulpy, garishly colored creatures are unpleasant and sinister-looking — the *Head of a Man* of January 1935 (**138**) is such a one — has led Dupin to a hypothesis connecting this change with the approaching European holocaust. He first points out that there is nothing in Miró's private life to explain this change in his art,[30] and suggests as an explanation of the appearance of these images as early as 1934 that they were a prefiguration. "It is as though the Spanish tragedy and the Second World War as well — with all its horrors — broke out first in the works of this Catalan artist, long before the conflagration broke out in his own country, to spread from there to the rest of the world."[31]

Miró's expressionistic, emphatically modeled metamorphic creatures such as the *Head* of 1935, the *Figure in a State of Metamorphosis* of 1936, or the *Seated Personages* of 1936 may have been prototypes for Gonzalez's metamorphic figures of the later thirties. Although the mood is entirely different, their forms are not far removed from Gonzalez's *Reclining Figure* of 1936 (**94**, cat. 107). The

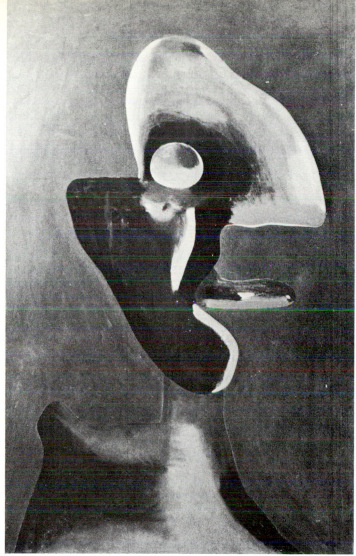

138. Miró, *Head of a Man,* January 2, 1935.

later cactus figures (**110**, **111**; cat. 121, 122), however, come even closer to Miró's inventions in both form and expressive mood. For both artists, this shift to a metamorphic expressive style was accompanied by a change toward a more coherent and "readable" image and away from the free-floating scattered constellations of motifs characteristic of their work in the early thirties.

We previously remarked that Gonzalez is said to have especially liked the painting of Miró and Léger. The common elements linking Miró and Gonzalez lie particularly in the realm of the mood or feeling generated by their works and their use of biomorphic abstraction. With Léger one finds more specific formal analogies and progressions not unlike those which we observed with Giacometti. Their most compelling similarities are on the level of formal devices, rather than expressive feeling as with Miró.

If the paintings of scattered motifs and free-floating images appear intuitive and spontaneous with Miró, it seems to have been a deliberate program with Léger. He even invented a term, "objets dans l'espace," to loosely designate paintings such as the "key" series of the late twenties and early thirties — the *Mona Lisa aux clés* of 1930 (**139**) and *Composition au parapluie* of 1932 are examples.

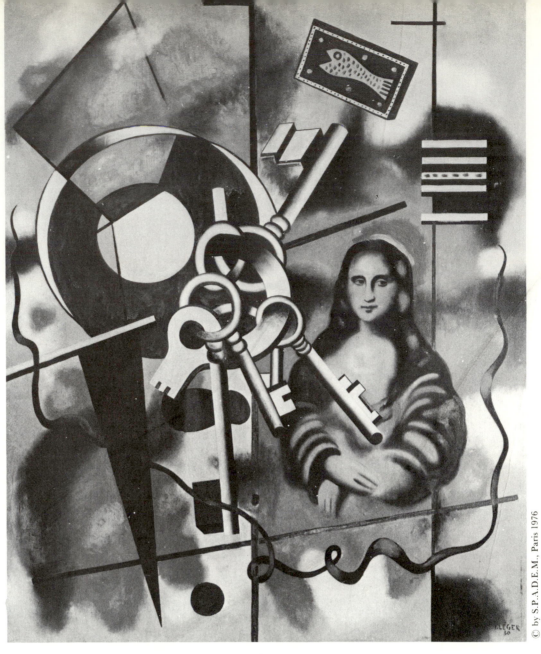

139. Léger, *Mona Lisa aux clés*, 1930.

Although Léger's paintings have no specific formal links with any particular Gonzalez sculpture, they achieve many of the same effects of scattered, dispersed compositions having no focal point which we have remarked in Gonzalez's work, and in that of Giacometti, Arp, and Miró. This type of composition is the more remarkable in Léger's paintings in that it was preceded by the tightly organized, compacted compositions in his Purist style in which all the elements were ordered on vertical-horizontal axes. Both its nature and timing immediately suggest that this dramatic change is analogous to that of Lipchitz, Giacometti, Arp, and Gonzalez.

Whether Gonzalez was close enough to Léger to have been invited to his

studio is not known. He would, in any case, have had ample opportunity to see Léger's "objets dans l'espace," since they received as much critical attention as did Lipchitz's transparencies. The first exhibition of these new paintings appears to have been in March 1928 at the Galerie de l'Effort Moderne. Eight of them were illustrated in *Cahiers d'art* preceding, it might be remarked, illustrations of Lipchitz's transparencies. That the new paintings were in the nature of a deliberate "program" on Léger's part, is reflected in Tériade's article accompanying the illustrations in which he states:

> *The extreme centralization which used to characterize the compositions of Léger, collaboration of both homogeneous and contrasting elements, grouped in an architecturally enclosed order, had of necessity to lead the painter to react against his own impulse: to change direction.*
>
> *Dissociation, dispersion, distribution, words which fit the situation. An almost musical moment, where the painter, breaking the constructed equilibrium of his elements, seeks to keep the feeling of this equilibrium by means of connections and rhythmic allusions of these same elements, although more spread out on the canvas.*[32]

In 1929 these paintings were again featured in *Cahiers d'art* in an article by Zervos entitled "Fernand Léger et le développement de sa conception des objets dans l'espace," accompanied by nine illustrations.[33] In the same "Peintres et sculpteurs nouveaux" series which had recently published Vitrac's study of Lipchitz's transparencies, Waldemar George wrote a justification of Léger's new departure as the "destruction of the subject."[34]

In 1930 Léger's paintings were again shown, this time in an exhibition of "Recent Paintings" at the Rosenberg Gallery which was extensively reviewed in *Cahiers d'art* and *Documents*.[35] A long article with nineteen illustrations of these paintings appeared in the serial article, "De l'importance de l'objet dans la peinture d'aujourd'hui (IV)."[36] In 1933 they were again featured in a special issue of *Cahiers d'art* which coincided with his large retrospective exhibition in Zurich.

In 1933 Léger painted the *Composition aux deux profils*, prophetic of a second important stylistic change which was fully manifest by 1935. Although the *Deux profils* is still composed of free-floating elements on a neutral ground, those forms are given new volume definition, not by using chiaroscuro, as was the case with his figures of the early twenties, but by using sharply defined colored planes. The faceted sunburst element of the right side of this picture is particularly indicative of this new departure in Léger's art. By 1935 and for many years thereafter, such stubby silhouetted forms with square-cut edges were broadly characteristic of Léger's painting. This change in Léger's painting seems to have come at the same moment Giacometti was making a similar shift, and just before Gonzalez moved away from his filiform sculpture. The similarities in their later style are particularly impressive in the case of Gonzalez's *L'Homme*

140. (left) Léger, *Eléments sur fond bleu*, 1941. **141**. (right) Léger, *La Branche*, 1952.

cactus I (**110**, cat. 121) and Léger's *Eléments sur fond bleu* of 1941 (**140**). Shortly after the Second World War, Léger translated the stubby, square-edged forms of this and other paintings into sculpture (**141**). While the evidence is lacking, it is possible that Léger saw Gonzalez's sculpture and appreciated the logic of re-creating the ideas expressed in his painting in sculptural form.

It is fitting that we should conclude this chapter by returning once again to Picasso, whose personality and artistic ideas had been so important for Gonzalez's development.

In 1936 Gonzalez published a short essay, "Picasso sculpteur," in *Cahiers d'art*. It is an affectionate eulogy, demonstrating that Gonzalez's admiration for his friend and colleague remained undiminished. "It gives me great pleasure to speak of Picasso as a sculptor," he wrote. "I have always considered him a 'man of form,' because by nature he has the spirit of form." After making some

142. Picasso, *Dream and Lie of Franco*, 1937.

observations on the Cubist reliefs and *Monument to Apollinaire* similar to those in his essay of 1932, Gonzalez continues: "I have observed many times that there is no form which leaves him indifferent. He looks at everything, on all sides, because all forms represent something to him; and he sees everything as sculpture." He concluded, "To my mind, the mysterious side, the nerve center, so to speak, is in his formal power."

Although Gonzalez may have continued to see form as the essential ingredient in Picasso's art, it was, as a matter of fact, a less urgent concern in his art of the thirties than it had previously been. We have already observed that after 1933, sculpture ceased to have as important an attraction for Picasso as it had during the past five years. Although his paintings after 1932 continued to be varied and rich in formal inventions, his most important innovations were not in the realm of formal language, but rather in that of iconography and imagery. Beginning in 1927 with the *Vollard Suite* and culminating in 1937 with the *Guernica*,

variations on the theme of the sculptor and his model, the drama of the Minotaur, and the bullfight had a primary place in Picasso's art. Graphic media, particularly drawing and etching, seemed to have been particularly congenial to Picasso's re-creations of these themes.

In our discussion of Gonzalez's sculpture done in the period he was working with Picasso, we observed that even when close comparisons can be made between works by Gonzalez and Picasso, there remain fundamental differences in the way these two artists used abstract form, and in the expressive tenor of their work. As an example of the latter distinction, we compared the demonic and anguished expression of Picasso's *Harlequin* with the humorous lyricism of Gonzalez's sculpture of the same title.

Even as Gonzalez's sculpture became more expressive and incorporated metamorphic imagery, its relationship to Picasso's painting and graphic work remained constant. A comparison of Gonzalez's sculpture and drawings of cactus figures (**112, 114**) with Picasso's *The Dream and Lie of Franco* (**142**), done between January and June of 1937, and many of the drawings of weeping women done during and immediately after his work on *Guernica*, finished in May 1937, is particularly arresting. The hairy tuber-head representing Franco in the *Dream and Lie*, and the spiky hair and eyelashes, the grotesque expressions, and upturned heads of the weeping women are all strongly reminiscent of Gonzalez's cactus figures. As with Gonzalez's cactus figures and the screaming *Montserrat*, the weeping or screaming figure is an important motif in Picasso's work, particularly in 1937. Although one can find a common source for Gonzalez's and Picasso's tortured and screaming figures in their reaction to the Spanish Civil War, it is probable that Gonzalez looked to his friend and mentor in finding the precise form this expression might take.

NOTES

1. Gonzalez, "Picasso sculpteur," *Cahiers d'art*, 1936, p. 189.

2. See installation view of the exhibition in "Première exposition annuelle d'un groupe de sculpteurs," *Cahiers d'art, Feuilles volantes*, Vol. 2, no. 10, 1927.

3. From Zervos, "Les 'Constructions' de Laurens (1915–1918)," *Cahiers d'art*, Vol. 5, 1930, p. 181. Laurens' construction, illustrated here, is *La Guitare*.

4. Rubin suggests that the flat, modeled reliefs and the two-dimensional linear sculptures were influenced by Brancusi and Lipchitz, respectively (William Rubin, *Dada and Surrealist Art*, New York, 1968, p. 250).

5. The previously mentioned *Femme couchée, Three Personages*, and other "linear" sculptures were first exhibited at the Galerie Pierre in 1929, and illustrated in Michel Leiris, "Alberto Giacometti," *Documents*, Vol. 1, 1929, pp. 209–14.

6. This exhibition was also held at the Galerie Pierre.

7. The exhibition was held at the Galerie Pierre Colle. The maquette for the *Palace* was illustrated in Christian Zervos, "Quelques notes sur les sculptures de Giacometti," *Cahiers d'art*, Vol. 7, 1932, p. 342. The finished version was illustrated in *Minotaure*, no. 3–4, 1933, p. 46.

8. From a letter addressed to Pierre Matisse, published in *Alberto Giacometti, Ex-*

hibition of Sculptures, New York, 1948, p. 36.

9. Palma Bucarelli, *Giacometti*, Rome, 1962, p. 18.

10. Ernst Scheidegger, ed., *Alberto Giacometti: Schriften*, Zurich, 1958, p. 8.

11. Both the *Projet pour un passage* and the *Femme angoissée* were illustrated in *Cahiers d'art*, Vol. 7, 1932, p. 339.

12. New York, Pierre Matisse gallery, *Alberto Giacometti, Exhibition of Sculptures*, 1948, p. 44.

13. Both Gonzalez and Giacometti were chosen for the exhibitions "Was ist Surrealismus?" at the Kunsthaus in Zurich in 1934, and in "Thèse, antithèse, synthèse" at the Kunstmuseum in Lucerne in 1935.

14. Giacometti's other entries were two heads in plaster, one of which was probably that illustrated in *Cahiers d'art*, Vol. 10, 1935, p. 19. Gonzalez was associated with the Cahiers d'Art gallery at this time and certainly saw the magazine regularly.

15. Sydney Geist, *Brancusi*, New York, 1968, p. 155.

16. Brancusi's *Leda* is an example of the mirror-based sculpture. Pointed out by Susi Block, *The Early Works of Alberto Giacometti: The Development of the Tableau-object*, unpublished Master's Thesis, N.Y.U., 1963, p. 13. The *Seal* (1936) is set on a circular base which is activated by a concealed motor.

17. "Je ne vais pourtant pas représenter de lourds portefaix, mais des êtres ailés et libérateurs" (Carola Giedion-Welcker, *Brancusi*, Neuchâtel, 1958, p. 196).

18. Compare this with Gonzalez's equating imagined and nonmaterial forms with the spiritual.

19. Giedion-Welcker, *Brancusi*, p. 196.

20. First verse of "muscheln und schirme," Meudon, 1936. Published in *On My Way*, New York, 1948, pp. 14–15. Marcel Jean, friend and historian of the Surrealists, remarked that "Arp . . . reconnaît que c'est à l'époque surréaliste que ses écrits poétiques et son écriture plastique 'se rejoignent le plus'" (in preface to Arp, *Jours éffeuillés*, Paris, 1966, p. 15).

21. See, for example, Tériade, in *L'Intransigeant*, Oct. 26, 1931. Of the sculptors, he singles out Gonzalez ("un style nerveux et d'un métier élégant") and Calder ("constructions spirituelles").

22. Exhibited first in May 1931 at the Galerie Percier, and later that year at the Surindépendants.

23. Foreword to the catalogue of the above-mentioned exhibition at the Percier.

24. Calder's version of this visit is widely quoted, but seems to have been first published in Myfanwy Evans, ed., *The Painter's Object*, London, 1937.

25. Quoted by Bernice Rose, *A Salute to Alexander Calder*, New York, 1969, p. 12.

26. James Johnson Sweeney, *Alexander Calder*, New York, 1951, p. 8.

27. The context of this remark was in answer to my question concerning Gonzalez's affiliations with the abstract artists of the thirties. Her reply was as follows: "Il ne partageait pas les mêmes idées que ce groupe [Cercle et Carré] mais il l'intéressait dans la mesure où ce milieu apportait quelque chose de nouveau à l'art—les artistes que mon père a le plus admirés avaient toujours été Picasso, Braque, Léger, Miró, plus prôches de son esprit" (questionnaire addressed to Mme. Gonzalez, Fall 1966).

28. The geometrical compositions of the "Ingres" series are an important exception. In this connection, Dupin has remarked, "Pictorial axes govern the course even of the slanting lines and movements of curves. We might also mention a certain suggestion of wire in these works—a hint of sculpture in wire—and how it brings space to life by imprisoning it in a cage. The deliberate rigidity of the line is counteracted by a kind of flexible pulsation of the entire space underneath. . . ." (Jacques Dupin, *Miró*, New York, 1962, p. 246).

29. Dupin, *Miró*, p. 265.

30. Dupin, *Miró*, p. 262.

31. Dupin, *Miró*, p. 264.

32. Tériade, "Oeuvres récentes de Léger: Les Objets dans l'espace," *Cahiers d'art*, Vol. 3, 1928, p. 145.

33. Zervos, "Fernand Léger et le développement de sa conception des objets dans l'espace," *Cahiers d'art*, Vol. 4, 1929, pp.

149–58.

34. Waldemar George, *Fernand Léger*, Paris, 1929, p. 7.

35. "Fernand Léger (Galerie Paul Rosenberg)," *Cahiers d'art*, Vol. 5, 1930, p. 550. G. Reusel, "Exposition Léger à la Galerie Paul Rosenberg," *Documents*, Vol. 2, 1930, pp. 439–40.

36. Written by Zervos, *Cahiers d'art*, Vol. 5, 1930, pp. 343–54.

VII

Gonzalez's Personal Synthesis

It was the purpose of the last chapter to establish the ways in which Gonzalez's art paralleled that of other sculptors and painters of the thirties. At that point, the emphasis was placed on qualities in his sculpture which resembled those of his colleagues, rather than those which distinguished his sculpture from the rest. To the extent that Gonzalez's sculpture had many things in common with the art of the thirties, he was a man of his time. What most clearly distinguishes Gonzalez's work is his technical handling of his metals, and his personal attitude toward abstraction.[1]

From our present vantage point, direct metal sculpture seems truly a protean medium. Although hard and durable, metals are among the most ductile and versatile of materials. They can be cut, forged, welded, or cast; because of their tensile strength, they set almost no limitations of form; and their surfaces can be corroded with acids, brazed, or burnished to glassy smoothness. The full potential of this adaptable medium has, however, only been realized since the Second World War. The increasingly varied and sophisticated techniques and materials now available,[2] serve equally the visions of artists as distinct as Rickey, César, and Chamberlain. For the postwar generation, direct metal sculpture is unfettered by any constricting traditions. More than one sculptor would probably agree with David Smith, who was attracted to direct metal sculpture because it had no "art history."[3]

Before art, however, there was the machine. Almost from the beginning, iron and steel were identified with the machine age, even before they were directly used as materials for sculpture. These industrial materials were inextricably bound up with the early admiration for streamlined forms, precision, dynamism — in short, the "machine aesthetic."

The Futurists were among the first to proclaim the machine as *the* source of

twentieth-century iconography. The first Futurist Manifesto of 1909 is a testament to their admiration of the "racing motor car," factories, bridges, the "nocturnal fervour of the arsenals and of the shipyards inflamed by violent electric moons," liners, airplanes, and locomotives—styled as "enormous steel horses bridled with steel tubes."[4]

What was begun by the Futurists was continued, in muted form, by Léger and the Purists.[5] Under Léger's hand, everything—people as well as objects—was transformed into smooth and powerful, albeit static, mechanical forms.[6] He stated that the modern epoch was dominated by the spirit of manufactured objects,[7] and he was attracted to machines because of their coldness, austerity, and powerful rhythms.[8]

The writings of Ozenfant are also sprinkled with references to the "machine aesthetic." He expressed his admiration for the precision of machinery which, he predicted, must inspire an "imminent metamorphosis" in art. It was the machine aesthetic, he went on to say, that "supports [our] desire for the well made, the exact, the swift, the precise."[9]

The basic flaw in the approach of both the Futurists and the Purists was that they talked around the machine without ever meeting it head on. They were sidetracked by the superficial phenomena of machines and technology and mistook the surface qualities for the essence of the "machine age."[10] What seems curious in retrospect is that in spite of their obvious fascination with industrial and machine technology, they made no use of it to revolutionize their own technical procedures.

The Russian Constructivists,[11] and particularly Gabo and Pevsner in their *Realistic Manifesto*, set out to correct this situation. The manifesto opens with a critique of Cubism and Futurism and goes on to demonstrate the novelty of their own endeavor. They went to the heart of the problem which was peculiar to the Futurists:

> *The pompous slogan of "Speed" was played from the hands of the Futurists as a great trump. We concede the sonority of that slogan. . . . But ask any Futurist how does he imagine "Speed" and there will emerge a whole arsenal of frenzied automobiles . . . and the noise and the clang of carrouseling streets—does one really need to convince them that all that is not necessary for speed and for its rhythms?*[12]

The manifesto notwithstanding, the Russians shared with the Futurists the same admiration of the machine, but they found a more direct means of expressing the machine aesthetic. The pioneering abstract metal constructions of Rodchenko, Tatlin, and Meduniezky consciously exploited the streamlined and impersonal qualities of the objects they echoed, but without having to resort to the more explicit imagery of the Futurists.

When the Russian Revolution turned its back on the avant-garde in 1922, Gabo and Pevsner moved to Europe, where they continued to refine the

aesthetic outlined in their manifesto. Their constructions in plastics and metals followed their manifesto to the letter, and had the neat precision of a mathematical theorem. "The plumb line in our hand, eyes as precise as a ruler, in a spirit as taut as a compass . . . we construct our work . . . as the engineer constructs his bridges, as the mathematician his formula of the orbits."[13]

There were many who responded to the simplicity, precision, and modernity of Pevsner's and Gabo's constructions. With his training as an engineer, Calder was quick to appreciate the ideas first proposed in their manifesto. The mechanical quality of his early stabiles harks back in spirit to the Russian Constructivists, while the motorized mobiles are a sprightly realization of the "kinetic rhythms" announced in the manifesto.

The new aesthetic of the machine engendered a common technical approach to the new materials. By the time that Gonzalez began his first sculptures in iron, direct metal sculpture had come to be more or less associated with artists of Constructivist sympathies. A very partial list of artists who used or incorporated metals in their sculptures would have to include Bodmer, Vantongerloo, Max Bill, Brignoni, Domela, Béothy, and Moholy-Nagy.[14]

All these sculptors used metals as the hard, brittle materials they are when worked cold. Although Pevsner had the customary accoutrements of the smithy, he did not forge his metals at white heat, nor did he strive for plastic effects. Calder completely dispensed with smithing, used mechanical rather than forged or welded joints, and cut his metals with a hacksaw rather than a torch. Surfaces were left clean and unadorned.

Even the most casual comparison of these artists with Gonzalez reveals the great aesthetic distance which separated them. It appears that Gonzalez started with a very different set of premises from those of Vantongerloo or Calder, to mention two sculptors whom Gonzalez knew personally.

To the *Realistic Manifesto* of Gabo and Pevsner, Gonzalez countered by saying that "one will not produce great art in making perfect circles and squares with the aid of compass and ruler. . . . The truly novel works . . . are, quite simply, those which are directly inspired by *Nature*, and executed with love and sincerity." For Gonzalez, the art of the "compass and ruler," whether it be the geometric decoration of the Alhambra, or the cool and precise constructions of Pevsner or Vantongerloo, omitted the most essential quality of art, if it was to be more than pleasing decoration and to have real meaning, namely the human and expressive content.

Translated into the practicalities of technical realization, this meant that for Gonzalez, iron and bronze were not the hard substances with smooth and streamlined surfaces that they commonly were for these other sculptors. They were, rather, malleable and responsive materials, in which the imprint of hammer on metal corresponded to the subtle manipulations of the modeler. In contrast to other sculptors in metal, Gonzalez consistently shaped his materials

at white heat, which allowed a greater plasticity in the large forms as well as the surface detail. Rather than regarding metal as hard and unyielding, Gonzalez treated it as a soft, ductile, and malleable material responsive to the most subtle modulations and inflections. Instead of the gleaming surfaces of Pevsner, Moholy-Nagy, or Brancusi,[15] or the flat painted disks of Calder's mobiles, we find pitted, rusted, and oxidized surfaces embellished with odd bits of solder and scrap.

These are qualities which are found early and late in Gonzalez's work, cutting across various changes of formal style. Whether it is the antique patina of the *Japanese Mask* of 1929 and the New York *Head* of 1935, or the surface modulations of the *Grande trompette* of 1932 and the *Torse* of 1936, there is a consistency of technical approach. Even in his more geometrical constructions such as the *Harlequin* of 1929, and the two *Femmes assises* of about 1935, Gonzalez broke a smooth curve in the former, or introduced a crumpled mass in the latter, in order to deflect them from simply being products of the "compass and ruler."

While it is apparent that this aesthetic informs Gonzalez's work from the beginning, it is also true that this approach became ever more deliberate with the succeeding years. The early abstract works, such as the *Harlequin* and the *Tête aigüe* have a crispness of form which is continued in the linear arabesques of the large filiform figures of 1934 and 1935. Gradually, these relatively hard surfaces and precise delineations were superseded by forms and surfaces which are broken and corroded. While this corrosion of the material could serve an expressive purpose — the *Masque de la Montserrat criant* being an example — in other cases, such as the *Reclining Figure*, similar techniques were used for more purely aesthetic purposes.

Comparing the sculpture of Gonzalez's mature years with one of the early bronze masks done in the repoussé technique provides one key to Gonzalez's radical approach to his art. The *Torse* on the one hand, and the early *Tête penchée ancienne* (**3**) on the other, demonstrate a plastic handling of the medium, be it in bronze or iron, and a sensuous love of textures, broken surfaces, and subtle modulations. Although the early masks are distinctively impressionistic, the sculptures of both periods have in common techniques first learned in Barcelona during his youth. This early training not only gave him an unparalleled technical mastery, but also contributed to the distinctiveness of his style.

The plastic treatment of metals, as pointed out in the first chapter, was characteristic of the Gonzalez workshop style. Such a plastic treatment can be achieved either by using very thin sheets of metal, as with the repoussé masks and decorative pieces, or by heating the larger and thicker pieces in the forge until they can be easily hammered, bent, and molded. The refined and controlled technique characteristic of the fragile bronze flowers and bibelots made in the family workshop is equally apparent in the early bronze repoussé masks, and later, in such sculptures as the *Torse*, the *Grande trompette*, and the late cactus men.

With his thorough grounding in this traditional technique, Gonzalez had a point of view which differed radically from that of his colleagues. He was not bound to regard iron simply as the hallmark of a machine civilization. More than sheer technical proficiency, Gonzalez's sculpture bespeaks a long-term familiarity with his chosen material. In his hands, forged bronze or iron could be transformed into the airy and skeletal *Giraffe*, the compacted *Homme cactus*, or the battered and lacerated visage of the *Masque de la Montserrat criant*. In sum, the use of metals did not dictate to Gonzalez any one aesthetic, and he felt himself free to use these materials both for abstract and expressive modes.

Gonzalez instinctively shied away from any suggestion of geometrical, cleanly defined forms, and insisted on the subtle deformations and "imperfections" which would proclaim the humanity of his sculpture. One phenomenon is revealing. While oxyacetylene welding — still an advanced technique at the time — is commonly used to make precise and clean-cut seams and joints, Gonzalez seldom used this indispensable technique for this purpose. Time and again, he welded his joints, and as if not completely satisfied, he subsequently forged and hammered them.

Gonzalez's radicalism colored many other aspects of his work, including his use of found objects and precious materials. For his iron sculptures, Gonzalez more often than not used scrap iron picked up in local junkyards.[16] The reasons, however, seem to have been largely economic[17] and were less motivated by the Surrealists' interest in the fortuitous revelations of found objects.

Gonzalez could not have failed to take note of the Surrealists' use of found objects, and their intentions in combining them in such unexpected ways. He had been in and out of Picasso's studio during the time he created his Surrealist assemblages of 1929, and had executed Picasso's equally Surrealist iron sculptures of the early thirties. In addition, he was probably aware of Miró's assemblages of objects of the same period;[18] and as was suggested in the previous chapter, he was probably also familiar with Giacometti's "affective objects" and other constructions of the early thirties.

But whether it was a question of Picasso's "double metamorphosis" or Max Ernst's "systematic putting out of place," Gonzalez steered clear of the Surrealists' search for the "merveilleux" in such chance encounters. Whenever Gonzalez used found objects, they *did* have a place. The many drawings and studies reveal the careful and altogether conscious planning that went into each sculpture. Gonzalez left very little to chance, and even the apparently spontaneous effects of the tangled chevelure of the New York *Woman Combing Her Hair* or the upward sweep of her derrière, were first worked out in drawings (**93**).[19]

When Gonzalez did use undisguised found objects — he seems to have favored nuts and bolts – they never dominated the sculpture. Rather, they were slipped in to give formal emphasis or punctuation to already established forms. The incorporation of several bolts in the fingers and hip joint of the *Danseuse à*

la marguerite (**100**, cat. 116), the nut and bolt punctuating the joining of arm and torso of the *Femme à la corbeille* (**62**, cat. 85), or the small nut interrupting the sweeping arc of the New York *Head* (**73**, cat. 95) are good examples.

For the Surrealists, the meaning of their objects and assemblages seldom derived from their purely formal qualities, but rather, as with Lautréamont's umbrella and sewing machine, from the surprise and shock engendered by displacing these usually ordinary objects from their habitual context. Although a bolt used as a hip joint is certainly a surprising use of an ordinary object, and has much the same effect of humor and fantasy as many Surrealist objects, the key to the difference between Gonzalez and the Surrealists lies in the completely subordinate role of this bolt. Gonzalez's constructions commonly maintain a unity of design which separate them from the more fragmented assemblages of the Surrealist objects.

While Gonzalez was able to realize sculptures of very small scale in iron, bronze, and silver, he never completed any works larger than life-size. Iron and steel are ideally suited to monumental works, and it seems at least possible that he would have tried such projects if he had had the equipment and had he been able to engage assistants. While the filiform sculptures of the mid-thirties are of a delicacy which perfectly suits their modest scale, for the same reason this would not have made them suitable as large scale works.

Size and scale are two attributes by which the physical impact of sculpture can be judged. A third quality, which relies on these two, but which can be measured independently, may be called *presence*. Although not a precise term, it can be used to describe the way a sculpture activates its surroundings, the way it captures and holds our attention, and the way it draws us in — or excludes us from — its ambience.

Gonzalez's sculptures are delicate and "quiet" in the sense that the spatial ambience which they claim is small; it does not extend much beyond the sculpture itself, and for this reason the sculpture does not demand a large space. Somewhat like Satie's Furniture music, they are delicate, unassertive, and seldom call attention to themselves. They create an atmosphere without insisting on being at its center.

It is perhaps for this reason that large museum or exhibition installations of Gonzalez's sculptures are seldom successful. More often than not, they shrink in stature when given the center of the stage.[20] The most sympathetic environment is a place where activities other than Looking at Sculpture take place: a studio, or a room that is lived in. Here the sculptures can be true to their role of creating an atmosphere.[21]

The filiform sculptures vary from life-size to half that size, while the works of the later thirties, generally more cubic and compact, are smaller. Yet it is these smaller works which have a more monumental quality, and would have been well adapted to a larger scale. The clearest indication that Gonzalez might have been interested in monumental projects are the drawings of the last two years

before his death in 1942 and the unfinished sculpture of that year (**127**, cat. 129). In 1939 he was forced to stop welding, and although he modeled a few sculptures after this, almost all his energy was directed toward drawing. All are studies for sculptures which were never to materialize, and many are of heroic and monumental proportions, indicating the direction of his thought (**128**).

Throughout his mature career as a sculptor — from the first Cubist heads and the most airy filiform constructions to the later compact figures — Gonzalez remained true to sculpture's traditional repertoire of subjects, which had as its basis the human figure, either alone or in simple groupings. Even in his earliest drawings, Gonzalez was consistently attracted to the study of the human figure, and only rarely ventured into landscape, still life, and other standard painting genres. We may hazard the guess that it was this initial interest which first led him to his early modeled sculpture, just as a similar interest had led Degas to take up sculpture in his later years.

As the early studies and drawings demonstrate, many of the themes of Gonzalez's abstract sculptures were far from being "modern," and had a tenaciously long history both in tradition and in his own past. All of them — the maternities, the women at their toilettes, the seated and reclining figures, and even the lovers, were well-established subjects in both sculpture and painting in the nineteenth century and before.

As was the case with the traditional craft techniques which Gonzalez employed, his use of these classic subjects is another instance in which he made creative use of his past. There is, however, an important difference in the way Gonzalez utilized these two legacies. While his traditional technical methods were deflected very little either by his assimilation of new techniques such as autogenous welding, or by his change to an abstract style, there is a break in the thematic continuity of his traditional subjects.

While the filiation of a sculpture such as the New York *Woman Combing Her Hair* is indeed fascinating, it yields little information about the end point of the succession, the abstract sculpture itself. In the process of its transformation, all the formal and associative links with tradition have been completely broken. In other words, this sculpture does not embrace any of the qualities traditionally associated with this subject. From Titian to Goya, and from Renoir to the early Picasso, it has commonly served to celebrate feminine beauty, sensuality, and narcissism, qualities which can scarcely be ascribed to Gonzalez's abstract construction.

The traditional import of Gonzalez's nominal subjects has been set aside, and the real "subject" of his sculpture is his creative transformation of this thematic material. Of possibly greater significance, in this respect, than Gonzalez's selection of themes with a history, is another quality which they have in common. Particularly in the early thirties, Gonzalez firmly eschewed overly assertive or intrusive themes; the women at their toilette, the maternities, and so on, are not only classic, they are quiet, unobtrusive, and even bland. It

seems fair to say that these unassertive subjects, capable of being used in a neutral and noncommittal way, bore the same relationship to the finished constructions as did the original guitar or pipe in the fractured Cubist painting. In both cases, these subjects were, from the artist's point of view, familiar and intimate and could therefore be more readily subsumed in a conceptual vision than could a subject which was more insistent in proclaiming its integrity.

The nominal subject never entirely disappeared, however, and although abstraction, or the artist's creative transformation, eventually triumphed over representation, Gonzalez was never to lose touch with what he termed *La Nature*. In the years that Gonzalez was creating his abstract constructions, the often delicate distinctions between complete abstraction, or nonobjective art, and an art in any way based on nature formed the basis of a continuing controversy among artists. The very idea of total abstraction was one of the few subjects on which Gonzalez could wax passionate; if it came to an argument, he could become quite angry if his ideas were challenged. His eagerness to plead the case for an art based on nature is all the more intriguing considering his reluctance to engage in theoretical "shop talk."[22] As we have already observed, Henri Goetz recalled that Gonzalez was "adamant in pointing out the relationship between his sculpture and the real elements — such as hair, teeth, eyes," and he added that Gonzalez once bought a rather expensive tool which he used to work on the detailing of the teeth.[23]

Hans Hartung, who from the beginning was an abstractionist, often had to bear the brunt of Gonzalez's argumentation, as was pointed out earlier. He has suggested that Gonzalez thought it presumptuous, and a sort of hubris, for an artist to think it possible to invent forms which were not in some way derived from nature. No matter how far his art might depart from nature, he is reported as saying, man can do no better than base his art on it.[24] While he allowed that some "distortion" is necessary, if it is "deliberate" and arbitrary, and has no expressive rationale, the result would be merely "interesting, but not serious."

In theory, Gonzalez seems to have tread a very fine line. It is clear that he emphatically rejected nonobjective art, which at that time was almost exclusively geometric and Constructivist. But with few exceptions, he also rejected realism as a satisfactory solution. On this point, he wrote that "the sculptor must give form not to the imitation of another real form, but to a light, to a color or to an idea. [Thus] this form, even the most human, will be altered from the model. Hence a new source of problems to solve, created by unexpected situations, and an *architecture to be created by the artist*."

These are the key words which allow us to arrive at a more precise understanding of Gonzalez's delicate balance between figuration and abstraction, between nature and art. If it is recalled that Gonzalez considered Picasso's abstract *Woman in the Garden* a "spiritual vision of nature," and a "human and personal" work, it will be understood how liberally he interpreted *La Nature*. In

fact, he at times considered it no more than the structural basis, providing the backbone and discipline in an artist's endeavor.[25] But if he used nature and natural forms as a foundation, he probably also used mathematically derived proportional systems, as we noted earlier.

It must be confessed that Gonzalez's position concerning the relationship of art to reality, as expressed in his writings and conversations with friends, is confusing and contradictory. Furthermore, his conflicting views do not reflect an evolution of his thinking, since both appear in his essay of 1932, and in his remarks made to Goetz and Hartung in the later thirties.

On the one hand, he insisted that there must be a fundamental, even if hidden relationship between the forms of nature and those of art, and that it was presumptuous of the artist to imagine that he could invent forms outside of nature. This is, in effect, an elaboration of the old adage, "man assembles, God creates," and probably reflects Gonzalez's exceptional modesty and humility.[26] On the other hand, he qualified this, as we have seen, by writing that "the sculptor must give form not to the imitation of another real form, but to a light, to a color, or to an idea. . . . Hence a new source of problems to solve, created by unexpected situations, and an *architecture to be created by the artist.*" Like so much of the talk about space, *creation* was one of the code words which figured importantly in several manifestos and other writings of the period. It carried the specific idea of conceptual invention, as opposed to imitation or copying from nature. One of the devices which Gonzalez used to create a "new architecture" was the mathematically based proportional systems previously mentioned.

In creating the new "architecture" which he referred to, Gonzalez inevitably violated the integrity of his model; he effectively admitted as much in writing that "the [sculptural] form, even the most human, will be altered from the model." In "giving form to . . . an idea," at the expense of the "tangible form of nature," the expressive distortion itself increasingly became the real subject of his sculpture. Even with such suggestive titles as *Femme allongée, Femme se coiffant,* or *Vénus,* it appears that the transformation of the image itself became the essential theme. The hybrid forms, often accomplished through surprising juxtapositions, as in the *Danseuse à la palette* and the multiple — and ambiguous — identities of *L'Ange,* the *Daphné,* or the New York *Woman Combing Her Hair* are the real "subject" of Gonzalez's sculpture and more, his signature.

With his classical and rational mode of composition, and his individual technical style ultimately derived from his early training, Gonzalez appears as an altogether independent figure, notwithstanding his Cubist apprenticeship. His originality and radicalism lay in accepting this past and refusing to acknowledge any decisive break between the old and the new, between inherited tradition and innovation.

Not being mesmerized by the modernity of welded metal sculpture freed Gonzalez to employ this altogether modern material without any explicit references to the technology which had, in fact, made it not only possible, but

relevant. By joining together past traditions with contemporary attitudes, Gonzalez forged a poetic and gestural style which extended the initially restricted expressive and technical range of direct metal sculpture. Subsequently, the modernity of welded metal sculpture could be assumed without insisting on its roots in a scientific and technological age.

Almost in spite of himself, Gonzalez emerges as something of a paradigm of the decade which witnessed both the beginning and the end of his brief career as an abstract artist.

Not being an intellectual, and unequipped to follow into the nether reaches of Surrealist philosophy or the more intricate reasoning of the Constructivists, Gonzalez used the most readily available and assimilable aspects of these differing approaches. One might say that he was an intellectual "innocent," accepting rather uncritically the dominant ideas of his time. When he did take issue, as with the Constructivist theories, it was a position of the heart, rather than the mind, emotional conviction rather than reason, which led him there. In this respect, he was at the opposite pole from Giacometti, who has revealed an extraordinary capacity to step outside himself, to rationalize his artistic motivations, and to situate himself in the realm of ideas.

The ways in which Gonzalez assimilated these various ideas gives us a window onto his decade. Although in a narrow sense he was indeed independent of the art movements of his time, he was not outside them. His graceful and airy constructions are a convincing demonstration of the continuing viability of the Cubist aesthetic, which has nourished so many branches of modernism.

In a sense, Gonzalez has only come into his own since his death in 1942. Because of his personal modesty and reticence, coupled with the economic difficulties of the thirties faced by many artists, Gonzalez's sculpture was not widely known until the large retrospective exhibition presented in Paris at the Musée National d'Art Moderne in 1952. But even before his position in the development of modern sculpture began to be publicly assessed in this and succeeding exhibitions, his own peers recognized his pioneering experiments in welded iron sculpture as an early confirmation of their own work. Gonzalez's influence on a whole generation of postwar sculptors is inestimable. And in keeping with the increasingly international scope of the modern movement, he has set the standard for sculptors on both sides of the Atlantic. In America, David Smith, Chamberlain, and Lippold, and in Europe, César, Butler, Caro, and Gonzalez's countrymen Chillida and Serrano, only begin to suggest the great number and diversity of sculptors who have worked in welded metals. All are indebted to Gonzalez for his part in creating a new vision of sculpture.

NOTES

1. Some of the material in this section was published in Josephine Withers, *Julio Gonzalez: Les Matériaux de son expression*, Paris, 1969.

2. As an indication of how rapidly technological advances have become available to the sculptor, David Smith, who regularly used arc welding, rather innocently asked Roberta Gonzalez if her father had also availed himself of this technique, little realizing how primitive, in fact, Gonzalez's equipment had been only fifteen years before (letter of David Smith to Mme. Gonzalez in preparation for his article in *Art News*, 1956; in the collection of Mme. Gonzalez).

3. "The metal itself possesses little art history. What association it possesses are those of this century: power, structure, movement, progress, suspension, destruction, brutality." Quoted by Sam Hunter, *David Smith*, New York, 1957, p. 7.

4. Raffaele Carrieri, *Il Futurismo*, Milan, 1961, p. 12. This was written by Marinetti before the movement was properly constituted, but it nevertheless is a fair statement of ideals of the artists who were shortly to join the group.

5. I shall not deal with those artists who had ambivalent attitudes towards the machine — for example, Duchamp and the Dadaists. For a good summary, see K. G. Pontus Hultén, *The Machine as Seen at the End of the Mechanical Age*, New York, 1968.

6. See Robert Delevoy, *Léger*, New York, 1962, pp. 9–11, 38, for Léger's relations with Futurism and Russian Rayonnism.

7. Léger, "Corréspondances," *Bulletin de l'effort moderne*, no. 4, April 1924, p. 12.

8. James Johnson Sweeney, "Fernand Léger et la quête de l'ordre," in *Fernand Léger*, Montreal, 1945, pp. 87–88.

9. Amédée Ozenfant, *Foundations of Modern Art*, New York, 1931, p. 117. See also the periodical *L'Esprit nouveau*, published between 1919 and 1925. The editorials, signed by the editors Ozenfant and Jeanneret (Le Corbusier), are a continuing series of Purist manifestoes.

10. See Hultén, *Mechanical Age*, pp. 11–12, who also discusses this and gives further bibliography on this problem.

11. The term *Constructivism* has been used in so many different ways that it is left to each author to define his own use of the word. I shall use Constructivism in its broadest sense to refer to art of an abstract and geometrical tendency having many regional manifestations besides Russia, such as De Stijl and Neoplasticism in Holland, the Bauhaus in Germany, and Art Concret (among other terms) in Paris.

12. Reprinted in Naum Gabo, *Gabo*, Cambridge (Mass.), 1957, p. 151.

13. *Gabo*, 1957, p. 152.

14. Although many nations are represented by these artists, it probably is no coincidence that they all had important contacts with Paris and Parisian artists: Bodmer, a Swiss, only began his wire abstractions after 1933, but he was in Paris at a crucial moment, in 1928; the Italian Brignoni lived in Paris from 1923 to 1940; both Bill and Moholy-Nagy were in close touch with many of the artists mentioned in Chapter VI. Domela, of Holland, Vantongerloo, from Belgium, and Béothy, from Hungary, were permanent residents of Paris.

15. The "aesthetic of surfaces" is discussed very perceptively, and of course from a quite different point of view, by Sidney Geist, *Brancusi*, New York, 1968, pp. 154–56 (surface polish), and pp. 157–61 ("contingency" of form).

16. One anecdote repeated to me by several of Gonzalez's friends has it that he regularly went out to the suburban dump yards in his old Renault to forage for scrap iron. As evidence of his impeccable — one might say obsessive — conscientiousness, he was once on his way back, and suddenly remembered that he had forgotten to pass by the Parisian octroi (a local customs control, abolished in 1943). He felt compelled to return to the city gates and declare his prize collection of junk.

17. Interview with Mme. Gonzalez. See also Roberta Gonzalez, "Notes on the Sculptor Gonzalez," in *Julio Gonzalez*, Paris, 1969, n.p.

18. He could have seen them either in his studio, or in reproductions. *Cahiers d'art* published the objects of Miró in 1931 and again in 1934.

19. The studies for this sculpture are in the collection of the Museum of Modern Art, New York. Whenever feasible, Mme. Gonzalez has made a gift of the studies and drawings relating to sculptures in public collections.

20. There are many reasons, of course, to call into question the monographic treatment favored by so many museums. Strict standards of quality, and variety of an artist's oeuvre are other obvious criteria.

21. The best "installations" of Gonzalez sculptures in my experience are Hartung's studios and living quarters, and the home of Mme. Gonzalez, who still owns by far the best collection of Gonzalez sculptures.

22. David Smith, *Art News*, Feb. 1956, p. 65.

23. Smith, *Art News*, p. 65.

24. Interview with Hans Hartung, July 25, 1967.

25. Interview with Hartung.

26. Without exception, these words were consistently used to describe Gonzalez by friends who had occasion to speak of him. John Graham, for example, described him as a "quiet and modest person, dreamy and detached, in the way of many thoughtful Spanish men, an attractive person looking more in than out. He commanded sympathy and respect" (Smith, *Art News*, Feb. 1956, p. 64).

Appendix I

Gonzalez's Unpublished Manuscript, "*Picasso sculpteur et les cathédrales*"

INTRODUCTION

In 1932, at the end of the fruitful period in which he was actively working with Picasso, Gonzalez wrote the first draft of an illuminating and remarkable essay which he intended to publish under the title "Picasso sculpteur et les cathédrales": illuminating, because it is the most explicit documentation of their well-known but little-understood collaboration, remarkable because it demonstrates the admiration which Gonzalez had for Picasso both as a man and as an artist.

Gonzalez not only admired Picasso, but in some way seems to have identified with him. In describing the making of the *Monument to Apollinaire*, now called the *Femme au jardin*, or *Woman in the Garden*, one might think that it was indeed Picasso who executed this sculpture when Gonzalez says: "he had no sketches the morning he went to work at the forge: his hammer was enough. . . . He worked on it many long months until it was finished." Since we know that Gonzalez took an active hand in working on the monument, this passage would be inexplicable, were it not for a remark made to his family, which was recalled by Mme. Gonzalez: "If they aren't interested in publishing my book on Picasso, I'll just change the name and put in mine."

In other ways it is evident that Gonzalez was writing as much about his own work and ideas as those of Picasso. Although the title implies that Gonzalez intended to establish a connection between Picasso's sculpture and medieval cathedrals, this is only a pretext for Gonzalez to praise the Gothic churches which he is known to have admired so much.

Although this particular essay was never published, parts of it did appear in published form. Some of the ideas in Gonzalez's discussion of Picasso were

131

incorporated into his later article, "Picasso sculpteur," which was published in *Cahiers d'art* of 1936, while other parts can be recognized as the "Notations," which was edited from this manuscript by Mme. Gonzalez and first published in 1952 in the exhibition catalogue of the Musée d'Art Moderne in Paris.

Translating the text has presented some difficulty. Gonzalez never had an extensive education—a lack which he himself keenly felt—and in this essay, he was writing in a foreign language. Thus there are many awkward or ungrammatical sentences in the original manuscript whose meaning had to be guessed. In a few cases, passages which were completely obscure have been omitted; in other cases, punctuation has been slightly modified for clarity. A full transcription of the French text follows the translation. Marginal numbers in the translation and transcription refer to manuscript pages.

TRANSLATION

1 "From one point to another, the straight line is the shortest," Picasso has said.

2 Picasso has caused a great deal of talk since [the time of] his first artistic activities up to this day. If in the criticism, since 1902, many have disliked him,

3 there have been many more, among intellectuals, who have praised him. We shall limit ourselves to showing by some statements, the new merits which complement his work, for [even if] he had done only painting, we would still gladly place laurels on his brow.

We shall, then, be concerned with him from this date [of] 1903. Picasso is twenty-two years old, he begins to feel a new world opening up to him. The road which leads there, it is not easy to enter into it; a thousand obstacles oppose him, [the road] is full of impediments. In order to enter there more freely, whether

4 to free the route, or to deliver himself of an annoying burden, he begins to burn his drawings, entire albums! He even warms himself in this way one winter. By the thousands, the fireplace of his hotel room in the Rue de Seine in Paris reduces them to ashes.

So restored to work he continues to be the same idealist, [and] from that moment [in] 1906, [when] he begins to translate reality in a new way, his canvases take on a strange direction; a new force, a very different spirit animates them, and for these reasons, they have greater breadth.

5 Having reached mysterious regions, he feels *alone*, trembles, fears, mistrusts himself. He searches, *for he has never searched*, but, in his solitude, he immediately sees his effort rewarded.

1911

Later on, perhaps unconsciously, in order to give air to his paintings, it occurs to him to execute these separately with cutout papers.

The alert is given! He doesn't stop, he works more than ever, he searches always, he contrives to make little boxes out of cardboard [which are] joined
6 together with string. He succeeds in making works of art full of emotion with a *new technique*: these assembled papers give the impression of things carved in rock.

1914

After this, with primitive tools, scratching his hands a thousand times with a stubborn tenacity, he makes his first [constructions in] sheet metal, as beautiful as they are original, the powerful and masterly still lifes.

He had just created his first sculptures. One can imagine the satisfaction which a real artist would feel in creating these works, but, when the *painter* Picasso, recalling this period of his life, still says of himself: "I have never been so
7 pleased! That was my point of departure. The departure on a new road to follow, I was happy." [If he can say that,] it surely means that this was of great importance to him!

In his abundant production, there is enough to nourish generations of artists who are willing to seriously study his drawings.

In only a few years, he found, created, invented, [and] drew new forms (we
8 speak of sculpture), new planes, opposition of planes, perspectives, *forms in space*. He is *still* looking, still working, he foresees something, he himself doesn't yet know what. He continues to paint, but, he thinks only of sculpture, because each color for him is only a means of distinguishing one plane from another, the light from the shadow, or yet other forms.

A painter or a sculptor can, the first on his canvas, the second on his block, make a form appear or disappear, that is to say a thing which does not have a precise form (shape) in itself, since it begins and ends nowhere, but as here the
9 sculptor must give form not to the imitation of another real form, but to a light, to a color, or to an idea, this [new, or sculptural] form, even the most human, will be altered from the model. Hence a new source of problems to solve, created by unexpected situations and an *architecture to be created by the artist*.
10 El gran Homero no escribió en latín, porque era griego, ni Virgilio escribió en griego, porque era latino. Cervantes.

Picasso was born in Málaga (Spain) where he stayed until he was four years old. This man of astonishing activity, whose brain measures and weighs every-thing, gifted with a limpid intelligence, who ponders endlessly, this man, who, obedient to his own ideal, is aware that he must leave the tranquil Mediterran-ean, drawn by the charms of the Seine which always beguile him, can only speak
11 of the city where he passed his youth, of its simple peasants of rough tongue, of its blue sea. He is the direct son of this land through his *heart*, through his *works*, and through his *direct ways of realizing them*. He lived until his departure for Paris, in this barbaric land, as beautiful as it is wretched — in this country which since

its beginning, was always subjugated to new conquerors, and which destiny finished by cutting in two, making of its mystic Montserrat the vassal of Spain and of its high Canigou the vassal of France — in this martyred people, oppressed, without their own liberty, without the hope of ever obtaining it. No matter! Attached to it as to a [gravely] ill person whom one loves, one holds him the more dear because he suffers, one always wants to relieve him of his ills, endure them for him, and in that sad impossibility, one is painfully resigned and

12 lives with bitterness in the heart. The stigmata of these moral miseries, Picasso carries deeply [within himself] and, as with his proud brothers from over there, laughs often in order not to cry: *Like a pure Catalan.*

13 One would never say that Gothic art is geometric. When the architect of a cathedral conceives one of his magnificent spires, it is not of geometry that he thinks; at this moment, it is only a question of giving it a beautiful form which, while responding to architectural requirements, can at the same time idealize that which his imagination and heart inspire in him. The aesthetic geometry which results is only secondary, and the geometry of each stone, so to speak,

14 depends only on the laws of construction and of the quality and resistance of the materials used.

15 Only a cathedral spire can indicate a point in the sky where our soul rests in suspension.

As in the restlessness of the night, the stars mark out points of hope in the sky, [so too] this immobile spire marks out an infinite number of them to us. It is

17 these points in the infinite which are the precursors of this new art: *To draw in space.*

The real problem to be solved here is not only to wish to make a harmonious work, of a fine and perfectly balanced whole — No! But to get this [result] by the marriage of *material* and *space*, by the union of real forms with imagined forms, obtained or suggested by established points, or by perforations, and, according to the natural law of love, to mingle and make them inseparable one from another, as are the *body* and the *spirit*.

18 The *Roman triumphal arch* is a striking example of this [union]. Later on the first great step in this order of ideas was the execution of the rose windows of our beautiful cathedrals, in which, by perforations in the stone, appear the heavenly and earthly figures; owing to the windows, [their] shapes [are] created both by the color and the outline. Why then, with a sort of evolution, should these spaces not one day become themselves directly human, without recourse to

19 painting? Hence, Christian art of purely Latin tradition, born of the spirit of faith in the mystery of the Trinity.

20 In a picture, a certain distortion of an optical-geometric nature is accepted. If this distortion is general, deliberate, completely of a scientific order, it could be *interesting*, but not *serious*. On the other hand, the distortion resulting from a synthesis can be both serious and beautiful, and more, being purely (entirely) a psychological creation, it can become a geometric distortion, if the realization of the work depends on it.

If the synthetic deformities of material, of color, and of light, the perforations, 21 the lack of material planes, give to the work a mysterious, fantastic, and diabolical appearance, then the artist, in addition to idealizing a material to which he gives life, is at the same time working with the ennobling space.

22 The Age of Iron began many centuries ago, by producing (unhappily) arms — some very beautiful. Today it makes possible the building of railroads. It is time that this metal cease to be [a] murderer and [the] simple instrument of an overly mechanical science. The door is opened wide to this material to be at last! forged and hammered by the peaceful hands of artists.

23 1931

Picasso never finds the time to execute one of his projects. If, rarely, he makes up his mind, he settles on his most recent idea. For he is so restless, always wanting to improve, he only succeeds in filling new pages of his sketchbook. This is why, in spite of the thousands of studies, he took not a one the morning of the day he went to work at the forge; his hammer alone was enough to try to bring 24 into being his monument to Apollinaire. He worked on it long months at a time and he finished it. He would often say, "Once again I feel as happy as I was in 1912."

This original work is a purely sculptural interpretation to its maximum of 25 expression of a spiritual vision of nature, combining organic forms — primordial characteristic of life. So full of fantasy and of grace, so well balanced, so human, so personal, this work is made with so much love and tenderness in the memory of his dear friend, at the moment he doesn't want to be separated from it, or to think of its being at Père Lachaise in that collection of monuments where people seldom go. He wished that this monument become the reliquary which would keep the ashes of the lamented poet and that he be authorized to place them near his house, in his garden — And often with friends, gather round him who is no longer.

26 Some critics have maintained that Picasso was mad, that he was joking, and that his art wasn't serious. They have only seen in it [some] strange fantasy, [or] bad painting. They haven't taken into account — the blindmen — the value of this treasure, this abundance in new means of expression.

27 If it is true that Picasso is gifted with an exceptional imagination which complements (perhaps) his work, it is also possible that he not have it and remain just as personal. The realist Velasquez, faithful interpreter of his model, is as great an artist as the spiritual El Greco in his fanciful compositions. The works of *Despiau*, full of reality, as well as the spiritual sculptures of the cathedral of Chartres, have the same force, and breathe the same beauty. Picasso, who always idealizes, simultaneously or separately (this doesn't depend on him, it is unconscious with the artist), but he always keeps in his work his force and his personality.

28 One could object that this kind of sculpture is limited, [but] it is no more so than the other (the full); there, the artist must express himself by other means.

The Oceanian sculptor, who has only a tree trunk for carving his *totem*, must press the arms to the body which is what gives the statue its force and beauty: he 29 succeeds in expressing himself; in the same way, the Negro makes the thighs of his seated fetish too short, his tree trunk not permitting him any more. We, the civilized ones, who have at our disposal the whole block, what do we most admire in a torso, if it is not the tree trunk?

With great humility, Picasso will limit himself—in his art—to the inspiration of Nature and to interpret it faithfully. It is for that reason, that he is original and ceaselessly renews himself; he wants to attain to perfection: unhappily one will never attain it.

30 "Try to draw by hand a perfect circle—a useless task—only the imperfections will reveal your personality," Picasso says.

One will not produce great art in making perfect circles and squares with the aid of compass and ruler, or in drawing one's inspiration from New York skyscrapers. The truly novel works, which often look bizarre, are, quite simply, those which are directly inspired by *Nature*, and executed with love and sincerity.

31 In order to give the most power and beauty to his work, the sculptor must be aware of the exterior contour, in order to preserve its sense of mass. So it is in the *center* of this mass that he must concentrate all his effort, all his imagination, [and] all his science, so that its power won't be weakened. It's there (at that point) that architecture and painting can come together with sculpture. That 32 is, one will eliminate, exaggerate, or soften various details in order to preserve this sense of mass. For example: in a statue, we take into account that the contour of a leg or of an arm is as beautiful from one side as the other. There, the artist must respect both [sides], even though one side may be attached to the block.

On the other hand, for sculpture [which does not originate with] the block, the block results from the execution of the work and it is [then] possible (if the material permits) to draw in space a single side of this arm which will enclose the [whole] block. That a drapery should hide one side of this arm is commonly accepted, we are not really saying anything new.

33 Our *material*, then, being *space*, this block can be formed around a void [which taken together] form a single block. With sculpture of *stone*, *holes* are not necessary. With sculpture having to do with space, they are necessary. It has never been claimed that the Triumphal Arch of Tiberius was *perforated*. Its architect knew how to obtain a [sense of] *mass* as *solid* as a pyramid.

One might claim that in architecture this is permitted; but why shouldn't this be true of sculpture, since we already have in front of our eyes Picasso's examples.

34 A statue of a woman can also be a woman (a portrait) which one should be able to see from all sides; from all aspects, she is a representation of Nature.

But, if in a certain attitude, she is holding an olive branch, she is no longer a

woman. She has become the symbol of Peace. [Once she has] become a symbol, do not walk around her, for as soon as you no longer see the attribute, she again

35 becomes [simply] a woman. So this classic art, which was thought complete, actually is not, simply because of its *solid* material.

Only certain lines or planes can give the necessary emphasis to the attribute. These essential lines, these *tracings* of paint on the canvas, ["traitée de fausse peinture, ou de peinture fantaisiste . . ." (omitted)], purely sculptural in conception and realization, will one day be replaced by Picasso with iron bars which he will take and arrange in such a way as to interpret the subject of one of his paintings, and *soldering them together*, he shall have obtained the best expression to give to his attribute Peace, which will become symbol as well as a statue of a woman, by the synthesis of the human being, thanks to certain forms (constructed — perhaps — in space) or by planes indicated on his canvas with colors (perhaps also constructed in space).

Picasso, then, realized *his most cherished dream*, that by this *incomplete art*, his attribute might be seen from all sides.

37 It is normal for painters to make sculpture, or sculptors to paint; it is, so to speak — to rest oneself, to have a *change of pace*. With Picasso, paintings as well as drawings, once they have taken tangible form [and] have been transformed into sculpture properly speaking, once again become paintings — that is to say color, or the black and white of drawings, according to the model. Painting, drawing, and sculpture finally become one with Picasso.

26–12–31

38 Picasso paints as always.

In looking at his latest painting — very restful — one notices that he [has] become more sensitive to color. These colors are not deliberately chosen, they are sensitive harmonies, delicate contrasts, where the color makes the ensemble vibrate.

But, this abstract painting, so very flat (perhaps more so than ever) is also his most beautiful sculpture. And as, astonished, we ask him why, Picasso answers, "Because in this painting, there is in its plasticity a perspective. One must create the planes of a perspective. Yes, it is the colors which do it."

[DRAFT, pages unnumbered]

In the Romanesque portals of our basilicas, the arch and tympanum, sculpted or not with living subjects, are *brutally* supported by abstract lines, by the rigid columns.

* * * *

Julio Gonzalez: Sculpture in Iron

In this central portal of the Cathedral of Paris [illustrated in ms.] we see the architect make the traditional columns rise up, like a graft, a *new column* at each one. One, the Ancient, "material," abstract form: Architecture. The other, the New, "spiritual," animated form: Sculpture. Inseparable, the two complement each other.

* * * *

The first [the architectural columns], discreetly attached to the wall, their capitals forming a frieze, powerfully support the abstract, logical ogive. The others, better yet, those which wonderfully give the illusion, these are the *Saints*, at the same time "Spiritual" *columns*, "divine" statues and "mystical" Caryatids of our cathedrals, which support this *void*, this *space* full of mystery (this horizontal bar of shadow made by the projecting canopy on the previously mentioned capital frieze) on which rises miraculously like a prayer, the sculptural (voussoirs), the *living*, pious ogive.

To fill out the ensemble of this marvelously realized (conceived) work, we should add that the saints rest not on socles, but on culs de lampe, and that these, projecting shadows on themselves, also form a horizontal bar of space which gives the impression that these saints rest on the infinite!

When the architect of a cathedral conceives one of his magnificent spires, he is not thinking in terms of geometry; at this moment, it is only a question of giving a satisfactory form which, while responding to architectural necessities, can at the same time idealize the promptings of his heart and imagination. The resulting aesthetic geometry of each stone depends, as it were, only on the laws (rules) of construction and on the resistance of the materials used.

By contrast, the principle of the arabesque in the Alhambra is purely objective geometry. The result is a marvel of art of a simply optical beauty.

Every religion has its temple, but the only one which through the mystery of its architectural lines, purifies our thoughts and raises them above the world, is Gothic (ogival) art. This is what the architect of the Ile de France, faithful interpreter of his country's spirit, has succeeded so well and with such grandeur in expressing!

TRANSCRIPTION

1 "D'un point à un autre point, la ligne droite est la plus courte" a dit Picasso.

2 Picasso . . . a fait énormément parler de lui depuis ses premières manifestations artistiques jusqu'à ce jour. Si dans la critique, à partir de 1902, beaucoup l'ont détesté, bien plus nombreux ont été, du côté des intellectuels, ceux qui l'ont loué. Nous allons nous limiter à montrer par quelques constatations, les

3 nouveaux mérites qui complètent son oeuvre, car, il n'aurait fait simplement

que de la peinture, que nous lui placerions volontiers des feuilles de laurier sur le front.

Nous allons donc, nous occuper de lui à partir de cette date 1903. Picasso a alors 22 ans, il commence à sentir un monde nouveau s'ouvrir à lui. Le chemin qui y mène, il n'est pas facile de s'y engager; mille choses s'y opposent, il est plein d'entraves. ([alternative written in margin] Le chemin qui conduit à ce monde nouveau, n'est pas très accessible. Il se révèle plein d'embûches et d'entraves. Mille obstacles s'y dressent la route.) Pour y pénétrer plus librement, soit pour dégager le passage, soit pour se délivrer d'un poids qui le gêne, il 4 commence à brûler ses dessins, des albums entiers! Il se chauffe même ainsi un certain hiver. Par milliers, la cheminée de sa chambre d'hôtel de la Rue de Seine à Paris les réduit en cendres. . . .

Si remis au travail, il continue à être toujours le même idéaliste, à partir de ce moment-là, 1906, il commence à traduire la réalité d'une nouvelle manière, ses toiles prennent une bizarre tournure; une nouvelle force, un esprit très différent les anime, et elles ont pour ces raisons-là, plus d'ampleur.

Ayant atteint des régions mystérieuses, il se sent *seul*, tremble, craint, se méfie. 5 Il cherche, *car il n'avait jamais cherché*, mais, il voit tout de suite son effort recompensé dans cette solitude.

1911

Plus tard, inconsciemment peut-être, pour *donner de l'air* aux plans de ses peintures, l'idée lui vient d'exécuter celles-ci séparément avec les papiers découpés.

L'alerte est donnée. . . . il ne s'arrête pas, il travaille plus que jamais, il cherche toujours, il entreprend de fabriquer des petites boîtes avec du carton et combinées avec des ficelles. Il réussit à faire des chefs d'oeuvres plein d'émotion 6 d'une *nouvelle technique*: ces papiers assemblés donnent l'impression de choses taillées dans le roc.

1914

Ensuite, avec des instruments trop rudimentaires, s'égratignant les mains mille fois avec une ténacité opiniâtre, il exécute ses premières tôles, aussi belles qu'originales, les puissantes et magistrales natures mortes.

Il vient de créer ses premières sculptures. On s'imagine la satisfaction que peut éprouver un véritable artiste en créant ses oeuvres, mais, quand le *peintre* Picasso, rappelant cette période de sa vie, dit encore de lui-même: "je n'avais jamais été 7 aussi content! Ce fut là mon point de départ. Le départ d'une nouvelle voie à suivre, j'étais heureux. . . ." C'est vraiment il y attache une très grande importance!

Dans sa production si abondante, il y a de quoi alimenter des générations

d'artistes qui voudraient se donner la peine d'étudier sérieusement ses dessins.

En quelques années seulement, il a trouvé, créé, inventé, dessiné des formes nouvelles (nous parlons sculpture), des plans nouveaux, des oppositions de plans, des perspectives, *des formes dans l'espace*. Il cherche encore, il travaille 8 toujours, il prévoit quelque chose, il ne sait pas encore lui-même quoi. Il peint toujours, mais, il ne pense qu'à la sculpture, car chaque couleur pour lui n'est que le moyen de différencier un plan d'un autre plan, la lumière et l'ombre, ou encore des formes.

Un peintre ou un sculpteur peuvent, le premier, sur sa toile, le second sur son bloc, faire apparaître ou disparaître une forme, c'est-à-dire une chose qui n'a pas de forme précise en elle-même, puisqu'elle ne commence ni finit nulle part, 9 mais comme ici le sculpteur doit donner forme non à l'imitation d'une autre forme réelle, mais à une lumière, à une couleur ou à une idée, cette forme-là sera toujours, même la plus humaine, déformée du modèle. De là une source nouvelle de problèmes à résoudre, posés par des plans inattendus et *d'une architecture à créer par l'artiste.*

10 . . . el gran Homero no escribiz en latin, porque era griego, ni Virgilio escribió en griego, porque era latino. Cervantes.

Picasso est né à Málaga (Espagne) ou il est resté jusqu'à l'âge de 4 ans. Cet homme d'une activité étonnante, dont le cerveau mesure tout, pèse tout, doué d'une intelligence claire, qui réfléchit sans cesse, cet homme qui ne pense, qui n'aime, qui ne sent que la liberté, cet homme, qui, obéissant à son idéal, sentit qu'il devait quitter la douce Méditerranée, attiré par les charmes de la Seine 11 qui le séduisent toujours, cet homme ne fait que parler de la ville où il a passé sa jeunesse, de ses paysans racés au langage âpre, de sa mer bleue, . . . il est le fils direct de cette terre par *son coeur*, par ses *oeuvres*, et par les *moyens rudes de les réaliser.* Il a vécu jusqu'à son départ à Paris, dans ce pays barbare, aussi beau que malheureux . . . dans ce pays que depuis son origine, toujours asservi à de nouveaux conquérants, et que le destin finit par couper en deux, faisant de son mystique Montserrat le vassal de l'Espagne et de son haut Canigou le vassal de la France; dans ce peuple martyr, oppressé, sans liberté propre, sans espoir de ne l'obtenir jamais, n'importe! attaché à lui comme à un grand malade qu'on aime, on le chérit davantage parce qu'il souffre, on voudrait toujours le soulager de ses maux, les endurer pour lui, et dans l'impossibilité désolé, on se résigne pénible- 12 ment et on vit l'amertume dans l'âme. Les stigmates de ses misères morales, Picasso les porte profondément et, de même que ses dignes frères de là-bas, rit souvent pour ne pas pleurer: *Comme un pur Catalan.*

13 On ne dira jamais que l'art gothique est géométrique. Quand l'architecte d'une cathédrale conçoit une de ses magnifiques flèches, ce n'est pas à la géo-métrie qu'il pense; il ne s'agit pour lui, à ce moment-là, que de lui donner une belle forme qui, tout en répondant aux nécessités architecturales, puisse en même temps idéaliser ce que son imagination et son coeur lui inspirent. La

géométrie esthétique qui en résulte n'est que secondaire, et la géométrie de chaque pierre ne dépend, pour ainsi dire, que des lois de la construction et de

14 la qualité et de la résistance des matériaux à employer.

15 Il n'y a qu'une flèche de cathédrale qui puisse nous signaler une pointe dans le ciel où notre âme reste en suspens!

 Comme dans l'inquiétude de la nuit, les étoiles nous indiquent des points d'espoir dans le ciel, cette flèche immobile nous en indique aussi un nombre sans fin. Ce sont ces points dans l'infini qui ont été les précurseurs de cet art

17 nouveau: *Dessiner dans l'espace.*

 Le vrai problème à résoudre ici n'est pas seulement de vouloir faire une oeuvre harmonieuse, d'un bel ensemble parfaitement équilibré. . . . Non! Mais de l'obtenir par le mariage de la *matière* et de *l'espace*, par l'union des formes réelles avec des formes imaginées, obtenues ou suggérées par des points établis, ou des perforations, et, telle la loi naturelle de l'amour, les confondre et les rendre inséparables les unes des autres, comme le sont le *corps* et *l'esprit*.

18 L'arc de triomphe romain en est un bel exemple. Plus tard le même problème a préoccupé les constructeurs des cathédrales. Plus tard le premier grand pas dans cet ordre d'idées a été l'exécution des rosaces de nos belles cathédrales, dans lesquelles, par des perforations dans la pierre, apparaissent, grâce à leurs vitraux, la forme étant aussi bien créée par la couleur que par le cerné des figures célestes et terrestres. Pourquoi donc, avec une sorte d'évolution, ces espaces . . . ne deviendraient-ils pas un jour eux-mêmes directement humains, sans avoir recours à la peinture?

19 Donc, l'art chrétien de tradition purement latine, né de l'esprit de croyance au mystère de la Trinité.

20 On peut accepter sur une toile, une certaine déformation d'ordre optico-géométrique. Si cette déformation est générale, voulue, complètement d'ordre scientifique, elle pourra être curieuse, mais pas sérieuse. Par contre, cette déformation résultant d'une synthèse, serait sérieuse en même temps que belle, et pourrait de plus, étant purement création psychologique, devenir déformation géométrique, si la réalisation de l'oeuvre en fait une nécessité (le lui rend nécessaire).

 Si les déformations synthétiques de la matière, de la couleur, et de la lumière,

21 les perforations, les manques de plans matériels donnent à l'oeuvre un aspect mystérieux, diabolique, fantastique, ici l'artiste, en plus d'idéaliser une matière à laquelle il donne la vie, a affaire en même temps à l'espace qui la divinise.

22 L'Age de fer a commencé, il y a des siècles, par fournir (malheureusement) des armes — quelques unes très belles. A présent il permet l'édification de ponts, de rails de chemin de fer! Il est grand temps que ce métal cesse d'être meurtrier et simple instrument d'une science trop mécanique. La porte s'ouvre toute grande aujourd'hui à cette matière pour être enfin! forgée et battue par de paisibles mains d'artistes.

Picasso ne trouve jamais le temps matériel d'exécuter un de ses projets. Si, rarement, il se décide, c'est toujours pour le dernier. Car, tellement il est inquiet, voulant toujours faire mieux, il ne fait que remplir de nouvelles pages de ses albums. Voilà la raison pour laquelle, malgré des milliers de croquis, il n'en a pas pris un seul le matin du jour où il s'est mis à la forge; son marteau seul

24 lui a suffi pour tenter de réaliser son monument à Apollinaire. Il y a travaillé de longs mois consécutifs et il l'a terminé. Souvent il répétait: "Je me sens de nouveau aussi heureux qu'en 1912."

Cette oeuvre originale est une interprétation purement sculpturale à son maximum d'expression de la vision spirituelle de la nature, synthétisant le

25 côté forme organique — caractéristique primordiale de la vie. Pleine de fantaisie et de grâce, si bien équilibrée, tellement humaine, tellement personelle, cette oeuvre faite avec tant d'amour et tant de tendresse au souvenir de son cher ami, il voudrait à présent ne pas s'en séparer, ne pas le savoir au Père Lachaise, dans ce bazar de monuments où personne ne va jamais ou rarement. Il voudrait que ce monument devienne le reliquaire qui garderait les cendres du regretté Poète, mais qu'on l'autorisât à les placer près de sa maison, dans son jardin. . . . Et souvent avec les amis, se grouper autour de celui qui n'est plus. . . .

26 Certains critiques ont prétendu que Picasso était fou, qu'il plaisantait, que son art n'était pas sérieux. Ils n'y ont vu qu'une drôle de fantaisie, qu'une mauvaise peinture. Ils ne se sont pas rendu compte — Oh! les aveugles — de la valeur de ce trésor, de cette abondance en moyens nouveaux de s'exprimer.

27 S'il est vrai que Picasso est doué d'une grande fantaisie qui complète (peut-être) son oeuvre, il pourrait aussi ne pas l'avoir et rester aussi personnel. Le réaliste Vélasquez, fidèle interprète de son modèle, est aussi grand artiste que le spirituel Gréco dans ses compositions fantaisistes. Les oeuvres de *Despiau* pleines de réalité, ainsi que les spirituelles sculptures de la Cathédrale de Chartres, ont la même force et respirent la même beauté. Picasso, qui toujours idéalise, simultanément ou séparément (cela ne dépend pas de lui-même, c'est inconscient chez l'artiste) mais, il garde toujours dans ses oeuvres sa force et sa personnalité.

28 On pourrait nous objecter que cette sorte de sculpture est limitée, elle ne l'est pas plus que l'autre (la pleine); là, l'artiste doit s'exprimer par d'autres moyens. Le sculpteur Océanien, qui ne dispose que d'un tronc d'arbre pour tailler son *totem* est forcé de lui *coller* les bras au corps, ce qui fait sa force et sa

29 beauté: il réussit à s'exprimer; de même, le nègre fait à son fétiche assis les cuisses trop courtes, son tronc d'arbre ne lui permettant davantage. Nous, les civilisés, qui se dispose tout du bloc, qu'est-ce que nous admirons le plus dans un torse, si ce n'est le tronc d'arbre?

Humble d'être humain, Picasso se limitera — dans son art — à ne s'inspirer que de la Nature et à l'interpréter fidèlement. C'est pour cette raison-là, qu'il est

original et se renouvelle sans cesse; il veut arriver à la perfection: on n'y arrivera jamais malheureusement.

30 "Efforcez-vous de tracer à la main un cercle parfait — peine inutile — seules les imperfections montreront votre personnalité" dit Picasso.

Ce n'est pas en faisant des cercles et des carrés tracés à la perfection avec le compas et la règle, ou en s'inspirant des buildings de New-Yorck [sic], qu'on fera du grand art. . . . Les oeuvres vraiment nouvelles qui ont souvent l'air bizarre, sont, tout simplement, celles inspirées directement de la *Nature*, et exécutées avec amour et sincérité.

31 Afin de donner le maximum de puissance et de beauté à son oeuvre, le statuaire est forcé, pour conserver une belle masse, de tenir compte du contour extérieur. C'est donc dans le *centre* de cette masse qu'il lui faudra porter tout son effort, toute son imagination, toute sa science, pour ne pas diminuer sa force.

32 C'est là qu'avec la sculpture vont collaborer l'architecture et la peinture. C'est-à-dire, qu'on va supprimer, exagérer ou adoucir divers détails au profit de la masse. Ex: dans une statue, nous considérons que le contour d'une jambe ou d'un bras est aussi beau d'un côté que de l'autre. Là, l'artiste est tenu de les respecter tous les deux et attacher le côté touchant au bloc à celui-ci.

Par contre, dans la sculpture sans bloc, le bloc résulte de l'exécution de l'oeuvre et il lui est possible (sa matière le permettant) de dessiner dans l'espace un seul côté de ce bras qui fermera le bloc. Qu'une draperie dissimule un côté de ce bras, c'est mille fois vu et accepté, nous ne disons donc rien de nouveau.

33 Alors, notre *matière* étant *espace*, ce bloc peut être constitué autour d'un vide formant ensemble un seul bloc. Dans la sculpture en *pierre*, il ne faut pas de *trous*. Dans la sculpture ayant affaire à l'espace, ils sont nécessaires. On n'a jamais dit que l'Arc de Triomphe de Tibère est *troué*. Son architecte a su obtenir une *masse* aussi *pleine* qu'une Pyramide.

On pourrait prétendre qu'en architecture c'est permis; mais pourquoi ne le serait-ce pas en sculpture, puisque nous en avons déjà par Picasso des exemples sous les yeux?

34 Une statue de femme peut être aussi une femme (un portrait) qu'on doit pouvoir regarder de tous côtés; elle est partout représentation de la nature.

Mais, si dans une certaine attitude, elle tient dans sa main une branche d'olivier, elle n'est plus une femme. Elle est devenue le symbole de la Paix. Devenue symbole, ne tournez pas autour, car aussitôt que vous n'apercevez

35 plus l'attribut, elle redevient une femme. Donc, cet art classique qu'on croyait complet ne l'est pas tout simplement à cause de sa matière *pleine*.

Ce n'est que par certaines lignes ou plans qu'on doit pouvoir donner l'importance nécessaire à l'attribut. Ces lignes essentielles, ces *traits* au pinceau sur la toile (traitée de fausse peinture, ou de peinture fantaisiste), de conception et de réalisation purement sculpturales, un jour Picasso les remplacera par des barres de fer qu'il prendra et disposera de façon à interpréter le sujet d'une de ses toiles et, les *soudant pour qu'elles tiennent*, il aura obtenu le maximum d'expression

à donner à son attribut Paix, lequel deviendra symbole en même temps que statue de femme, par la synthèse de l'être humain, grâce à certaines formes (établies — peut-être — dans l'espace) ou par des plans indiqués sur sa toile par des couleurs (peut-être aussi établis dans l'espace).

Alors, réalisant *son plus beau rêve*, Picasso aura obtenu par cet *art incomplet* que cet attribut soit vu de partout.

37 Que des peintres fassent de la sculpture ou que les sculpteurs fassent de la peinture, c'est chose normale, c'est pour ainsi dire — pour se reposer, pour changer. . . . Chez Picasso, les peintures ainsi que les dessins, une fois qu'ils ont pris forme réelle transformés par lui en sculpture proprement dite, celles-ci redeviennent ses peintures, c'est-à-dire, couleur, ou blanc et noir des dessins, selon les modèles choisis. Peinture, dessin et sculpture ne font que devenir une seule chose chez Picasso.

<div align="center">

26–12–31

38 Picasso peint toujours

</div>

En regardant sa dernière peinture — très reposante — on s'aperçoit qu'il devient plus sensible à la couleur. Ce ne sont pas des couleurs voulues, ce sont des harmonies sensible, des contrastes délicats, où l'ensemble vibre par la couleur.

Mais, cette peinture abstraite, tellement plate (peut-être plus que jamais), est sa plus belle sculpture. Et comme, étonnés, nous lui demandions le pourquoi, Picasso nous répondit, "parce que dans cette peinture, il existe en sa plasticité une perspective. Il faut créer les plans d'une perspective. Oui, ces couleurs les ont créés."

<div align="center">

[DRAFT]

</div>

Dans les portails romans de nos basiliques, l'arc et le tympan sculptés ou non de sujets vivants, sont supportés *brutalement* par des lignes abstraites, par de rigides *colonnes*.

<div align="center">

✻ ✻ ✻ ✻

</div>

En ce portail central de la Cathédrale de Paris [illustrated], nous voyons l'architect faire surgir les traditionnelles colonnes, comme d'une greffe, une *nouvelle colonne* à chacune d'elles. L'une l'Ancienne, "matérielle," forme abstraite: l'Architecture. L'autre, la Nouvelle, "spirituelle," forme animée: la Sculpture. Inséparables, les deux se complètent.

<div align="center">

✻ ✻ ✻ ✻

</div>

Les premières discrètement fixées au mur soutiennent avec puissance leurs

chapiteaux formant une frise, l'abstraite, la logique ogive. Les autres, pour mieux dire, celles qui donnent prodigieusement l'illusion, ce sont ces *Saints*, à la fois "Spirituelles" *Colonnes*, "divines" statues et "mystiques" Cariatides de nos cathédrales, qui soutiennent ce *vide*, cet *Espace* plein de mystère (cette barre horizontale d'ombre projetée par les dais en saillie sur la frise des chapiteaux déjà cités) sur lequel miraculeusement s'élève comme une prière, la (cordon des voussures) sculpturales, la *Vivante*, la pieuse ogive.

Nous devons ajouter pour compléter l'ensemble de cette oeuvre merveilleusement réalisée, que les Saints reposent non pas sur des socles mais sur des culs de lampe. Et que ceux-ci, projetant l'ombre sur eux-mêmes, forment aussi une barre horizontale d'espace qui donnent l'impression que ces Saints reposent sur l'infini!

Quand l'architecte d'une Cathédrale conçoit une de ses magnifiques flèches, ce n'est pas à la géométrie qu'il pense; il ne s'agit pour lui, à ce moment-là, que de lui donner une belle forme qui, tout en répondant aux nécessités architecturales, puisse en même temps idéaliser ce que son imagination et son coeur lui inspirent. La géométrie esthétique qui en résulte n'est que secondaire, et la géométrie de chaque pierre ne dépend, pour ainsi dire, que des lois de la construction et de la qualité et la résistance des matériaux à employer.

Par contre, le principe de l'arabesque de l'Alhambra est purement d'imagination géométrique objective. Son résultat est une merveille d'art d'une beauté simplement optique.

N'importe quelle religion a un temple, la seule qui par le mystère de ses lignes architecturales, purifie nos pensées et les élève au-dessus de ce monde, c'est l'art gothique (ogival). C'est ce que l'architecte de l'Ile de France, fidèle interprète de l'âme de son pays, a réussi si bien à exprimer et avec tant de grandeur!

Documentation

SUMMARY

For the documentation of this monograph on Gonzalez, I had access to published and unpublished material in the collection of Mme. Gonzalez. This included:

1. Letters, of all periods
 a. 1900–c. 1915. Among members of the family as they moved back and forth between Barcelona and Paris.
 b. All periods. Friends of Gonzalez, including a valuable Picasso correspondence of the early years (1903–04) and during the years of their collaboration (1928–32).
 c. 1940–42. Correspondence between Gonzalez and the rest of the family during the times they were separated: Gonzalez in Paris, his family in the Lot.
2. Unpublished manuscript, "Picasso sculpteur et les cathédrales," reproduced here in Appendix I.
3. A clipping file, to which Gonzalez subscribed between 1913 and 1937 (these are the dates of the first and last entries).
4. Miscellaneous
 a. Contract of December 1, 1929, with the Galerie de France.
 b. Record of sculptures sent to the Galerie de France, reproduced on page

 c. An informal list of exhibitions drawn up by Gonzalez about 1937, reproduced on page
 d. A few early exhibition catalogues; the checklist of the May 1931 exhibition at the Galerie de France is reproduced on page 147.

EARLY EXHIBITION RECORDS

Galerie de France. Compte-rendu (transcription, with catalogue numbers in brackets).

Pièces livrées 1930

Tête d'homme (bronze) [cat. 30]
Femme à la cruche (fer) [cat. 37]
Femme nue allongée (bronze)
Tête égyptienne (fer)
Tête allongée (bronze) [cat. 32]
Tête égyptienne (bronze)
Le Baiser (fer) [cat. 34]
Petite tête (fer)
Petite tête (bronze)
Petite tête (bronze)
Tête cubiste (bronze)
Tête couchée (bronze)
Femme couchée (fer) [cat. 35?]
Sculpture cubiste (bronze)
Tête de femme (fer)

Pièces reçues à la Galerie de France, mai 1931

Harlequin (fer) [cat. 33]
Don Quichotte (fer) [cat. 23]
Femme assise (fer) [cat. 12?]
L'Etreinte (fer) [cat. 11]
Deuxième baiser [cat. 50]
1 masque
1 grande figure [cat. 51]

List of Sculptures in Exhibition Catalogue, Galerie de France, May 1931.

Le Baiser [cat. 34]
Pierrot [cat. 33]
Don Quichotte (illustrated) [cat. 23]
Jeune femme
Nature morte [cat. 20 or 21]
Femme à l'amphore (illustrated) [cat. 37]
Portrait d'homme [cat. 22]
La Baigneuse [cat. 12?]

L'Echarpe
Le Couple [cat. 11]
Maternité
Tête composition [cat. 30]
Portrait [cat. 26 or 27?]
Masque (illustrated) [cat. 32]
Composition [cat. 49 or 50]
Composition [cat. 49 or 50]

Gonzalez's List of Exhibitions (c. 1937) (transcription)

Expositions depuis la guerre, et dans l'ordre (à peu près) où se sont succédées
 ces expositions.
Salon des Artistes Français
Salon de la Nationale
Salon d'Automne (où je suis sociétaire de Peinture et Arts Décoratifs) 2 fois
Galerie de France (plusieurs fois)
Salon Surindépendants, 2 ou 3 fois
Galerie Percier
Galerie des Cahiers d'Art (3 fois)
Collège d'Espagne (Cité Universitaire), invité
Musée de Zurich, invité
Galerie Pierre
Galerie Castelucho
Musée du Jeu de Paume
Salon de l'Art Mural
Exposition 1937 (Pavillon Espagnol), invité

SUMMARY OF INTERVIEWS

In addition to allowing access to the documents, Mme. Gonzalez cheerfully submitted to interviews spread over several months in 1967, and gave me much valuable information on all aspects of her father's life and his art. I found a similar cooperation among Gonzalez's friends. Their reminiscences were more often anecdotal, but they, too, often shed light on Gonzalez's art. Although these interviews are mentioned in the text where pertinent, I shall list the names of those who were most valuable to me, and add a short statement on the nature of their information and their relationship to Gonzalez.

Gio Colucci (February 23, 1967). Artist. Met Gonzalez about 1923. Helped to confirm details of the collaboration with Picasso, although he was not too reliable for dates as they reflected precedence — Gonzalez versus Picasso — since he was quite bitter on Picasso's dominance of the art world.

Domela (May 29, 1967). Painter. Acquainted with, but not close to Gonzalez. Useful for general background on Constructivist activities in Paris.

Louis Fernandez (May 18, 1967). Artist. Met Gonzalez about 1930. Useful for Picasso and Gonzalez anecdotes. Also provided information on their collaboration. Fernandez was present at Gonzalez's funeral, probably at the request of Picasso.

Mme. Gargallo-Anguierra (March 7, 1967). Daughter of Gargallo. Her knowledge of Gonzalez and her father's career are mostly secondhand, through her mother, but she provided valuable details regarding Gargallo's work with Gonzalez.

Henri Goetz (March 1, and April 15, 1967). Painter. Met Gonzalez about 1936, through Hartung. He knew Gonzalez well, and was familiar with Gonzalez's feelings about abstract art. Also provided useful background on the "politics" of Parisian Constructivism in the thirties.

Hans Hartung (July 25, 1967). Painter. Met Gonzalez about 1936, and lived with the family after his marriage to Roberta in 1937. In addition to his fine collection of Gonzalez sculptures and drawings, which he made available, he was able, to some extent, to articulate Gonzalez's ideas on "La Nature" and proportional systems.

Jaime Sabartés (June 2, 1967). Picasso's friend and one-time secretary. Sabartés' memory by this time was rather dim, but he was able to provide memories of Barcelona as well as Paris.

Michel Seuphor (July 19, 1967). Art critic and writer. Seuphor didn't know Gonzalez personally, but was able to provide valuable information on Constructivist activities which elaborated his published material.

Tutunjian (May 24, 1967). Artist. Not a friend of Gonzalez, but like Seuphor he provided information on Parisian Constructivism of the twenties and thirties.

Christian Zervos (February 20, 1967). Editor of *Cahiers d'art* and director of the gallery. Helpful for details of the Picasso collaboration.

CHRONOLOGY

Established on the basis of interviews with Mme. Gonzalez, letters, the clipping files, catalogues, and magazine publications. All exhibitions are in Paris, unless otherwise noted.

1876 — Born in Barcelona, the last of four children, to Concordio and Pilar Gonzalez.

1892 — Exhibits, under his own name, in the Expositión di Bellas Artes y Industrias Artísticas, Barcelona: "Varios ramitos con insectos, en hierro."

1893 — Exhibits in World Colombian Exposition, Chicago.

1896 — Exhibits, under his own name, in the Expositión di Bellas Artes y Industrias Artísticas, Barcelona: "Ramo de flores, hierro forgado y repujado."

1898 — Exhibits in the Expositión di Bellas Artes y Industrias Artisticas, Barcelona: "Ramo de Amapolas, hierro forjado."

— Father Concordio dies.

c. 1900 — Gonzalez moves with his family to Paris. Shortly thereafter meets Picasso and his friends, including Manolo, Sabartés, Paco (Francisco) Durrio, and Gargallo.

1902 — Spring and summer. Spends time with Picasso in Barcelona, and later goes to Mallorca.

c. 1905 — Gonzalez meets the composer Varèse, with whom he spends time in Burgundy in 1906; they will remain friends through the years.

1906 — Gonzalez's brother, Juan, returns to Barcelona because of illness.

1907 — March–April. Exhibits in the Salon des Indépendants, 6 paintings: *Sur les fortifs, Môme au capuchon, Petit frère, Femme au fichu blanc, Maternité, Portrait de Mlle. X.*

1908 — Death of Juan, age forty, in Barcelona.

1909 — Gonzalez marries Jeanne Berton.

1911 — Daughter Roberta is born. Shortly thereafter, the parents separate, the child remaining with Gonzalez.

1913 — November. Exhibits in the Salon d'Automne, 1 painting: *Femme à la toilette*; 3 portraits in copper repoussé (one is ill. in *Montjoie!*, November–December); and various pieces of jewelry and objets d'art.

1914 — March–April. Exhibits in the Salon des Indépendants, 1 painting: *Sur la plage*; 1 repoussé mask; and jewelry.

1915 — March–April. Exhibits in the Salon des Indépendants, 6 pastels.

1916 — March–April. Exhibits in the Salon des Indépendants, 3 paintings, 2 repoussé bronzes.

1918 — Gonzalez begins his employment in the Renault branch at Boulogne-

Billancourt, where he learns the techniques of autogenous welding.

1919 — November. Exhibits as a Sociétaire in the Salon d'Automne, 1 painting: *Pêcheurs catalans*, and various objets d'art belonging to Mme. Mercereau.

1920 — April. Exhibits objets d'art in metal at the Salon des Artistes Français (review of April 14 in the *Figaro*).

— November. Exhibits in the Salle catalane at the Salon d'Automne, 3 paintings, including 2 landscapes; 1 sculpture: *Femme assise*, bronze; 2 repoussé masks in bronze and silver; decorative goldwork and jewelry.

1921 — January. Has a one-man exhibition at the Caméléon, organized by Mercereau. Includes paintings, sculpture, drawings, pastels, forged and repoussé objets d'art, and jewelry.

— April. Exhibits in the Salon des Indépendants, 3 paintings: including *Marocaine*, and *Mendiante*; 2 repoussé bronzes.

— June. Exhibits in a group show at the Galerie Devambeg which includes Epstein, Ortiz de Zarate, Kisling (review in *Radical* of June 18).

— November. Exhibits in the Salon d'Automne, 4 paintings; 4 forged bronzes; 1 forged silver; and 1 sculpture: *Eve*. One of the forged bronzes, a *Masque de femme*, bought by the state for 1,000 francs.

c. 1921 — Contact with Picasso reestablished. They see each other from time to time through the rest of the decade.

1922 — March. One-man exhibition at the Galerie Povolovsky which includes paintings, watercolors, drawings, sculpture, jewelry, various objets d'art in silver, iron, repoussé, faience, wood, and lacquer. Besides several sympathetic reviews in Parisian journals, he is mentioned in *Art News*, March 25: "Julio Gonzalez applies a large design to the smallest object, whether a ring or a wall relief" (signed "M.C.").

— May. Exhibits at the Salon de la Nationale, 2 portraits in bronze repoussé: Roger and Jean de Neyris (Fig. 4). Gustave Kahn writes of the "portraits d'un art sobre et vivant de Julio Gonzalez," in the *Mercure*, May 15, 1922.

— November. Exhibits at the Salon d'Automne, 2 paintings: *Tête d'enfant* and *Nature morte*; repoussé masks; and objets d'art in silver.

— December. Exhibits at the Caméléon, paintings, sculptures, drawings, forged and repoussé metal works, and jewelry.

1923 — January. Exhibits with Zadkine, Foujita, and others in "Peintres de Montparnasse" at the Galerie la Licorne (Gonzalez's clipping file, no source).

— November. Exhibits in the Salon d'Automne, 2 paintings: still lifes; 1 medallion in iron, commissioned by the Musée Pasteur.

1924 — June. Exhibits in the Salon des Tuileries, 3 still-life paintings (review in *Paris-Journal*, June 28).

— November. Exhibits in the Salon d'Automne, 2 paintings: *Femme au champs* and *Nature morte*.

c. 1925 — Begins visiting the dance academy of Jeanne Ronsay, to sketch. He had probably met Mlle. Ronsay through the Salon d'Automne, where she collaborated in the Section de Danse established in 1922.

1926 — Buys property in Monthion, near Paris. Later uses the friable stone from a nearby demolition site to carve various heads.

— February–March. Exhibits at the Salon des Indépendants. This includes a special retrospective for members. Included in Gonzalez's entries: 4 paintings of 1908 and 1925; 2 repoussé bronzes of 1913.

1928 — Death of Gonzalez's mother, Pilar Gonzalez-Pellicer.

— Begins collaboration with Picasso; on May 14 Picasso sends Gonzalez a letter with a check for work already completed.

— November. Exhibits in the Salon d'Automne, 4 bronze repoussé masks.

1929 — November. Exhibits first forged iron sculptures at the Salon d'Automne.

— December. Signs a contract with the Galerie de France (a small left-bank gallery on the Rue de l'Abbaye, now defunct; it has no relation to the present Galerie de France, which now handles Gonzalez's work); the contract specifies three years, all production.

1930 — February. First exhibition at the Galerie de France. A review in the *Renaissance* (February 1930) mentions various figurative works; "with [this iron], the artist encloses figures of peasants, carrying large baskets. . . ."

— December. Exhibits at Galerie de France. No catalogue, but this show probably included those pieces listed in *Pièces livrées, 1930* (Documentation). Louis Vauxcelles "discovers" Gonzalez again (*Carnet de la semaine*), December 7 having already discovered him in 1921.

1931 — May–June. Exhibits at the Galerie de France and Galerie le Centaure, Brussels. See exhibition list in Documentation.

— July. Participates in group show organized by the Casa de Catalunya held at the Galerie Billet.

— October–November. Exhibits at the Salon des Surindépendants, 8 "sculptures, fer forgé." Tériade speaks of his "style nerveux et d'un métier élégant" (*Intransigeant*, October 26). Most reviews of the exhibition single out Gonzalez and Calder.

1932 — October–November. Exhibits at the Salon des Surindépendants, 3 "sculptures fer forgé."

1933 — April. Participates in the Cahiers d'Art auction, exhibiting the

Harlequin. Other sculptors include Giacometti, Laurens, Lipchitz.

— October–November. Exhibits at the Salon des Surindépendants, 6 sculptures: *Masque bronze* (cat. 32); *Femme au fagot*, fer forgé (cat. 53); *Masque*, fer forgé; *Tête pierre*; *Le Baiser*; *Tête en bronze* (cat. 64).

— End of year. Moves studio from Rue du Médéah to larger quarters which Gonzalez built in Arceuil. Continues to live in Paris.

1934 — April. Exhibits at the Galerie Percier.

— May. Participates in "Exposition de la sculpture contemporaine" at Georges Petit. Exhibits the *Don Quixote* (cat. 23), and a *Masque*.

— Exhibits at Cahiers d'Art gallery; those pieces illustrated in *Cahiers d'art* are: *Le Pompier* (cat. 63); *Untitled* (cat. 61); *Petite trompette* (cat. 57). Cat. 61 was also illustrated in *Abstraction-Création*, no. 3.

— October–November. Participates in the exhibition, "Was ist Surrealismus?" at the Kunsthaus, Zurich. Gonzalez's entries are: *Baiser (Amoureux)* (cat. 34 or 66); *Rêve* (cat. 54); *Don Quixote* (cat. 23); *Colombine et Pierrot*; and *Femme se coiffant* (cat. 51 or 86). Other exhibitors are: Arp, Ernst, Giacometti, and Miró.

1935 — February–March. Participates in the exhibition, "Thèse, antithèse, synthèse," at the Kunstmuseum, Lucerne. Gonzalez's entries arc: *Femme se coiffant*, illustrated (cat. 86); *Maternité*, bronze (cat. 82); *Baiser*, iron; *Danse*, iron (cat. 84). All dates given in the catalogue are 1934.

— June. Organizes and participates in a group exhibition at the Galerie Castelucho (this was a small room adjoining the art supply store of his friend Castelucho). Exhibitors include Hélion, Kandinsky, Laurens, Léger, Lipchitz, Magnelli, Picasso, Benno.

— Participates in group exhibition at the Spanish foundation, Cité Universitaire. Review in *Axis*, no. 3, July, signed H. Wescher: "A figure, seemingly nothing but suppleness and dynamic accentuation. . . ."

— Publishes his response, in "Réponse à l'enquête sur l'art actuel," in *Cahiers d'art*; accompanying illustrations are: *Femme se coiffant* (cat. 86); *Les Amoureux* (cat. 66); *Tête au miroir* (cat. 80); and *Danseuse à la palette* (cat. 84).

— Anatole Jakowski publishes *Vingt trois gravures* which includes Gonzalez's drypoint and etching, *Femme se coiffant*, based on cat. 86 (Collection, Museum of Modern Art, New York).

— Exhibits at the Galerie Pierre (from Gonzalez's list of exhibitions; no further information).

1936 — February–March. Participates in "L'Art espagnol contemporain" at the Jeu de Paume. Gonzalez's entries are: *Les Acrobates* (see entry for cat. 92); *Ballarine*, argent forgé (cat. 88?); *Tête*, argent forgé (cat. 100); *Tête*, argent forgé; and *Ballarine*, argent forgé. "Une fantaisie

pleine de grâce anime les fers et les argents forgés de Julio Gonzalez" (review in *Miroir du Monde*, February 22).

— March–April. Participates in the exhibition "Cubism and Abstract Art," Museum of Modern Art, New York. Entries are: *Standing Figure* (cat. 60) and *Head* (cat. 95), which was bought from this show by the Museum.

— June–July. Participates in group show at the Galerie des Cahiers d'Art which includes Picasso, Miró, and Fernandez. Illustrated in *Cahiers d'art*: *Femme allongée* (cat. 107) and *Femme se coiffant* (cat. 108).

— Publishes "Picasso, sculpteur" in *Cahiers d'art*.

1937 — Marries Marie-Thérèse Roux, his companion of several years. Moves with his sisters and daughter to Arcueil.

— Published in Giedion-Welcker's pace-setting *Modern Plastic Art*. *L'Ange* illustrated (cat. 94).

— July–October. Participates in "Origines et développement de l'art international indépendant" at the Jeu de Paume. Exhibits the *Montserrat* (cat. 118) and the *Femme au miroir* (cat. 117).

— End of year. Exhibits the *Montserrat* at the Spanish Pavilion at the Paris World's Fair. This is the last time Gonzalez will exhibit during his lifetime.

1939 — July–September. Gonzalez and his family in the Lot (Mirabelle-par-Montcuq); unable to do any sculpture.

— September. Returns to Paris with his family.

1940 — Early June. Again goes to the Lot just before the Germans arrive in Paris; remains there for more than a year.

1941 — Fall. Returns to Paris for the last time, with his wife, leaving the rest of the family in the south.

1942 — March 27. Death of Gonzalez in Arcueil. Picasso, Fernandez, Zervos, and another friend, Mouillot, attend his funeral.

Catalogue of the Sculpture

INTRODUCTION

This catalogue comprises the years 1927 to 1942 and includes sculpture in all media.

A NOTE ON FORMAT AND TERMINOLOGY

1. The accepted, or most frequently used title is given, followed by variants, if any.
2. The material is that of the original, even if, in addition, there is an edition in bronze. Thus a sculpture in bronze, unless otherwise indicated, was executed directly in that material (forged, repoussé, etc.).
3. Information on collections is given only for the original piece.
4. Dates. The system used by the Museum of Modern Art has been employed, i.e., an assigned date is indicated in parentheses, a dated work is not in parentheses.
5. "Traditional date." Those dates given in postwar exhibition catalogues. In most cases, this information was provided by Mme. Gonzalez.
6. Distinctions between *drawings* and *studies* are made on the following basis: *Drawing* — more finished work, usually done on good paper stock and in a variety of media, including pasted papers. *Study* — or sketch, more informal, and done with pencil or pen on papers of varying quality.
7. Cross-references appear, as appropriate, for both sculptures and drawings.

CATALOGUE

1. *Profil au chapeau*
 Iron, mounted on wood plaque
 H. 25 cm.
 Coll. Musée National d'Art Moderne, Paris
 Date (c. 1927)
 This, or a similar one, was exhibited at the Galerie de France in 1930, and was described in the *Renaissance* (December 1930): "Gonzalez a sculpté aussi une tête de jeune femme parisienne avec l'indication en relief du chapeau enfoncé et du nez."
 Fig. 21

2. *Les trois éléments*
 Copper, mounted on wood plaque
 H. (of plaque) 25 cm.
 Coll. Musée National d'Art Moderne, Paris
 Date (c. 1927)

3. *Petite maternité*
 Iron
 H. 25 cm.
 Coll. Estate of Roberta Gonzalez, Paris
 Date (c. 1927)
 This is essentially the same motif on which Gonzalez based the *Montserrat* of 1937 (cat. 118).

4. *Petit visage découpé*
 Iron
 H. 14 cm.
 Coll. Estate of Roberta Gonzalez, Paris
 Date (c. 1927)

5. *Petit masque baroque*
 Iron
 H. 12·5 cm.
 Coll. Private collection, Paris
 Date (c. 1927). Traditional date. Probably done before Gonzalez began working with Picasso in 1928.
 Fig. 13

6. *Nu assis de profil*
 Iron relief
 H. 25 cm.
 Coll. Museo de Arte Moderno, Barcelona. Gift of Roberta Gonzalez
 Date (1927)

7. *A la fontaine*
 Iron
 H. 20 cm.
 Coll. Estate of Roberta Gonzalez, Paris
 Date (1927)

8. *Femme à la corbeille*
 Iron
 H.?
 Coll. Whereabouts unknown
 Date (c. 1927–29)
 Illustrated in *L'Art vivant*, VI, 1930, p. 261.
 Exhibited in the Galerie de France, 1930.

9. *Petit profil de paysanne*

Iron

H. 15 cm.

Bronze edition of 8

Coll. Estate of Roberta Gonzalez, Paris

Date (1927–29)

10. *Petit buste*

Iron

H. 8 cm.

Coll. Estate of Roberta Gonzalez, Paris

Date (c. 1928)

11. *Le Couple*

Iron

H. 8 cm.

Coll. Private collection, Paris. Formerly Galerie Denise René

Date (1929). Traditionally dated 1927–29.

First exhibited in Paris and Brussels in May–June 1931; first illustrated *A.C.* (Barcelona), no. 5, January 1932.

Fig. 28

12. *Vénus*

Iron

H.?

Coll. Whereabouts unknown

Date (1929)

Same period as *Le Couple*. All information is from Giedion-Welcker, *Contemporary Sculpture*, p. 196.

Fig. 102

13. *Masque*

Copper?

H.?

Coll. Formerly David Smith

Date (c. 1929)

Smith wrote that "This is the Head [John] Graham gave me in 1934. Its date is probably '27 to '29."

14. *Masque My*

Bronze

H. 20 cm.

Bronze edition of 9

Coll. Musée National d'Art Moderne, Paris

Date (c. 1929). Traditionally dated between 1927 and 1930.

15. *Visage intérieure. Pensive Face*

Iron

H. 28 cm.

Coll. Private collection, Ossining, New York

Date 1929. Signed and dated lower right.

16. *Femme aux genoux. Nu aux genoux*

Iron

H. 18 cm.

Coll. Estate of Roberta Gonzalez, Paris

Date 1929. Signed and dated lower right.

17. *Nu assis*

Iron

H. 15 cm.

Coll. Estate of Roberta Gonzalez, Paris

Date 1929. Signed and dated lower right.

18. *Tête de jeune fille*

Iron

H. ?

Coll. Whereabouts unknown

Date (1929 or before)

Exhibited in the Galerie de France, February 1930. Illustrated in *Renaissance*, February 1930. This is probably either the "Petite tête fer," or "Tête de femme, fer" mentioned in Gonzalez's list of "pièces livrées" (see Appendix II).

19. *Deux Paysannes*

Iron

H. 25 cm.

Coll. Museo de Arte Contemporaneo, Madrid. Gift of Roberta Gonzalez

Date (1929)

20. *Nature morte I*

Iron relief

H. 27 cm. W. 18 cm.

Coll. Private collection, Italy

Date (1929)

This is probably the piece described in the *Marseille-Matin*, August 3, 1931: "Sa bouteille inscrite dans un pot adjouré est aussi fort intéressante" (signed) Héraut. In this case, it would have been exhibited at the Galerie de France in 1931.

21. *Nature morte II*

Iron

H. 18 cm. W. 25 cm.

Coll. Museo de Arte Moderno, Barcelona. Gift of Roberta Gonzalez

Date (1929). Traditional date.

Fig. 30

22. *Masque japonais*

Bronze

H. 18 cm.

Coll. The Arthur and Madeleine Lejwa Collection, New York
Date (1929). Traditional date, 1928–29. This is a humorous portrait of Foujita, a colorful Montparnasse artist, who was well known for his bangs and nearsighted vision.
Fig. 24

23. *Don Quixote. Le Lancier*
Iron
H. 44 cm.
Bronze edition of 6
Coll. Musée National d'Art Moderne, Paris
Date (1929)
First exhibited in Paris and Brussels in 1931. Illustrated in Ricardo Perez-Alfonseca, *Julio Gonzalez*, Madrid, 1934.
Fig. 11

24. *Tête en fer poli*
Iron
H. 27 cm.
Coll. Galerie de France, Paris
Date (1929). Traditionally dated 1929–30.
Fig.23

25. *Tête en relief, dite "le poète." Masque dit "le poète"*
Iron
H. 25 cm.
Coll. Galerie de France, Paris
Date 1929. Signed and dated lower right.

26. *Masque de Pilar "dans le soleil"*
Iron
H. 18 cm.
Coll. Musée National d'Art Moderne, Paris
Date 1929. Signed and dated lower left corner.
This is a portrait of Pilar, Gonzalez's sister.
Fig. 31

27. *Masque de Roberta "dans le soleil"*
Iron
H. 18 cm.
Coll. Estate of Roberta Gonzalez, Paris
Date (1929). Traditionally dated 1927–29.
This a portrait of Roberta Gonzalez, who was about 18 at the time. Similar to

Masque de Pilar "dans le soleil," cat. 26 (Fig. 31).

28. *Tête d'homme*
Bronze or copper?
H. ?
Coll. Whereabouts unknown
Date (1929)
Illustrated in *Das Kunstblatt*, XV, August 1931, indicating that it was exhibited in Paris and Brussels in May–June 1931. This may be the piece mentioned in Gonzalez's list of "pièces livrées" as "Tête d'homme, bronze" (see Appendix II). It may also be the piece described in the *Renaissance* of December 1930: "La tête d'homme en cuivre du même artiste est plus systématique [than *Jeune fille au chapeau*] et elle me plaît moins."

29. *Petit masque découpé de Montserrat*
Iron
H. 20 cm.
Bronze edition of 9
Coll. Estate of Roberta Gonzalez, Paris
Date (1929–30). Sometimes dated as late as 1935. Although it logically belongs to this period in which Gonzalez concentrated on masks and other small pieces, it is possible that it was done later.

30. *Petit masque Don Quixote*
Bronze
H. 12·5 cm.
Coll. Museo de Arte Moderno, Barcelona. Gift of Roberta Gonzalez
Date (1929). Traditionally dated 1930. This is possible, although it seems closer to other "primitive" masks of 1929, for instance the *Tête en fer poli*, cat. 24 (Fig. 23), or the *Masque japonais*, cat. 22 (Fig. 24).
Fig. 26

31. *Tête plate. Tête*
Iron
H. 22 cm.
Coll. Hans Hartung, Paris
Date (1930 or before). Traditionally dated c. 1930.

32. *Masque espagnol*
Bronze
H. 20 cm.
Coll. Museo de Art Contemporaneo, Madrid

Date (1930). Traditional date.
Exhibited in Paris and Brussels, May–
June 1931. May be the "Tête allongée,
bronze," mentioned in Gonzalez's list
"pièces livrées" (see Appendix II).
Fig. 22

33. *Harlequin*
Iron
H. 42 cm.
Bronze edition of 4
Coll. Kunsthaus, Zurich
Date (1930). Traditional date, 1929.
First exhibited in Paris and Brussels,
May–June 1931. Gonzalez lists this as a
Harlequin in "pièces livrées" (see
Appendix II) but the gallery subsequently
refers to it in their catalogue as a
"Pierrot." Later in 1931 this was ex-
hibited in a group show of Catalan artists
at the Gallery Billiet and described by
Adolphe de Falgairolle in *Nouvelles
Littéraires,* July 11, 1931: "comment ne
pas relier à une tradition purement
catalane ce sens de l'invention et cette
transformation de la matière qui donnent
à Gonzalez la sobriété dans la fantaisie
de son 'Pierrot' en équerres, vides
losangés, et relief par arêtes subtilement
prêtées au fer forgé?" Sold at the Cahiers
d'Art auction of 1933 to André Lefèvre,
part owner of the Galerie Percier.
Illustrated in Ricardo Perez-Alfonseca,
Julio Gonzalez, 1934.
Fig. 17

34. *Le Baiser*
Iron
H. 26 cm.
Coll. The Lydia and Harry Winston
Collection (Dr. and Mrs. Barnett
Malbin), New York
Date 1930. Dated on back.
Similar in style and technique to the
Harlequin. This was probably begun in
1929 and finished sometime in the
following year. It is one of the two
"Baisers" which Gonzalez mentioned in
his list of "pièces livrées" (see Appendix
II). It was exhibited in Paris and Brussels
in May–June 1931, and illustrated in
A.C. (Barcelona), January 1932, and in
an advertisement for the Galerie de

France in *Cahiers d'art,* 1931.
Fig. 35

35. *Femme allongée lisante*
Iron
H. 35 cm.
Coll. Galerie de France, Paris. Formerly
Marie-Thérèse Gonzalez-Roux
Date 1930. Signed and dated lower left.

36. *Tête aigüe*
Iron
H. 31 cm.
Bronze edition of 9
Coll. Estate of Roberta Gonzalez, Paris
Date (1930). Traditionally dated be-
tween 1927 and 1930.
Fig. 32

37. *Femme à l'amphore No. 1*
Iron
H. ?
Coll. Whereabouts unknown.
Date (1930 or before)
Exhibited in Paris and Brussels in May–
June 1931. Illustrated in the *Kunstblatt,*
August 1931. Compare this with the
open-form sculpture *Femme à la corbeille*
of 1934, cat. 85 (Fig. 62).
Fig. 64

38. *Femme à l'amphore No. 2*
Bronze
H. 35 cm.
Coll. Estate of Roberta Gonzalez, Paris
Date (c. 1930)

39. *Femme au balai*
Iron
H. 32 cm.
Coll. The Lydia and Harry Winston
Collection (Dr. and Mrs. Barnett
Malbin), New York
Date (1930). Traditionally dated 1929
or 1930. Signed "J. Gonzalez" on back
left corner of iron base.
This was first exhibited in Paris and
Brussels in May–June 1931. Illustrated
in *L'Art vivant,* VII, 1931, p.121; and
Ricardo Perez-Alfonseca, *Julio Gonzalez,*
1934.

40. *Petit masque à l'oeil carré*
Bronze
H. 14 cm.
Coll. Museo de Arte Moderno, Barcelona.
Gift of Roberta Gonzalez

Date (c. 1930)

41. *Tête en profondeur. Tête profonde*
Iron
H. 26 cm.
Coll. Hans Hartung, Paris
Date 1930. Signed and dated on back.
Fig. 34

42. *Tête "Oncle Jean" I*
Iron
H. 38 cm.
Coll. Museo de Arte Moderno, Barcelona.
Gift of Roberta Gonzalez
Date (c. 1930). Traditional date.
"Uncle" Jean would in fact have been
Gonzalez's brother, transposed to
"uncle" in explaining it to Roberta
Gonzalez, who later had the task of
putting her father's work in order and
giving titles to many of the works.

43. *Tête "Oncle Jean" II*
Iron
H. 37·5 cm.
Coll. Private collection, Paris
Date (c. 1930)

44. *Tête penchée*
Iron
H. 17 cm.
Coll. Private collection, Paris
Date (c. 1930). Traditionally dated
1929–30.
Fig. 33

45. *Tête de la petite Montserrat*
Iron
H. 32·5 cm.
Coll. Private collection, Paris. Formerly
Hans Hartung
Date (c. 1930)
Inscription on base: "La Motserrat"
(sic). Although commonly dated 1932,
the conventions used in delineating the
facial contours with cut and bent planes,
and the ribbon motif on the bust, relates
it to earlier heads such as the two versions
of *Tête Oncle Jean*, cat. 42, 43.
Fig. 27

46. *Tête dite "le lapin"*
Iron
H. 33 cm.
Coll. Museo de Arte Contemporaneo,
Madrid. Gift of Roberta Gonzalez
Date (1930). Traditional date. Done

during the same period as *Tête en
profondeur*, cat. 41 (Fig. 34).

47. *Tête*
Iron
H. 32 cm.
Coll. Present whereabouts unknown.
Formerly André Salmon, Sanary (Var)
Date (c. 1930). Traditional date.
Similar in style and execution to *Tête
penchée*, cat. 44 (Fig. 33).

48. *Tête*
Iron
H. 40 cm.
Coll. Wilhelm-Lehmbruck Museum,
Duisberg. Formerly Maurice Raynal
Date (c. 1930). Dated by the Wilhelm-
Lehmbruck Museum 1927–29.
Fig. 36

49. *Composition*
Iron
H. ?
Coll. Whereabouts unknown
Date (early 1931 or before). First illus-
trated in *A.C.* (Barcelona), January 1932,
and exhibited in the Galerie de France
in 1931.
Fig. 18

50. *Le Baiser*
Iron
H. ?
Coll. Whereabouts unknown
Date (1931)
Dates to the same period as the Paris
Femme se coiffant, cat. 51. This is probably
the "deuxième baiser" mentioned in
Gonzalez's list of sculptures sent to the
Galerie de France in May 1931. There
are several studies dated 1930 and 1931
which seem to be related to this sculpture.
Illustrated in *Paris-Midi*, October 28,
1933, with the caption "Cette curieuse
composition-rébus est exposée aux
'Surindépendants' sous le titre *Le Baiser*."
Fig. 19

51. *Femme se coiffant*
Iron
H. 170 cm.
Coll. Musée National d'Art Moderne,
Paris
Date (1931). Probably begun late 1930.
This is almost certainly the piece de-

scribed as "un grand figure" (since it was the only large piece done up to this time) in Gonzalez's list of sculptures delivered to the Galerie de France for his exhibition in May 1931. Compare the studies for this sculpture (Figs. 38, 39).
Fig. 37

52. *Femme dite "aux trois plis"*
Iron
H. 126 cm.
Coll. Estate of Roberta Gonzalez, Paris
Date (c. 1931)

53. *Femme au fagot*
Iron
H. 36 5 cm.
Coll. Hirshhorn Museum and Sculpture Garden, Washington, D.C. Formerly M. J. Ulmann, Paris.
Date 1932. Signed "J. Gonzalez 1932." Exhibited October 1933 at the Surindépendants (see Chronology, Appendix II).

54. *Le Rêve. Le Baiser*
Iron
H. 67 cm.
Coll. Estate of Roberta Gonzalez, Paris
Date (1932). Traditionally dated 1931; this is possible, although its relationship to the *Grande trompette* of 1932, cat. 56, suggests the later date. Gonzalez gave the title "Baiser" to many of his sculptures of this period, without further distinction, so without more information, there is no sure way to know which "Baiser" is being referred to in early catalogues.
Fig. 40

55. *La Suissesse*
Iron
H. 38 cm.
Coll. Private collection, Liège
Date (1932). Traditional date.
Fig. 41

56. *Grande trompette*
Iron
H. 98 cm.
Coll. Dr. Walter Bechtler, Zurich
Date (1932). Traditional date. Compare *Le Rêve*, cat. 54 (Fig. 40) and *Petite trompette*, cat. 57 (Fig. 43).
Fig. 42

57. *Petite trompette*
Silver
H. 12 cm.
Coll. Musée National d'Art Moderne, Paris
Date (1932). Traditionally dated 1933–34. Almost certainly done after the *Grande trompette*, cat. 56 (Fig. 42).
Fig. 43

58. *Tête à l'auréole*
Iron
H. 20 cm.
Coll. Estate of Roberta Gonzalez, Paris
Date (c. 1932). Traditional date.

59. *Tête longue tige*
Iron
H. 60 cm.
Coll. Musée National d'Art Moderne, Paris
Date (1932). Traditional date 1930–33. The manner of abstraction is similar to that of such sculptures as the *Tête* in silver, cat. 62 (Fig. 51).
Fig. 48

60. *Standing Figure*
Silver
H. 21 cm.
Coll. Philadelphia Museum of Art, The A. E. Gallatin Collection, Philadelphia
Date 1932. Signed and dated on base.
This was acquired by Gallatin in 1935 for his Museum of Living Art, and was lent to the Museum of Modern Art for its exhibition, "Cubism and Abstract Art," of 1936.
Fig. 47

61. *Petite tête au triangle. Tête au triangle.*
Silver
H. 23 cm.
Coll. Hans Hartung, Paris
Date (1932–33)
First illustrated in *Abstraction-Création*, 1934. Compare *Tête dite "le pompier,"* cat. 63 (Fig. 49).
Fig. 50

62. *Tête*
Silver
H. 15 cm.
Coll. Estate of Roberta Gonzalez, Paris
Date (1932–33). Traditional date.
Done at the same period as *Petite*

trompette, cat. 57 (Fig. 43), and *Le Rêve*, cat. 54 (Fig. 40).
Fig. 51

63. *Head. Tête dite "le pompier"*
Silver
H. 14 cm.
Coll. Mr. and Mrs. Andrew Carduff Ritchie, Canaan, Connecticut
Date (1933). Traditional date.
Illustrated in *Cahiers d'art*, 1934, and *Axis*, no. 1, January 1935. Compare *Petite tête au triangle*, cat. 61 (Fig. 50).
Fig. 49

64. *Tête abstraite inclinée. Le Baiser*
Bronze
H. 23 cm.
Coll. Private collection,. Cleveland
Date (1933)
This is almost certainly the sculpture exhibited at the Surindépendants in November 1933 as "le baiser, tête en bronze." Compare *Le Baiser* in stone, cat. 106 (Fig. 84).
Fig. 87

65. *Les Amoureux I*
Iron
H. 12·5 cm.
Coll. Estate of Roberta Gonzalez, Paris
Date (1933). Traditionally dated 1932. Probably done before *Les Amoureux II*, cat. 66 (Fig. 46).

66. *Les Amoureux II*
Iron
H. 44 cm.
Bronze edition of 3
Coll. Estate of Roberta Gonzalez, Paris
Date (1933). Traditionally dated between 1933 and 1935.
Probably done before the *Tunnel*, cat. 71 (Fig. 44), to which it is related. First illustrated in *Cahiers d'art*, 1935..
Fig. 46

67. *L'Apôtre*
Iron and wood
H. 32 cm.
Bronze edition of 1
Coll. Musée National d'Art Moderne, Paris
Date (1933–34)
Illustrated in *d'Aci d'Alla* (Barcelona), December 1934.

68. *Barbe et moustache*
Wood
H. 20·5 cm.
Bronze edition of 1
Coll. Musée National d'Art Moderne, Paris
Date (1933–34)

69. *Petit masque*
Wood
H. 5 cm.
Bronze edition of 1
Coll. Estate of Roberta Gonzalez, Paris
Date (1933–34)

70. *Petite maternité*
Wood
H. 13 cm.
Bronze edition of 1
Coll. Musée National d'Art Moderne, Paris
Date (1933–34)

71. *Tête dite "le tunnel"*
Iron
H. 46 cm.
Bronze edition of 4
Coll. Tate Gallery, London
Date (1933–34). Traditionally dated between 1933 and 1935.
Stylistically, this falls between sculptures such as the *Amoureux II* cat. 66 (Fig. 46), and the open-form constructions such as the Stockholm *Femme se coiffant*, cat. 86 (Fig. 55). Compare the drawing done after this sculpture, dated 1934 (Fig. 45); Gonzalez gave this drawing to Gallatin when he purchased the *Standing Figure*, cat. 60.

72. *Tête d'homme couchée*
Stone
H. 20 cm.
Bronze edition of 9
Coll. Estate of Roberta Gonzalez, Paris
Date (1933–35). Traditional date.
The heads in stone, of which a selection is included here, are difficult to date with any precision. Although they are stylistically coherent, they cannot be dated by external evidence such as dated drawings, contemporary exhibitions, etc. In a general way, they are certainly related to Gonzalez's interest in closed-form, cubic sculpture in metal, which begins

about 1935. Most of the heads are carved in a friable stone obtained near his small property in Monthion which he bought in 1926.

73. *Jeune fille mélancholique*
Stone
H. 24·5 cm.
Bronze edition of 9
Coll. Estate of Roberta Gonzalez, Paris
Date (1933–35). Traditional date.
See entry for cat. 72.

74. *Jeune fille fière*
Stone
H. 31 cm.
Bronze edition of 6
Coll. Estate of Roberta Gonzalez, Paris
Date (1933–35). Traditional date.
See entry for cat. 72.
Fig. 83

75. *Tête, double tête*
Stone
H. 20 cm.
Bronze edition of 9
Coll. Estate of Roberta Gonzalez, Paris
Date (1933–35). Traditional date.
See entry for cat. 72.
Figs. 85, 86

76. *Tête plate No. 1 Monthyon*
Stone
H. 21 cm.
Bronze edition of 9
Coll. Estate of Roberta Gonzalez, Paris
Date (c. 1933–36). Traditional date.
See entry for cat. 72.

77. *Tête plate No. 2*
Stone
H. 19·5 cm.
Bronze edition of 9
Coll. Estate of Roberta Gonzalez, Paris
Date (1933–36). Traditional date.
See entry for cat. 72.

78. *Jeune fille nostalgique*
Stone
H. 24·5 cm.
Bronze edition of 9
Coll. Estate of Roberta Gonzalez, Paris
Date (1933–36). Traditional date.
See entry for cat. 72.

79. *Petite paysanne*
Silver
H. 16·5 cm.

Coll. Estate of Roberta Gonzalez, Paris
Date (1934). Traditional date. This could, however, have been done earlier; the head is similar to *Tête de la petite Montserrat*, cat. 45 (Fig. 27).

80. *Tête au miroir*
Iron
H. 59 cm.
Bronze edition of 1
Coll. Present whereabouts unknown. Formerly Christian Zervos, Paris
Date (1934). Traditional date.
The date is confirmed by several studies and drawings, all dated 1934 (Fig. 72). There is a possibility, however, that this head, or one similar to it which is now lost, was exhibited in November 1933 at the Surindépendants. Since the exhibition catalogues are often incomplete, the fact that this head is not listed is no guarantee that it was not exhibited, for in a review in a Liège newspaper one reads the following commentary on Gonzalez: "It would be unfortunate to pass up a superb Lion's head, whose mouth is embellished with a plate containing two fried eggs. It makes a stupendous effect" (Liège, November 29, 1933).
Fig. 71

81. *Daphné*
Iron
H. 142 cm.
Bronze edition of 2
Coll. Dr. Walter Bechtler, Zurich
Date (1934). Traditionally dated 1930–33.
Roberta Gonzalez recalls that this sculpture was completed in the new studio at Arcueil (see Chronology, Appendix II), dating it into 1934.
Figs. 53, 54

82. *Petite maternité. Maternité au rectangle*
Copper wire
H. 76 cm.
Coll. Staatsgalerie, Stuttgart
Date (1934). This is the date given in the Lucerne catalogue of 1935. Compare this with the *Maternité* in iron, cat. 83 (Fig. 66), for which this sculpture may be a preliminary study.

83. *Maternité*

Iron
H. 32 cm.
Coll. Tate Gallery, London
Date (1934). Traditionally dated 1933.
In a questionnaire addressed to Mme.
Gonzalez in 1968, she agreed that this
piece was executed in the new studio at
Arcueil, which Gonzalez began using
late in 1933.
Fig. 66

84. *Danseuse à la palette*
Iron
H. 82 cm.
Bronze edition of 3
Coll. Estate of Roberta Gonzalez, Paris
Date (1934). Traditionally dated 1933.
The studies for this sculpture are dated
1934 (Figs. 59, 60), indicating that
Gonzalez was working on it in this year.
This was also the date given in the
Lucerne catalogue of 1935.
Fig. 58

85. *Femme à la corbeille. Le Tub*
Iron
H. 180 cm.
Coll. Estate of Roberta Gonzalez, Paris
Date (1934). Traditionally dated 1931,
but Mme. Gonzalez recalls that this was
done in the studio at Arcueil, which
would date it after the end of 1933.
Compare with *Femme à l'amphore No. 1*,
cat. 37 (Fig. 64) and the study for this
sculpture, dated 1934 (Fig. 65).
Fig. 62

86. *Femme se coiffant*
Iron
H. 122 cm.
Coll. Moderna Museet, Stockholm
Date (late 1934). Traditionally dated
1931.
1934 is the date given in the Lucerne
catalogue of 1935, and the numerous
studies and drawings for this sculpture
are all dated 1934 (Figs. 56, 57).
Fig. 55

87. *Grand profil de paysanne*
Iron
H. 41·9 cm.
Bronze edition of 8
Coll. Galerie de France, Paris
Date (c. 1934–35)

Fig. 108

88. *Petite danseuse*
Silver
H. 22 cm.
Coll. Musée National d'Art Moderne,
Paris
Date (1934–35). Traditionally dated
variously between 1934 and 1937.
Compare this with drawings for *Danseuse
à la palette* (Figs. 59, 60). This may be the
sculpture exhibited in 1936 at the Jeu de
Paume as "Ballarine, argent forgé."
Fig. 61

89. *Danseuse échevelée*
Iron
H. 62 cm.
Coll. Musée de Nantes, Centre Gildas
Fardel, Nantes
Date (1935). Traditionally dated
variously between 1932 and 1937.
Similar in style and execution to *La
Prière*, cat. 93 (Fig. 70) and *Petite
danseuse*, cat. 88 (Fig. 61).

90. *Cagoulard*
Bronze
L. 22 cm.
Bronze edition of 9
Coll. Musée National d'Art Moderne,
Paris
Date (1935). Traditionally dated be-
tween 1933 and 1935.
A related drawing, dated 1935, is in the
collection of the Museum of Modern Art,
New York.
Fig. 88

91. *Petite danseuse*
Iron
H. 17·5 cm.
Bronze edition of 6
Coll. Musée National d'Art Moderne,
Paris
Date (1935). Traditional date.
No studies are known to exist. Probably
done at about the same time as other
dancers such as the *Danseuse à la palette*,
cat. 84 (Fig. 58).
Fig. 101

92. *Figure debout. Personnage debout*
Iron
H. 128 cm.
Coll. Foundation Maeght, St. Paul. Gift

of Roberta Gonzalez

Date (1935). Traditionally dated 1931–33.

In 1935, Gonzalez made a sculpture called "Les Acrobates" (Fig. 69), which he exhibited at the Jeu de Paume early in 1936. Realizing that the sculpture was unstable, Gonzalez separated it into two pieces which today are known as *Figure debout*, which can be recognized as the base and central part of "Les Acrobates," and *La Prière*, which can be recognized as the flying figure, cat. 93.

Fig. 68

93. *La Prière*

Iron

H. 92 cm.

Coll. National Museum Kröller-Müller, Otterloo, The Netherlands

Date (1935). Traditionally dated 1932. See entry for *Figure debout*, cat. 92.

Fig. 70

94. *L'Ange. L'Insecte. Danseuse*

Iron

H. 160 cm.

Coll. Musée National d'Art Moderne, Paris

Date (1935). Traditionally dated 1933. The unusually complete series of nineteen dated and numbered studies indicate that Gonzalez was working on this sculpture in 1935. Thirteen studies remain (see Figs. 75–78). 1935 was also the date given by Giedion-Welcker in *Modern Plastic Art*, 1937. Gonzalez's original title for this sculpture was *L'Insecte*; it was Picasso who rebaptized it with its present title after seeing it in Gonzalez's studio (interview with Mme. Gonzalez).

Fig. 74

95. *Head. L'Escargot*

Iron

H. 45 cm.

Coll. Museum of Modern Art, New York

Date (1935). Sometimes dated 1934.

A series of four sequentially numbered drawings dated 1935 (Collection Museum of Modern Art, New York) indicate that Gonzalez was working on this sculpture at that time. He may have begun it late in the year, and only finished it early in

1936 (questionnaire addressed to Mme. Gonzalez, 1968). It was included in the exhibition, "Cubism and Abstract Art," and bought by the museum at that time.

Fig. 73

96. *La Giraffe*

Iron

H. 95 cm.

Coll. Estate of Roberta Gonzalez, Paris

Date (1935). Traditionally dated 1934. This was probably done at the same time as the New York *Head*, cat. 95, and possibly also finished early 1936.

Fig. 81

97. *Femme assise I*

Iron

H. 116 cm.

Coll. Estate of Roberta Gonzalez, Paris

Date (c. 1935). Traditional date.

Related to other cubic works of this period, for example *Petite femme assise*, cat. 99, and *Reclining Figure*, cat. 107 (Fig. 94). The study for this figure is dated 1935 (Fig. 79).

Fig. 80

98. *Femme assise II*

Iron

H. 85·5 cm.

Bronze edition of 2

Coll. Estate of Roberta Gonzalez, Paris

Date (c. 1935). See entry for *Femme assise I*, cat. 97.

Fig. 123

99. *Petite femme assise*

Bronze, from plaster original

H. 14 cm.

Bronze edition of 9

Coll. Estate of Roberta Gonzalez, Paris

Date (1935–36). Traditionally dated 1935.

No known studies remain. The cubic rendering of volumes is similar to the *Tête couchée, petite*, cat. 101 (Fig. 89). The classical restraint and serenity also recall the *Montserrat* of 1937, cat. 118 (Fig. 115).

100. *Petit masque argent*

Silver

H. 6 cm.

Coll. Musée National d'Art Moderne, Paris

Date (1935–36). Traditionally dated

variously between 1934 and 1937.
Similar to a cubic head in plaster by Giacometti, illustrated in *Cahiers d'art*, 1935, p. 19 (Fig. 134).
Fig. 91

101. *Tête couchée, petite*
Bronze, from plaster original
H. 16 cm.
Bronze edition of 9
Coll. Estate of Roberta Gonzalez, Paris
Date (1935–36)
Done at about the same time as the *Petit masque argent*, cat. 100 (Fig. 91). Compare this with the drawing, *Tête aux cubes* (Fig. 90).
Fig. 89

102. *Masque l'aimée*
Iron
H. 25 cm.
Coll. The Arthur and Madeleine Lejwa Collection, New York
Date (c. 1936)
This continues, in a more abstract style, the cutout masks of the early thirties. It is a formal complement of the *Tête couchée, petite*, cat. 101 (Fig. 89) and other cubic works of the period.

103. *Buste d'une femme*
Iron
H. 48·4 cm.
Coll. Estate of Roberta Gonzalez, Paris
Date (c. 1936)

104. *Torse. Torso*
Iron
H. 61·5 cm.
Coll. Museum of Modern Art, New York
Date (c. 1936). Traditional date.
Figs. 106, 107

105. *Torse égyptien. Petit torse égyptien*
Iron
H. 25 cm.
Bronze edition of 9
Coll. Estate of Roberta Gonzalez, Paris
Date (c. 1936). Traditionally dated 1935–37.
Probably done about the same time as the *Torse* of c. 1936, cat. 104 (Figs. 106, 107).

106. *Le Baiser. Tête plate dite "le baiser"*
Stone
H. 24 cm.
Bronze edition of 9

Coll. Estate of Roberta Gonzalez, Paris
Date (c. 1936)
Mme. Gonzalez indicated that this was probably done in 1934–35, or possibly as late as 1937 (interview).
Fig. 84

107. *Reclining Figure*
Iron
H. 42·5 cm.
Coll. Nelson A. Rockefeller, New York
Date (1936). Traditionally dated 1934 or 1935.
There are several related drawings dated 1935 and 1936. The closest one, of 1936 (Fig. 95), was probably done after the sculpture. Related to the *Woman Combing Her Hair* of 1936, cat. 108 (Fig. 92).
Fig. 94

108. *Woman Combing Her Hair*
Iron
H. 130 cm.
Coll. Museum of Modern Art, New York
Date (1936). Traditional date.
There are many drawings and studies for this sculpture, all dated 1936, except the study closest to the finished sculpture; the lower left corner, where it may once have been dated, has been burned (Fig. 93).
Fig. 92

109. *Personnage allongé*
Iron
H. 25 cm.
Coll. Musée National d'Art Moderne, Paris
Date (c. 1936)
There are several related drawings dated 1936. Compare the other two reclining figures, cat. 107 (Fig. 94) and cat. 110.
Fig. 96

110. *Femme allongée. Personnage étendu*
Bronze
H. 33 cm.
Coll. Private collection, Paris. Formerly Gildas Fardel
Date (c. 1936). Traditionally dated 1935 or 1936.
Probably done at the same time as the other two reclining figures, cat. 107 (Fig. 94) and cat. 109 (Fig. 96).

111. *Grande Vénus*
Iron

H. 27·5 cm.
Bronze edition of 9
Coll. Estate of Roberta Gonzalez, Paris
Date (1936). Traditionally dated 1935–37.
Done at about the same time as the *Petite Vénus*, cat. 112 (Fig. 104). Compare the New York *Woman Combing Her Hair*, cat. 108 (Fig. 92).
Fig. 103

112. *Petite Vénus*
Iron
H. 29 cm.
Bronze edition of 6
Coll. Estate of Roberta Gonzalez, Paris
Date (1936). Traditionally dated 1935–37.
Done at about the same time as the *Grande Vénus*, cat. 111 (Fig. 103).
Fig. 104

113. *Grande faucille*
Bronze
H. 51 cm.
Coll. M. Prévot-Douatte, Paris
Date (1936–37). Traditional date.
A drawing probably done after the sculpture is dated 1937.
Fig. 97

114. *Petite faucille. Femme debout*
Bronze
H. 30 cm.
Bronze edition of 6
Coll. Estate of Roberta Gonzalez, Paris
Date (1937)
Done at about the same time as the *Grande faucille*, cat. 113 (Fig. 97). Compare with the two *Hommes cactus*, cat. 121 (Fig. 110) and cat. 122 (Fig. 111), and *L'Homme gothique*, cat. 120 (Fig. 124).
Fig. 98

115. *L'Ostensoir*
Iron
H. ?
Coll. Whereabouts unknown
Date (c. 1937)
Fig. 105

116. *Danseuse à la marguerite*
Iron
H. 46 cm.
Bronze edition of 6
Coll. Estate of Roberta Gonzalez, Paris
Date (1937). Traditionally dated 1937–

38.
No known studies remain. Compare *Grande faucille*, cat. 113 (Fig. 97). This is the last of the series of dancers.
Fig. 100

117. *Femme au miroir*
Iron
H. 205 cm.
Coll. Estate of Roberta Gonzalez, Paris
Date (1937). Traditionally dated 1936. This was probably begun in 1936, but the great number of studies, dated as late as July 1937, indicate that he worked on this through the first half of the year. Executed concurrently with the *Montserrat*, cat. 118 (Fig. 115) (interview with Mme. Gonzalez).
Fig. 109

118. *Montserrat*
Iron
H. 162·5 cm.
Coll. Stedelijk Museum, Amsterdam
Date (1937). Traditional date.
Probably begun 1936; done concurrently with *Femme au miroir*, cat. 117 (Fig. 109). Exhibited at the Spanish Pavilion of the Paris World's Fair, 1937.
Fig. 115

119. *Masque de la Montserrat criant*
Iron
H. 27 cm.
Bronze edition of 6
Coll. Musée National d'Art Moderne, Paris
Date (1937). Traditional date 1935 or 1936.
Although similar in technical style to the *Torse* of c. 1936, cat. 104 (Figs. 106, 107), the expressive screaming figures do not appear elsewhere in the sculpture or drawings before 1937.
Fig. 119

120. *L'Homme gothique. Personnage debout*
Iron
H. 57 cm.
Bronze edition of 2
Coll. Hans Hartung, Paris
Date 1937. Signed and dated on the stone socle; the markings on the stone are not clear, but the last number, "7," is the most visible. Compare *Petite faucille*, cat. 114 (Fig. 98), the two *Hommes cactus*,

cat. 121 (Fig. 110) and cat. 122 (Fig. 111), and the drawing after the sculpture, dated 1937 (Fig. 125).
Fig. 124

121. *L'Homme cactus I*
Iron
H. 65 cm.
Bronze edition of 3
Coll. Estate of Roberta Gonzalez, Paris
Date (1938). Traditional date 1939–40.
There are at least two drawings dated toward the end of 1938 which appear to be after the sculpture (Fig. 112).
Fig. 110

122. *L'Homme cactus II*
Iron
H. 78 cm.
Bronze edition of 3
Coll. M. Prévot-Douatte, Paris
Date (1939). Traditionally dated 1939–40.
A second and curvilinear version of the *Homme cactus I*, cat. 121 (Fig. 110). There are several dated drawings done after the sculpture (Fig. 114).
Fig. 111

123. *Tête d'homme*
Copper repoussé
H. 26 cm.
Coll. Estate of Roberta Gonzalez, Paris
Date (1941)

124. *Portrait de Marie-Thérèse*
Bronze
H. 20 cm.
Coll. Private collection, Paris. Formerly Mariè-Thérèse Gonzalez-Roux
Date (1941–42)

125. *Petite Montserrat effrayée*
Bronze, from plastilene original
H. 30 cm.
Bronze edition of 9
Coll. Estate of Roberta Gonzalez, Paris
Date (late 1941, early 1942). Traditional date.
This was probably intended as a preparation for a larger figure of the Montserrat, of which only the head was finished; see entry for cat. 128.
Fig. 120

126. *Masque couché, dit "le religieux"*
Plaster

H. 17 cm.
Bronze edition of 9
Coll. Estate of Roberta Gonzalez, Paris
Date (1941–42)
Done between the time Gonzalez returned to Paris in the fall of 1941 and his death in March 1942.

127. *Médaille*
Plaster
H. 17 cm.
Bronze edition of 9
Coll. Estate of Roberta Gonzalez, Paris
Date (1942)
Done between the time of Gonzalez's return to Paris in the fall of 1941 and his death in March 1942.

128. *Tête de la Montserrat criant II*
Plaster
H. 32 cm.
Bronze edition of 6
Coll. Estate of Roberta Gonzalez, Paris
Date (1942). Traditional date.
This is part of a full figure sculpture which remained incomplete at the time of Gonzalez's death in March 1942. Other fragments of the sculpture, two arms and hands, formerly in the collection of Mme. Gonzalez-Roux, suggest that the posture of the figure would have been similar to that of the *Petite Montserrat effrayée*, cat. 125 (Fig. 120).
Fig. 121

129. *Sculpture dite abstraite*, unfinished
Plaster
H. 31·5 cm.
Bronze edition of 6
Coll. Estate of Roberta Gonzalez, Paris
Date (1942). Traditional date.
Gonzalez was apparently working on this at the time of his death in March 1942. Although called abstract, it bears an unmistakable relationship to many drawings of figures with upstretched arms of this period (Fig. 128).
Fig. 127

130. *Masque rond*
Bronze repoussé
H. 20 cm.
Coll. Estate of Roberta Gonzalez, Paris
Date (1942)

Bibliography

The bibliography is arranged in the following sections:

I. Writings by Gonzalez, in chronological order.
II. Works on Gonzalez, in chronological order. The bibliography up to 1952 is comprehensive. Because of the importance of the 1952 exhibition at the Musée National d'Art Moderne in Paris in establishing Gonzalez's reputation, the bibliographical entries for the years since that date present a critical selection, concentrating on one-artist exhibition catalogues, important exhibition reviews, and general works which include substantial references to Gonzalez.
III. General. Works consulted or cited, in alphabetical order.

I. WRITINGS BY GONZALEZ, IN CHRONOLOGICAL ORDER

"Picasso sculpteur et les cathédrales." [1932]. Manuscript in the collection of Mme. Gonzalez, published here in Appendix I.

"Réponse à l'enquête sur l'art actuel," *Cahiers d'art*, Vol. 10, 1935, pp. 32–34.

"Desde Paris," *Cahiers d'art*, Vol. 10, 1935, p. 242. In Catalan.

"Picasso sculpteur," *Cahiers d'art*, Vol. 11, 1936, pp. 189–91.

"Notations," *Julio Gonzalez*, Paris, 1952. First publication of the "Notations," which was edited from "Picasso sculpteur et les cathédrales."

II. WORKS ON GONZALEZ, IN CHRONOLOGICAL ORDER

Paris, Société des Artistes Indépendants. *Catalogue* for the years 1907, 1914–16, 1921, 1926.

Paris, Salon d'Automne. *Catalogue* for the years 1913, 1919–24, 1928, 1929.

Paris, Société Nationale des Beaux-Arts. *Catalogue* for the years 1920, 1922.

Falgairolle, Adolphe. "Catalans al Saló de Tardor," *D'Aci d'allà* [Barcelona], Jan. 1925.

Julio Gonzalez: Sculpture in Iron

Paris, Galerie de France. *Julio Gonzalez*. Paris, 1931. Exhibition also shown in Brussels, Galerie le Centaure.

Paris, Association Artistique des Surindépendants. *Catalogue* for the years 1930–33.

Westheim, Paul. "Paris neue Zeilsetzung," *Das Kunstblatt*, Vol. 15, Aug. 1931, pp. 244–46.

Fernandez, Luis. "El Escultor Gonzalez," *A.C.* [Barcelona], Vol. 2, no. 5, 1932, pp. 30–31.

Paris, Galerie Percier. *Julio Gonzalez*. Paris, 1934. Foreword by Maurice Raynal.

Jakovski, Anatole. "Julio Gonzalez [Galerie Percier]," *Cahiers d'art*, Vol. 9, 1934, pp. 207–09.

Perez-Alfonseca, Ricardo. "Julio Gonzalez: Escultor en hierro y espacio forjados," *Cartillas* [Madrid], Spring 1934.

Perez-Alfonseca, Ricardo. ["Julio Gonzalez,"] *Gaceta de arte* [Tenerife], Vol. 3, Sept.–Oct. 1934.

Jakovski, Anatole. ["Gonzalez,"] *D'Aci d'allà* [Barcelona], Vol. 22, no. 191, Dec. 1934, p. [52].

Zurich, Kunsthaus. *Was ist Surrealismus?* Zurich, 1934. Foreword by Max Ernst.

Jakovski, Anatole. "Inscriptions under Pictures," *Axis*, no. 1, Jan. 1935, pp. 14–20.

Giedion-Welcker, Carola. "New Roads in Modern Sculpture," *Transition*, no. 23, Feb. 1935, p. 198.

Wescher, H. "Paris Notes," *Axis*, no. 3, July 1935, p. 29.

Lucerne, Kunstmuseum. *Thèse, antithèse, synthèse*. Lucerne, 1935. Foreword by Anatole Jakovski.

Dudley, Dorothy. "Four Post-Moderns," *Magazine of Art*, Vol. 28, no. 9, Sept. 1935, pp. 546–47, 572.

[Illustrations], *Cahiers d'art*, Vol. 11, 1936, pp. 201–02.

Paris, Musée du Jeu de Paume. *L'Art espagnol contemporain*. Paris, 1936.

Barr, Alfred H. *Cubism and Abstract Art*. New York: Museum of Modern Art, 1936.

Giedion-Welcker, Carola. *Modern Plastic Art*. Zurich: H. Girsberger, 1937.

Paris, Musée du Jeu de Paume. *Origines et développement de l'art international indépendant*. Paris, 1937.

Paris, Galerie L. Reyman. *Premier salon d'art catalan*. Paris, 1946.

Degand, Léon. "Un Méconnu volontaire: Julio Gonzalez," *Juin*, Oct. 6, 1946.

Prague, Dům Umění Nám. *Umění republikanského Španělska. Španělsti umělci pařizské Školy*. Prague, 1946 [Prague, House of Art. *The Art of Republican Spain. Spanish Artists of the School of Paris*].

Cassou, Jean. "Julio Gonzalez," *Cahiers d'art*, Vol. 22, 1947, pp. 135–41.

Degand, Léon. "Julio Gonzalez, 1876–1942," *Art d'aujourd'hui*, Vol. 6, Jan. 1950, pp. [16–20].

"Les Danseuses," *Du*, Vol. 10, no. 5, May 1950, pp. 28–29.

Paris, Musée National d'Art Moderne. *Julio Gonzalez, sculptures*. Paris, 1952. Introduction by Jean Cassou.

Brugière, P.-G. "Julio Gonzalez: Les étapes de l'oeuvre," *Cahiers d'art*, Vol. 27, 1952, pp. 19–31.

Estienne, Charles. "Un grand sculpteur: Gonzalez," *L'Observateur*, no. 91, Feb. 7, 1952, pp. 20–21.

Klerx, Alexandre. "Julio Gonzalez; ouvrier du fer," *Beaux Arts* [Brussels], Feb. 15, 1952.

Courthion, Pierre. "Gonzalez au Musée d'Art Moderne," *XX^e siècle*, n.s., no. 3, 1952, p. 81.

Amsterdam, Stedelijk Museum. *Julio Gonzalez*. Amsterdam, 1955. Text in Dutch and French. Biblio. Exhibition also shown at Brussels, Palais des Beaux Arts; Berne, Kunsthalle; La Chaux de Fonds, Musée des Beaux Arts.

Netter, Maria. "Hommage à Gonzalez — Eisenplastik," *Werk* [Zurich], Vol. 42, no. 8, Aug. 1955, pp. 164–66.

Cirlot, Juan Eduardo. "El Escultor Julio Gonzalez," *Goya*, Vol. 4, 1955, pp. 206–12.

Jiminez-Placer y Suarez de Lezo. [Julio Gonzalez] in *Historia del arte español*. Madrid, Vol. 2, 1955, pp. 968–71.

New York, Museum of Modern Art. *Julio Gonzalez*. New York, 1956. Introduction by Andrew C. Ritchie. Exhibition also shown at Minneapolis Institute of Arts. Biblio. First one-artist exhibition in the United States.

New York, Museum of Modern Art. *Gonzalez Scrapbook: Statements and Writings about Julio*

Gonzalez. n.p., n.d. Clipping file available in the library of the Museum of Modern Art. Compiled in preparation for the 1956 exhibition.

New York, Kleeman Gallery. *Julio Gonzalez*. New York, 1956. Preface by Charles Weidler.

Steinberg, Leo. "Month in Review," *Arts*, Vol. 30, no. 6, 1956, pp. 52–54.

Smith, David. "Julio Gonzalez, First Master of the Torch," *Art News*, Vol. 54, no. 9, Feb. 1956, pp. 34–37, 64–65.

Gonzalez, Roberta. "Julio Gonzalez, My Father," *Arts*, Vol. 30, no. 5, Feb. 1956, pp. 20–24.

Paris, Galerie Berggruen. *Julio Gonzalez: Dessins et aquarelles*. Paris, 1957. Preface by George Salles.

Hanover, Kestner Gesellschaft. *Julio Gonzalez*. Hanover, 1958. Introduction by Werner Schmalenbach. Exhibition also shown at Krefeld, Museum Haus Lange; Dortmund, Museum an Ostwall; Leverkusen, Stedelijk Museum.

Paris, Galerie de France. *Julio Gonzalez*. Paris, 1959. Biblio.

Degand, Léon. *Gonzalez*. New York, 1959. Biblio.

Madrid, Ateneo de Madrid. *Julio Gonzalez*. Madrid, 1960. Introduction by Alfonso Roig.

Cirici-Pellicer, Alejandro. "Arts plastiques: Juli Gonzalez i 'La Montserrat,'" *Serra d'or*, 2ᵉ època, Any 11, no. 6, June 1960, pp. 25–27.

New York, Galerie Chalette. *Julio Gonzalez*. New York, 1961. Introductory essay by Hilton Kramer. Biblio.

Kosloff, Max. [Review of exhibition at Galerie Chalette]. *The Nation*. Nov. 25, 1961, p. 439.

Aguilera Cerni, Vicente. *Julio Gonzalez*. Rome, 1962. Text in Spanish, Italian, English. Biblio.

Gottlieb, Carla. "The Pregnant Woman, the Flag, the Eye: Three New Themes in Twentieth Century Art," *Journal of Aesthetics and Art Criticism*, Vol. 21, no. 2, Winter 1962, pp. 177–87.

Arean, Carlos Antonio. "La Escultura no imitativa en España," *Hogar y arquitectura*, no. 46, May–June 1963, pp. 48–64.

Paris, Galerie de France. *Joan, Julio et Roberta Gonzalez: Peintures et dessins*. Paris, 1965. Introduction by Pierre Descargues.

Arean, Carlos Antonio. "Julio Gonzalez y la problematica de la escultura del siglo XX," *Quadernos de arte* [Madrid], no. 60, 1965, n.p.

Los Angeles, Felix Landau Gallery. *Julio Gonzalez: Sculpture, Paintings and Drawings*. Los Angeles, 1965.

Danieli, Fidel. "Julio Gonzalez: A Representative Showing at the Landau Gallery," *Artforum*, Vol. 4, no. 4, Dec. 1965, pp. 28–29.

Pradel, Marie N. "La Donation Gonzalez au Musée National d'Art Moderne," *La Revue du Louvre*, no. 1, 1966. Introductory essay, and catalogue of the donation.

Pradel de Grandry, Marie N. *Julio Gonzalez*, no. 25 of *I Maestri della scultura*. Milan, 1966.

Turin, Galleria Civica d'Arte Moderna. *Julio Gonzalez*. Turin, 1967. Introductory essay by Luigi Mallé, "Fatica e fervore in Julio Gonzalez." Biblio.

Withers, Josephine. Preface, *Julio Gonzalez: Les Matériaux de son expression*. Paris: Galerie de France, 1969. Exhibition also shown in New York, Montreal, Zurich, London, Essen, and Copenhagen. Preface reprinted in *Art and Artists*, Vol. 5, Oct. 1970, pp. 66–69.

London, Tate Gallery. *Julio Gonzalez*. London, 1970. Exhibition catalogue. Includes "Notes on Gonzalez" by Roberta Gonzalez and Hans Hartung.

Descargues, Pierre. "Gonzalez, sculpteur du fer," *XXᵉ siècle*, n.s., no. 35, Dec. 1970, pp. 151–56.

Descargues, Pierre. *Julio Gonzalez*. Paris: Le Musée de Poche, 1971.

Saint-Paul, Fondation Maeght. *Donation Gonzalez*. Saint-Paul, 1972. Catalogue of the gift.

Carmean, A. E. "Cactus Man Number Two," *Bulletin of the Museum of Fine Arts, Houston*, n.s., Vol. IV, no. 3, Fall 1973, pp. 38–45.

Tucker, William. *Early Modern Sculpture*. New York: Oxford University Press, 1974. Gonzalez essay first published in *Studio International*, Vol. 180, Dec. 1970, pp. 236–39.

Alley, Ronald. *The Gonzalez Gift to the Tate Gallery: Drawings by Joan and Julio Gonzalez Presented to the Tate Gallery by Mme. Roberta Gonzalez-Richard*. London: Tate Gallery, 1974.

Gibert, Josette. *Catalogue raisonné des dessins de Julio Gonzalez*. Paris: Carmen Martinez, 1975. 9 vols.

Withers, Josephine. "The Artistic Collaboration of Pablo Picasso and Julio Gonzalez," *Art Journal*, Winter 1975–76, pp. 107–14.

New York, Pace Gallery, *Julio Gonzalez*. New York, 1976.

III. GENERAL. WORKS CONSULTED OR CITED, IN ALPHABETICAL ORDER

Abulina, R. *Vera Ignat'evna Mukhina*. Moscow, 1954.

Arp, Jean. *On My Way*. New York: Wittenborn, 1948.

———— *Jours éffeuillés: Poèmes, essais, souvenirs, 1920–1965*. Paris: Gallimard, 1966. Preface by Marcel Jean.

"L'Art usual: L'Ambient artistic," *Pel y ploma*, no. 44, Mar. 31, 1900, pp. [2–3].

Barcelona, Ateneo Barcelones. *Manifestación artística del Ateneo barcelones*. Barcelona, 1893.

Barcelona, *Catálogo de la primera exposición general de bellas artes*. Barcelona, 1891.

Barcelona, *Catálogo de la exposición nacional de industrias artísticas e internacional de reproducciones*. Barcelona, 1892.

Barcelona, *Catálogo de la segunda exposición general de bellas artes e industrias artísticas*. Barcelona, 1894.

Barcelona, *Catálogo ilustrado de la tercera exposición general de bellas artes e industrias artísticas*. Barcelona, 1896.

Barcelona, *Cuarto exposición de bellas artes e industrias artísticas, Catálogo ilustrado*. Barcelona, 1898.

Barr, Alfred H. *Picasso, Fifty Years of His Art*. New York: Museum of Modern Art, 1946.

Block, Susi. *The Early Works of Alberto Giacometti: The Development of the Tableau-objet*. Master's Thesis, New York University, 1963. Copy in the library of the Museum of Modern Art.

Bohigas-Tarrago. "Apuntes para la historia de las exposiciones oficiales de arte de Barcelona de 1890–1900," *Anales* (de Museo de Arte Moderno), Barcelona, Vol. 3, Apr. 2, 1945, pp. 95–112.

Brassaï. *Picasso and Co*. New York: Doubleday, 1966.

Breton, André. "Picasso dans son élément," *Minotaure*, Vol. 1, June 1933, pp. 3–[29]. Illustrated with photographs of Picasso's Boisgeloup sculpture studios by Brassaï.

Bucarelli, Palma. *Giacometti*. Rome: Editalia, 1962.

Camon-Aznar, José. *Picasso y el Cubismo*. Madrid: Espasa-Calpe, 1956.

Carrieri, Raffaele. *Il Futurismo*. Milan: Edizioni del Milione, 1961.

Cirici-Pellicer, Alejandro. *El Arte modernista catalán*. Barcelona: Aymá, 1951.

Cirlot, Juan Eduardo. "Schema de la sculpture espagnole," *Art actuel international*, no. 12, 1959, p. [2].

Clouzot, Henri. "La Ferronerie d'à présent," *L'Art vivant*, Vol. 6, 1930, pp. 926–31.

Daix, Pierre, and Georges Boudaille. *Picasso, the Blue and Rose Periods*. New York: New York Graphic Society, 1966.

Delevoy, Robert. *Léger*. Geneva: Skira, 1962.

Duncan, Isadora. *The Art of the Dance*. New York: Theatre Arts, 1928. Includes illustrations by José Clara.

Dupin, Jacques. *Miró*. New York: Abrams, 1962.

Einstein, Carl. [Review of sculpture exhibition, Georges Bernheim], *Documents*, Vol. 1, 1929, p. 391.

Bibliography

Elsen, Albert. "The Many Faces of Picasso's Sculpture," *Art International*, Vol. 13, no. 6, Summer 1969, pp. 24–34, 76.

Evans, Myfanwy, ed. *The Painter's Object*. London: G. Howe, Ltd., [1937].

Fierens, Paul. *Sculpteurs d'aujourd'hui*. Paris: Editions des chroniques du jour, 1933.

Gabo, Naum. *Gabo*. Cambridge: Harvard University Press, 1957.

Geist, Sydney. *Brancusi*. New York: Grossman, 1968.

George, Waldemar. "Bronzes de Jacques Lipchitz," *L'Amour de l'art*, 1926, pp. 299–302.

———. *Fernand Léger*. Paris: Gallimard, 1929.

———. "Jacques Lipchitz: Père légitime des transparences," *Art et industrie*, Vol. 27, no. 24, 1952, pp. 28–29.

Giedion-Welcker, Carola. *Brancusi*. Neuchâtel: Editions du griffon, 1958.

———. *Contemporary Sculpture*. New York: Wittenborn, 1960.

Gilot, Françoise. *Life with Picasso*. New York: Signet, 1965.

Goldwater, Robert. *Primitivism in Modern Art*. New York: Harper, 1938.

Hope, Henry. *The Sculpture of Jacques Lipchitz*. New York: Museum of Modern Art, 1954.

Huidobro, Vicente. "Jacques Lipchitz," *Cahiers d'art*, Vol. 3, 1928, pp. 153–57.

Hultén, K. G. Pontus. *The Machine as Seen at the End of the Mechanical Age*. New York: Museum of Modern Art, 1968.

Hunter, Sam. *David Smith*. New York: Museum of Modern Art, 1957.

James, Philip, ed. *Henry Moore: Writing and Words*. New York: Viking, 1966.

Jourdain, Frantz, and Robert Rey. *Le Salon d'Automne*. Paris: Les Arts et le livre, 1926.

Kahnweiler, Daniel Henri. *Les Sculptures de Picasso*. Paris: Editions du chêne, 1949.

Laurens, Marthe. *Henri Laurens, sculpteur*. Vol. I: *Années 1915–1924*. Paris, 1955.

Léger, Fernand. "Corréspondances," *Bulletin de l'effort moderne*, no. 4, April 1924, pp. 10–12.

"Fernand Léger (Galerie Paul Rosenberg)," *Cahiers d'art*, Vol. 4, 1930, pp. 550–51.

Leiris, Michel. "Alberto Giacometti," *Documents*, Vol. 1, 1929, pp. 209–14.

Metzinger, Jean. "Alexandre Mercereau," *Vers et prose*, no. 27, Oct.–Dec. 1911, pp. 122–29.

Morris, G. L. K. "Relations of Painting and Sculpture," *Partisan Review*, Vol. 10, no. 1, Jan.–Feb. 1943.

New York, Pierre Matisse Gallery. *Alberto Giacometti, Exhibition of Sculptures*. New York, 1948. Foreword by Jean-Paul Sartre, statement by the artist.

New York, Solomon Guggenheim Museum. *Alexander Calder*. New York, 1964.

Nin, Anaïs. *The Diary of Anaïs Nin*. New York: Gunther Stuhlmann, Vol. I (1931–34), 1966; Vol. II (1934–39), 1967.

Olson, Ruth and Abraham Chanin. *Naum Gabo and Antoine Pevsner*. New York: Museum of Modern Art, 1948.

d'Ors, Eugenio. *Pablo Picasso*. Paris: Editions des chroniques du jour, 1930.

Ozenfant, Amédée. *Foundations of Modern Art*. New York: Brewer, Warren & Putnam, 1931.

Paris, Galerie Georges Petit. *Exposition Picasso*. Paris, 1932.

Paris, Galerie Percier. *Constructivistes russes: Gabo et Pevsner: Peintures et constructions*. Paris, 1924. Introduction by Waldemar George. Photostat copy in the library of the Museum of Modern Art.

Paris, Galerie Percier. *Calder*. Paris, 1931. Foreword by Fernand Léger.

Parnac, Valentin. "Danses," *Cahiers d'art, Feuilles volantes*, Vol. 2, no. 6, 1927, pp. 4–5.

Patai, Irene. *Encounters: The Life of Jacques Lipchitz*. New York: Funk & Wagnalls, 1961.

Penrose, Roland. *Picasso, His Life and Work*. New York: Schocken, 1962.

———. *The Sculpture of Picasso*. New York: Museum of Modern Art, 1967.

"Première exposition annuelle d'un groupe de sculpteurs," *Cahiers d'art, Feuilles volantes*, Vol. 2, no. 10, 1927, pp. 4–6. Review of exhibition at Georges Bernheim.

Rafols, José. *Modernismo y modernistas*. Barcelona: Destino, 1949.

Raynal, Maurice. "Dieu — table — cuvette," *Minotaure*, Vol. 1, Dec. 1933, pp. 39–53. Illustrated with photographs of Giacometti's objects and sculpture.

Reusel, G. "Exposition Léger à la Galerie Paul Rosenberg," *Documents*, Vol. 2, 1930, pp. 439–40.

Rose, Bernice. *A Salute to Alexander Calder.* New York: Museum of Modern Art, 1969.

Rubin, William. *Dada and Surrealist Art.* New York: Abrams, 1968.

Sabartés, Jaime. *Picasso, documents iconographiques.* Geneva: P. Cailler, 1954.

Salmon, André. "Nouvelles sculptures de Jacques Lipchitz," *Cahiers d'art*, Vol. 1, 1926, pp. 162–65.

———. "La Sculpture vivante," *L'Art vivant*, Vol. 2, 1926, pp. 130 ff., 208 ff., 258 ff., 334 ff., 742 ff.

———. *L'Art russe modern.* Paris: Laville, 1928.

Scheidegger, Ernst, ed. *Alberto Giacometti: Schriften, Fotos, Zeichnungen.* Zurich: Verlag der Arche, 1958.

Seuphor, Michel. *Le Style et le cri.* Paris: Editions du Seuil, 1965.

Soby, James Thrall. *Joan Miró.* New York: Museum of Modern Art, 1959.

Sovetskoe Iskusstvo: 1917–1957. Moscow, 1957.

Spies, Werner. *Sculpture by Picasso, with a Catalogue of the Works.* New York: Abrams, 1971.

Sterling, Charles. *Still Life Painting from Antiquity to the Present Time.* New York: Universe Books, 1959.

Sweeney, James Johnson. "Fernand Léger et la quête de l'ordre," in *Fernand Léger: La Forme humaine dans l'espace.* Montreal: Les Editions de l'arbre, 1945.

———. *Alexander Calder.* New York: Museum of Modern Art, 1943.

———. *Alexander Calder.* New York: Museum of Modern Art, 1951.

Tériade, E., "Pablo Gargallo," *Cahiers d'art*, Vol. 2, 1927, pp. 283–86.

———. "Oeuvres récentes de Léger: Les Objets dans l'espace," *Cahiers d'art*, Vol. 3, 1928, pp. 145–52.

———. "A propos de la récente exposition de Jacques Lipchitz," *Cahiers d'art*, Vol. 5, 1930, pp. 259–65.

Torrès-Garcia, Joaquin. *Historia de mi vida.* Montevideo: [Talleres gráficos "Sur"], 1939.

———. *Raison et nature: Théories.* Paris, 1932. Available in library of the Museum of Modern Art, New York.

Vantongerloo, Georges. *Paintings, Sculptures, Reflections.* New York: Wittenborn, 1948.

Veu de Catalunya, Vol. 6, no. 19, March 8, 1896.

Vitrac, Roger. *Jacques Lipchitz.* Paris: Gallimard, 1929.

Walter, Gérard. *La Vie à Paris sous l'occupation: 1940–1944.* Paris: A. Colin, 1960.

Zervos, Christian. "Fernand Léger et le développement de sa conception des objets dans l'espace," *Cahiers d'art*, Vol. 3, 1928, pp. 149–58.

———. "Picasso à Dinard, été 1928," *Cahiers d'art*, Vol. 4, 1929, pp. 5–20.

———. "Léger et le développement des objets dans l'espace," *Cahiers d'art*, Vol. 4, 1929, pp. 149–58.

———. "Projets de Picasso pour un monument," *Cahiers d'art*, Vol. 4, 1929, pp. 341–53.

———. "Exposition de dessins des sculpteurs (Galerie de France)," *Cahiers d'art*, Vol. 4, 1929, pp. 419, 421.

———. "Notes sur la sculpture contemporaine: A Propos de la récente exposition internationale de sculpture," *Cahiers d'art*, Vol. 4, 1929, pp. 465–73. Exhibition held at Georges Bernheim.

———. "Les 'Constructions' de Laurens (1915–1918)," *Cahiers d'art*, Vol. 5, 1930, pp. 181–91.

———. "De l'importance de l'objet dans la peinture d'aujourd'hui," *Cahiers d'art*, Vol. 5, 1930, pp. 343–54.

Bibliography

————. "Vie spirituelle ou activité utile?" *Cahiers d'art*, Vol. 7, 1932, pp. 5–8.

————. "Quelques notes sur les sculptures de Giacometti," *Cahiers d'art*, Vol. 7, 1932, pp. 337–42.

————. *Picasso: Oeuvres*. Paris: Editions des Cahiers d'art, Vol. 7, 1955; Vol. 8, 1957.

Index

Works by Gonzalez are indexed by title; works by other artists are listed under their names. Page numbers in italics refer to illustrations.

176